Los Borrachos ("The Drunkards") is Diego de Velázquez's earliest painting of a mythological subject. Created for Philip IV of Spain around 1627–29, its naturalistic portrayal of exuberant peasants drinking wine with Bacchus has long baffled its admirers, who have failed to agree on what the artist has depicted. What prompted Velázquez to try his hand at mythology, and why did he choose such a bewildering subject? In this penetrating study, Steven N. Orso reconstructs Velázquez's early years in the king's service and his competition with rivals for royal favor. By tracing their conflicts over the merits of different styles of painting and by demonstrating the role of history painting as a vehicle for artists to make their reputations at Philip IV's court, Orso establishes the basis for a provocative new explanation of *Los Borrachos* and Velázquez's reasons for painting it.

VELÁZQUEZ, *LOS BORRACHOS*, AND PAINTING
AT THE COURT OF PHILIP IV

Velázquez,
Los Borrachos,
and Painting
at the Court of Philip IV

STEVEN N. ORSO
University of Illinois at Urbana–Champaign

CAMBRIDGE
UNIVERSITY PRESS

Published by the Press Syndicate of the University of Cambridge
The Pitt Building, Trumpington Street, Cambridge, CB2 1RP
40 West 20th Street, New York, NY 10011–4211, USA
10 Stamford Road, Oakleigh, Melbourne 3166, Australia

First published 1993

Printed in the United States of America

Library of Congress Cataloging-in-Publication Data
Orso, Steven N., 1950–
Velázquez, Los Borrachos, and painting at the Court of Philip IV /
Steven N. Orso.

 p. cm.

Includes bibliographical references and index.

ISBN 0–521–44452–7
1.–Velázquez, Diego, 1599–1660. – Topers. 2. Velázquez, Diego,
 1599–1660 – Criticism and interpretation. 3. Philip IV, King of
Spain, 1605–1665 – Art patronage. 4. Painting, Modern – 17th–18th
centuries – Spain. I. Title.
ND813.V4A76 1993
759.6–dc20 93–493
 CIP

A catalog record for this book is available from the British Library.

ISBN 0–521–44452–7 hardback

For my sister, Karen

CONTENTS

ILLUSTRATIONS

PREFACE

It is with pleasure that I acknowledge the assistance and encouragement of colleagues who facilitated the completion of this book. As always, my greatest debt is to Jonathan Brown, who first set me thinking about Velázquez when I was an undergraduate, and whose tutelage and friendship since that time have proved a constant source of inspiration. His incisive comments on a draft of this study proved immeasurably helpful as I sought to sharpen my arguments. James J. O'Donnell, whose translations from Latin prose and verse grace this volume at several points, put his mastery of classical philology at my disposal with exemplary generosity. I am much obliged to William B. Jordan and Gridley McKim-Smith, who weighed in with thoughtful criticisms and helpful suggestions at a pivotal moment in the development of my ideas, and to Carol Bolton Betts, who offered welcome advice on solving editorial problems that bedeviled my text. For other contributions along the way, I thank Rocío Arnáez, Emmett Bennett, Marcus B. Burke, Craig Felton, Madlyn M. Kahr, John Rupert Martin, Geoffrey Parker, and Donald Posner. I am likewise grateful to Beatrice Rehl, Katharita Lamoza, and Cary U. Groner for the consummate professionalism they brought to the production of this book at Cambridge University Press.

I conducted much of the research for this study while on a leave of absence from the University of Illinois at Urbana-Champaign, which I spent as an honorary fellow at the University of Wisconsin at Madison. Following my return to Urbana-Champaign, the Research Board of the University of Illinois assisted the later stages of my work by granting me one of its Arnold O. Beckman Research Awards. I am grateful to both institutions for accommodating my efforts. I also thank the Program for Cultural Cooperation Between Spain's Minis-

try of Culture and United States' Universities for a generous subvention that made possible the inclusion of color illustrations to my text.

Evoe!

Urbana, Illinois
12 October 1992

DOCUMENTATION

Quotations from prose sources in other languages are generally given in English translation; the principal exceptions are Appendixes B to D, where texts are given in both Castilian and English. Quotations from poetic sources in other languages are given both in original verse form and in English prose translation. Unless indicated otherwise in the notes or Bibliography, such translations are my own.

Titles of early books that I discuss in my text are given in modernized spelling to avoid the confusion that might arise from orthographic inconsistencies between different editions of the works in question. Readers wishing to consult the particular editions to which I have referred will find their titles given with the original orthography in the Bibliography.

Citations in the notes of works listed in the Bibliography are generally by author's last name and date of publication; when authorship is unknown, a short form of the title is used instead. If an author published two cited works in the same year, letters appended to the publication date distinguish the works from each other (for example, Martín González, 1958a and 1958b). The following abbreviations also appear in the notes:

APM	Archivo del Palacio Real, Madrid
APM, SA	Sección Administrativa
APM, SH	Sección Histórica
BAV	Biblioteca Apostolica Vaticana
leg.	legajo
reg.	registro

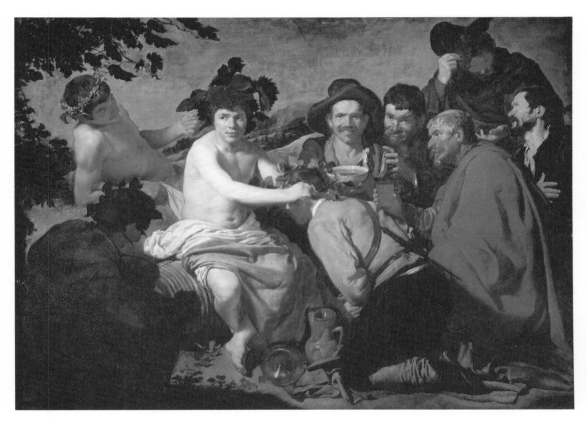

Plate 1. Diego de Velázquez, *Los Borrachos*, here identified as *Bacchus in Iberia* (Madrid, Museo del Prado).

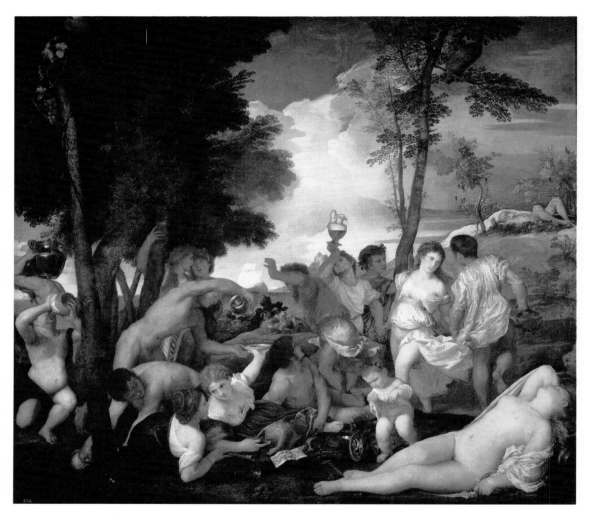

Plate 2. Titian, *Bacchanal of the Andrians* (Madrid, Museo del Prado).

Plate 3. Vicente Carducho, *Saint Bruno Renounces the Archbishopric of Reggio* (Madrid, Museo del Prado).

Plate 4. Diego de Velázquez, *Adoration of the Magi* (Madrid, Museo del Prado).

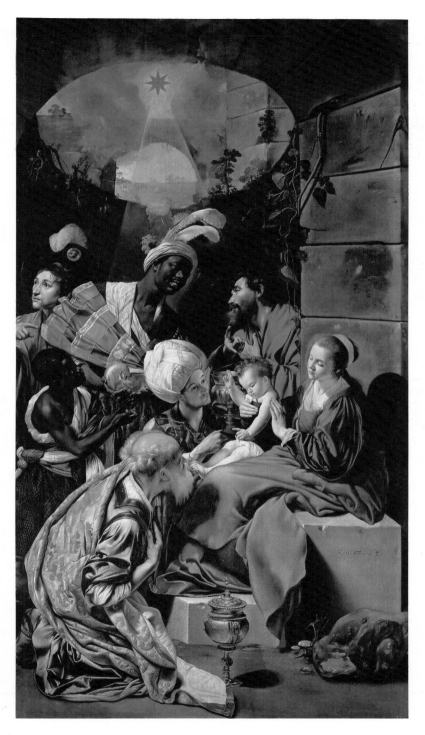

Plate 5. Juan Bautista Maino, *Adoration of the Magi* (Madrid, Museo del Prado).

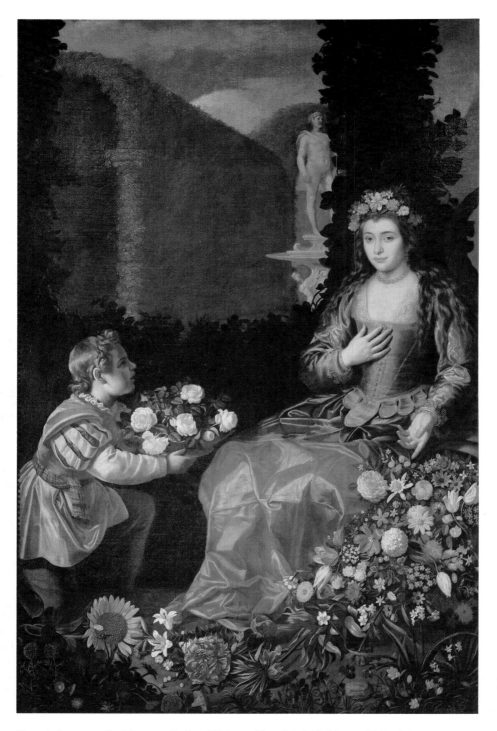

Plate 6. Juan van der Hamen y León, *Offering to Flora* (Madrid, Museo del Prado).

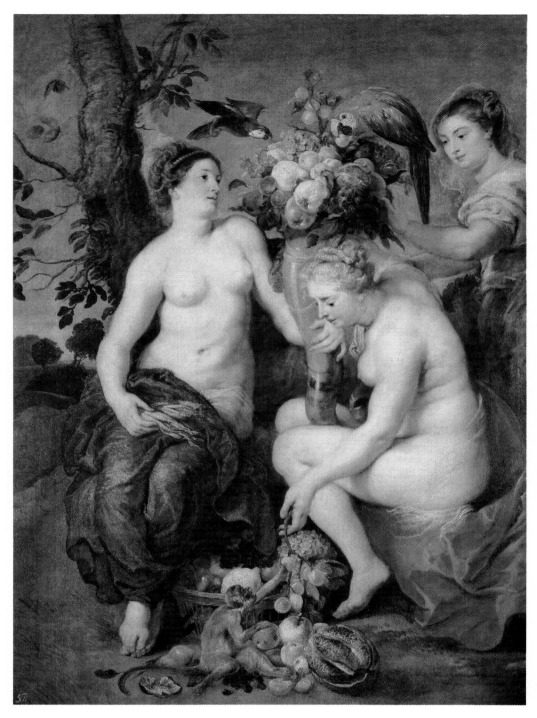

Plate 7. Peter Paul Rubens and Frans Snyders, *Three Nymphs Filling the Horn of Plenty* (Madrid, Museo del Prado).

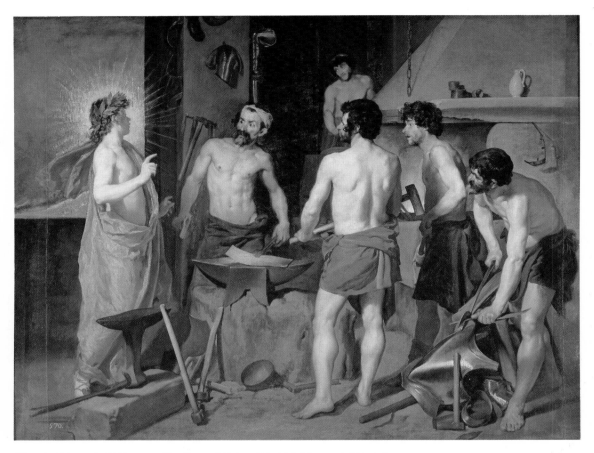

Plate 8. Diego de Velázquez, *The Forge of Vulcan* (Madrid, Museo del Prado).

INTRODUCTION

LOS BORRACHOS (fig. 1, plate 1), Diego de Velázquez's celebrated painting of ordinary peasants drinking wine in the presence of Bacchus, is suffused with infectious good cheer. Time and again, visitors to the Prado who arrive at the picture in the grip of museum fatigue find that its air of joyful revelry restores their flagging spirits. Nevertheless, the intuitive delight that the painting evokes should not blind us to the fact that it is one of Velázquez's most baffling works. It prompts a deceptively simple question: What is going on here?

At first glance, the actions of this group appear straightforward. A company of drinkers has assembled in an open landscape on a sunny day. Bacchus, who presides over the gathering, sits atop a wine cask with his legs crossed (fig. 2). He can be identified as the ancient god of wine from the garland of large, floppy vine leaves entwined in his thick black hair, and from the loose bolts of red and white fabric spread casually about his legs and waist in a manner vaguely suggestive of classical dress.

Clustered to the right are six men whose ruddy coloring and rough, wrinkled skin are in marked contrast to the creamy complexion of the smooth-skinned god. Their homely features and plain outfits characterize them as Spanish peasants. One man, wearing a short sword in his belt, kneels so that Bacchus can crown him with a garland (fig. 3); yet, even as Bacchus places the ring of leaves on the man's head, the god looks off to the left for no apparent reason. An earthenware pitcher and an overturned glass or jar lie on the ground between Bacchus and the man. Two peasants seated behind the kneeling man smile at the viewer, and one of them cradles in his hands a shallow drinking bowl filled with wine (fig. 4). Farther to the right, a gray-haired man holding a beaker of wine fixes his gaze upon Bacchus. Behind him another member of the company presses a bagpipe against his chest while looking up toward a man who approaches the group from behind. This newcomer extends his

left hand with its palm turned up and doffs his hat with his right (fig. 5).

To the left of Bacchus, another figure reclines on the ground behind the god and watches him crown the kneeling man (fig. 6). Like Bacchus, this figure is naked from the waist up except for a garland in his hair. Owing to his lack of clothing he has sometimes been identified as a satyr even though he lacks the caprine features typical of such creatures. He rests his weight on his right forearm, and with his left hand he lifts an elegant glass of wine by its base. In the left foreground, a fully dressed man also wearing a garland sits in the shade of a tree, some branches of which fill the upper left corner of the composition. Seen from behind, this figure takes hold of a large, upright wine jar with both hands, and he, too, watches the god. Damage that the picture sustained in 1734 (in a Christmas Eve fire that destroyed the Alcázar of Madrid) has exaggerated the effect of the tree's shade, reducing this fellow to a blur (fig. 7).[1]

To describe these characters and their actions is not, however, to understand them. Our initial delight upon encountering them soon gives way to bewilderment at Velázquez's intentions; this

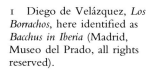

1 Diego de Velázquez, *Los Borrachos*, here identified as *Bacchus in Iberia* (Madrid, Museo del Prado, all rights reserved).

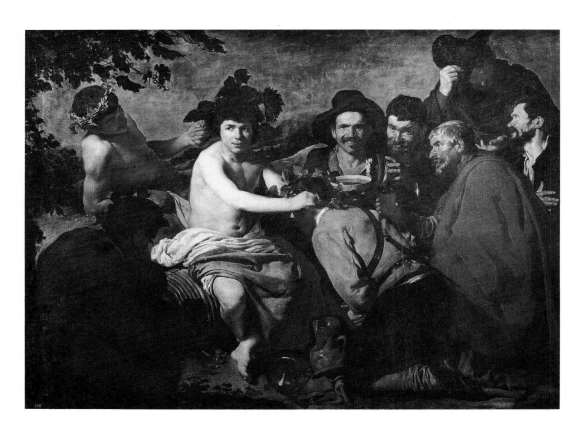

prompts a torrent of questions. Why does he show Bacchus, a deity associated with ancient Greece and the Near East, presiding over a drinking party of Spanish peasants? Does the picture illustrate a narrative, and if so, what is its text? Why does Bacchus garland the kneeling man and why does he look away from the act? Does Bacchus sympathize with the peasants or does he mock them? Is the man with a sword a soldier or does he merely pretend to be one? For that matter, is the figure identified as Bacchus truly meant to be perceived as the ancient deity or is he to be understood as a young man playing the role of the god? Is the man who approaches the group from behind an accepted member of the company asking for a glass of wine or is he a wandering beggar who, having happened upon the others,

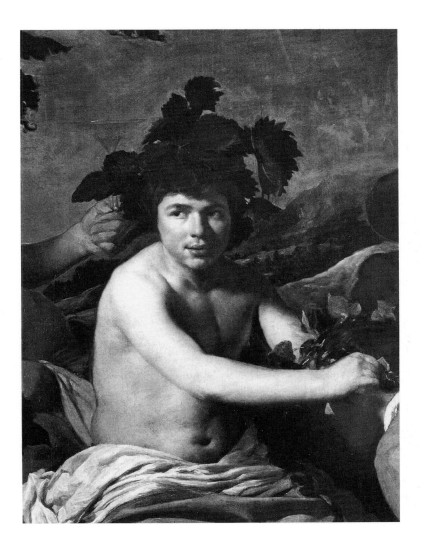

2 Detail of Figure 1.

pleads for alms? How is the viewer meant to respond to this scene?

One measure of the difficulties such questions pose is that there is no generally accepted title for the picture. Suggested names for it have included "Bacchus," "Bacchus and His Companions," "The Drinkers," "The Topers," "The Brotherhood of Bacchus," "The Feast of Bacchus," "The Rite of Bacchus," and "The Triumph of Bacchus," but in the absence of a consensus, the painting has been known most widely by its popular nickname: *Los Borrachos,* "The Drunkards."

Behind the uncertainty over what is happening in *Los Borrachos* lies a more fundamental question. As a young artist in his native Seville, Velázquez had painted genre scenes, religious subjects, and the occasional portrait. During his first years in service at the royal court of Madrid, he had made his reputation as a portraitist. Within that context, *Los Borrachos* constituted a striking departure from the path his career had thus far taken. The very size of the picture (1.65 × 2.25 meters) suggests that Velázquez regarded it as an important work.[2] What circumstances prompted him to paint a mythological subject at all, let alone one so enigmatic in character?

3 Detail of Figure 1.

4

The questions that *Los Borrachos* provokes are difficult to answer because documents pertaining to it from Velázquez's lifetime are few in number and limited in content. On 22 July 1629 Philip IV of Spain signed an order that Velázquez was to be paid 400 ducats, of which 300 were owed him for "paintings that he made for my use" and 100 were owed him for "a painting of Bacchus that he has made for my use."[3] That suggests a *terminus ante quem* for the delivery of the picture. By reference to other documents, a *terminus post quem* can be deduced as well. On 18 September 1628 Philip had ordered that Velázquez was to receive from the royal household a daily ration equal in value to that received by the king's barbers "in satisfaction of all that is owed him until today for the works of his office, which he has made for my service, and for all those that I shall command him to make in the future."[4] This boon, which was worth 12 *reales* per day, was duly entered in the records of the Bureo, the committee that governed the royal household.[5] The Bureo took care to note that the royal favor was granted "for his works for His Majesty's service" and that it was distinct from Velázquez's regular salary as a court painter,

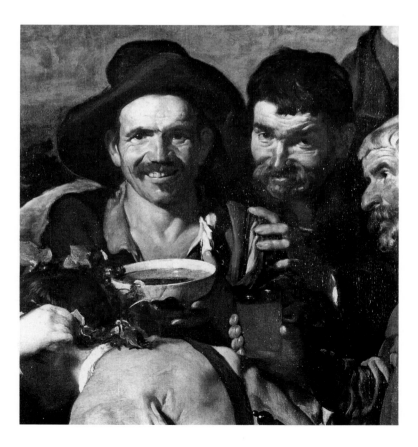

4 Detail of Figure 1.

which was to be paid not by the royal household, but rather by the Junta de Obras y Bosques (Committee of Works and Woods).[6] On 9 February 1629 the king signed a second, explanatory order that clarified that the future works by the artist to which his first order referred "are to be the original portraits that I shall command him to make."[7]

These records indicate that Velázquez's salary during the 1620s was a kind of retainer that kept him in Philip's service, and that the pictures he painted for the king were paid for separately. Because the royal order of 18 September 1628 covered the balance due the artist for any works he had painted until then, Velázquez could not have delivered *Los Borrachos* to the king before that date. If he had done so, the king would not have had to pay 100 ducats

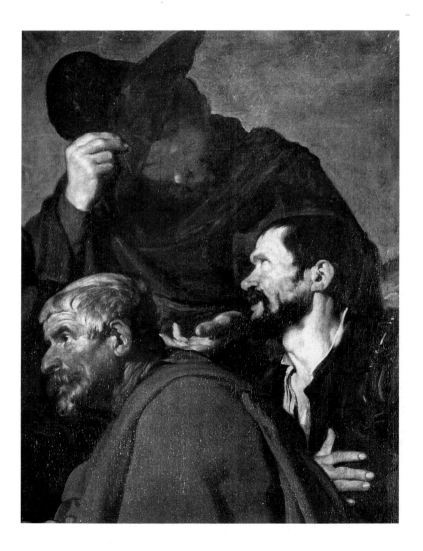

5 Detail of Figure 1.

6

for it in 1629.[8] As for the subsequent royal order of 9 February 1629, its bearing on *Los Borrachos* is more ambiguous. Because it refers specifically to "portraits" as the works for which the daily ration was compensation, it leaves unresolved whether the king had taken possession of Velázquez's mythological subject by then. That it makes no mention of the picture might mean that the king had not yet acquired it, but this is by no means certain.[9] On balance, it seems prudent to conclude that Velázquez presented *Los Borrachos* to his royal patron definitely after 18 September 1628, and possibly (but not certainly) after 9 February 1629.

After 1629 *Los Borrachos* appeared regularly in the inventories of the royal art collection, invariably identified as Velázquez's work. When a list of the king's paintings, sculptures, and furnish-

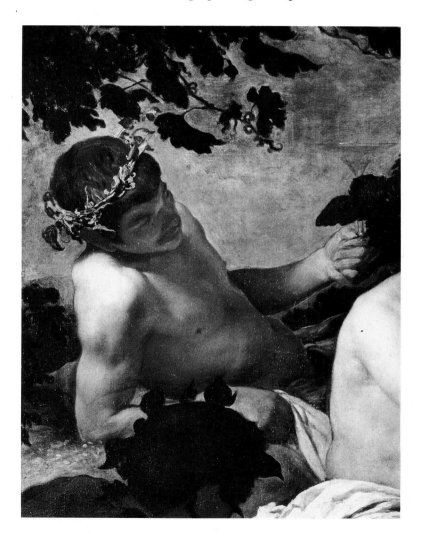

6 Detail of Figure 1.

ings in the Alcázar of Madrid was compiled in 1636, *Los Borrachos* was recorded in the bedroom of his summer apartments:

> Another canvas measuring almost three *varas* in length, with a gilded and black frame, in which is Bacchus seated on a cask, crowning a drunkard. There are other figures who accompany him on their knees, another behind with a bowl in his hand, and another who is going to take off or put on his hat. It is by the hand of Diego Velázquez.[10]

By the time the collection in the Alcázar was next inventoried in 1666, the painting had been moved to the North Gallery of the king's quarters. It was then described as "another painting measuring two and one-half *varas* in length and one and one-half in height, with its black frame, a history painting [*historia*] of Bacchus crowning his *cofrades,* by the hand of Diego Velázquez, [appraised] at 300 silver ducats."[11] Although Velázquez had been dead for six years by then (and Philip IV for one), the entry carries particular authority because the expert who appraised the paintings was Velázquez's son-in-law, the painter Juan Bautista del Mazo. The word used to describe Bacchus's companions has special significance: A *cofrade* was a member of a *cofradía* – that is, a confraternity or brotherhood, typically one with a religious purpose. For a contemporary understanding of *cofrade,* we can turn to the 1611 dictionary of Castilian compiled by Sebastián de Covarrubias Orozco, who defined it as commonly referring to "those who have a brotherhood in some pious and religious work."[12] The use of *cofrades* in the inventory suggests that the peasants in *Los Borrachos* were understood to be men engaged in some service to the god, but the terseness of the entry leaves the nature of their activity unexplained. Subsequent inventories compiled in 1686, 1700, and 1702 also record the picture in the North Gallery and identify its subject with the same phrase, "a history painting of Bacchus crowning his *cofrades.*"[13]

The picture was next cited in 1735, on a list of works that had been rescued from the Alcázar fire of 1734, as "the triumph of the god Bacchus."[14] Its new home became the Palace of the Buen Retiro, and in 1746 it was entered on a list of paintings that had been assigned to the decoration of the Infante Felipe's quarters, described once again as "the triumph of the god Bacchus."[15] After the present-day Royal Palace of Madrid was built, the picture was displayed there. An inventory of 1772 identifies its subject as "the triumph of Bacchus," and inventories of 1789 and 1814 refer to it as "the coronation of Bacchus."[16] The picture entered the Prado in 1819 and sometime thereafter became known as *Los Borrachos.*[17]

Terse as these inventory entries are, they are voluminous when compared to what two fundamental sources about Velázquez's

career, the treatises on painting by Francisco Pacheco and Antonio Palomino de Castro y Velasco, say about *Los Borrachos:* nothing. Pacheco was Velázquez's teacher and father-in-law, and his *Arte de la pintura,* published in 1649 (from a manuscript that he had completed by 24 January 1638), provides valuable information about Velázquez's early years at court.[18] Nevertheless, Pacheco makes no mention of his son-in-law's initial venture into painting mythology. Palomino's *El museo pictórico y escala óptica* was published in two parts issued in 1715 and 1724. The second part contains 226 biographies of artists, all but a few of them Spaniards, for which he has been dubbed "the Spanish Vasari." His life of Velázquez is by far the most thorough of his biographies, but on the subject of *Los Borrachos* he provides not a word.[19]

The dearth of information about the painting in the early

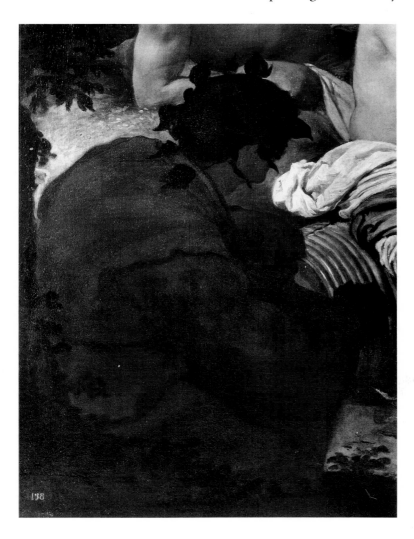

7 Detail of Figure 1.

sources is one reason that the many questions it inspires have elicited a plethora of contradictory answers. No two viewers standing before a painting see exactly the same thing, but reactions to *Los Borrachos* have proved remarkably diverse. Any effort to explain the picture must begin by assessing the arguments of those who have previously addressed its mysteries, for it is on the foundation of their discoveries that new contributions must stand.

THE WEB OF RESPONSES

MONG THE MANY attempts to explain *Los Borrachos,* one of
the most enduring schools of interpretation has regarded
the picture as a burlesque of classical mythology.[1] This
approach emerged in the late eighteenth century, as is evident
from Antonio Ponz's encyclopedic survey of the notable works of
art in Spain, the *Viaje de España.* Ponz cited the painting three
times. In his first reference (1776), which appeared in one of two
volumes he devoted to Madrid, Ponz declared that the picture
depicted "one who plays the role of Bacchus with various figures
who form a kind of Bacchanal."[2] Later in the same volume he
incorporated a letter from the painter Anton Raphael Mengs that
described important paintings in the Royal Palace, among them
Los Borrachos, which Mengs called "the picture of the feigned
Bacchus who crowns some drunkards."[3] Ponz subsequently re-
ferred to the painting in the final volume of the *Viaje* (1794) as
"the Triumph of Bacchus in burlesque, which Don Francisco de
Goya etched."[4]

The print to which Ponz referred was an etching after Veláz-
quez that Goya had offered for sale in December 1778 (fig. 8).
Evidently Goya was familiar with Ponz's volumes on Madrid be-
cause his identification of the subject in the inscription on his
print, "a feigned BACCHUS crowning some drunkards," echoed
the phrase in Mengs's letter to Ponz.[5] Goya's distortion of some
details of the painting – Bacchus's tight smile became a smirk, and
the peasant holding the wine bowl acquired a toothier grin –
facilitated the interpretation of the picture as a burlesque rather
than as a straightforward rendering of a mythological episode.[6]

To be sure, it was possible for a viewer in the late eighteenth
century to accept the figure of Bacchus as a representation of
the god appearing to mortal men rather than as an ordinary
youth playing the role of the deity for his companions' amuse-
ment. One of Goya's contemporaries, Manuel Salvador Carmona,
made an etching and engraving that reproduced the painting more

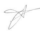

faithfully and that identified its subject simply as "Bacchus crowning the drunkards" (fig. 9).[7] Similarly, Juan A. Ceán Bermúdez, whose *Diccionario histórico de los más ilustres profesores de las bellas artes en España* (1800) remains a fundamental source for historians of Spanish art, was content to identify the picture in passing as "Bacchus crowning some drunkards," with no indication that the god was a fake.[8] Nevertheless, the early perception of the picture as a burlesque of classical mythology gained many supporters.

Those who considered *Los Borrachos* a comic travesty commonly held a negative judgment of the peasants as men who deserved to be mocked or scorned. To Aureliano de Beruete (1898), the man kneeling to be crowned was a "vagabond," the man with the drinking bowl was a "rogue," and the smiling figure at that rogue's side was "of equally forbidding appearance." He added, "Any one interested in types of criminal anthropology, or desirous of studying the distinctive characteristics of the ruffians, sharpers, and cut-purses of Spain in the seventeenth century, would be fully supplied by this picture, where the faces are so real as to be almost

8 Francisco de Goya after Diego de Velázquez, *A False Bacchus Crowning Some Drunkards* (Courtesy Museum of Fine Arts, Boston, Harvey D. Parker Collection).

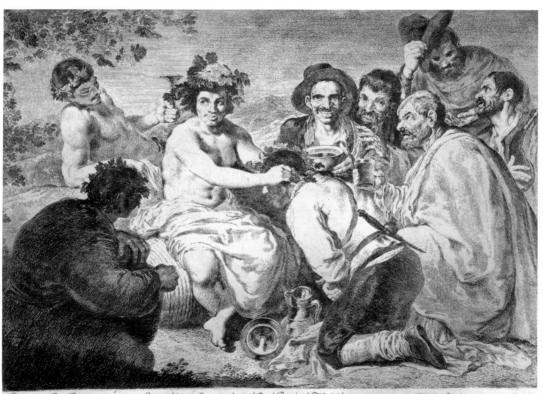

Pintura de Don Diego Velazquez, con figuras del tamaño natural, en el Real Palacio de Madrid, que representa un BACO fingido coronando algunos borrachos: dibujada y grabada por D. Francisco Goya, Pintor Año de 1778.

12

living."[9] Perhaps the harshest judgment of all was that of Arthur S. Riggs (1947):

These men are the soldiers returned from the wars, the loafers, the military and civilian scum and slime flowing in a never ending stream through the alleys and byways of every Spanish city of the period as the shameful backwash of conflicts that were rapidly destroying all the moral and many of the cultural fundaments of the nation. Cutpurse and hireling thug, gutter drunkard and wastrel, beggar and hooligan, they are all there, true to life, tanned, dry, with grins that fail to mask the brutalized expressions of the different individuals, ferocious or cynically equivocal. These are the same people Cervantes immortalized in type in *Rinconete y Cortadillo* and who, in *La Ilustre Fregona,* made a large part of the tunny fisherman's group on the blazing beach of San Lúcar de Barrameda.[10]

Over the years those who interpreted *Los Borrachos* as a burlesque advanced several explanations to account for Velázquez's departure from conventional renderings of mythology. As the passage from Riggs indicates, some perceived affinities between the

9 Manuel Salvador Carmona after Diego de Velázquez, *Bacchus Crowning the Drunkards* (Courtesy Museum of Fine Arts, Boston, Bequest of William P. Babcock).

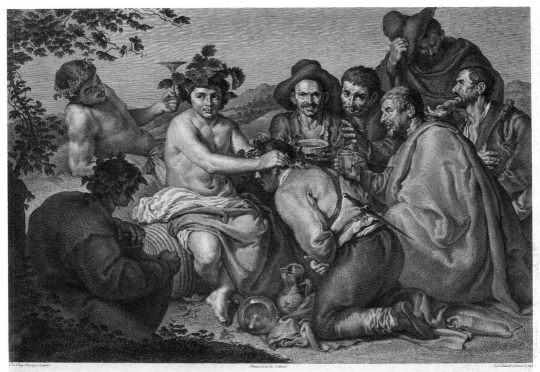

Baco coronando à los Borrachos, pintado por D. Diego Velázquez de Silva, natural de Sevilla, Caballero de la Orden de Santiago, Primer Pintor Fuida de Camara, y Apeventador mayor del Rey D. Felipe IIII; admirable en la imitacion de la verdad y en la soltura y libertad de su estilo: Este Quadro, que es de su tiempo medio, tiene de ancho siete pies de rey, y de alto cinco y pulgada y media: está en el Real Palacio de Madrid.

painting and the picaresque novel. Enrique Lafuente Ferrari (1960) adopted a similar position using more temperature language:

The Topers, though it falls in line with his Sevillian works, denotes a higher ambition and raises a major problem: the anti-rhetorician Velazquez confronts a mythology. He had already become acquainted with the great Italian masters, in the matchless gallery of the Alcazar in Madrid, and also with Rubens, but had remained virtually uninfluenced by them. His devotees of the cult of Bacchus might have stepped from the pages of *Lazarillo de Tormes* or *Guzman de Alfarache,* picaresque wine-bibbers grouped around a handsome, half-naked youth.[11]

Similarly, the pseudonymous Bernardino de Pantorba (1955) saw the painting as "this authentic page of the Spanish picaresque, sister of the carefree *costumbrista* novels of our Golden Age."[12] However, as is revealed by Riggs's and Lafuente Ferrari's having chosen different novels to make their points, and by Pantorba's having referred to the genre as a whole, *Los Borrachos* has yet to be convincingly related to a specific passage from contemporary Spanish literature. At most the painting honors the spirit, not the letter, of the picaresque tradition.

Another early hypothesis relating the picture to a literary effort perceived *Los Borrachos* as a re-creation of a "stupendous tourney of the vassals of Bacchus and the confraternity of the Brindonica," an entertainment that had been performed in Spanish at the court of Brussels for the Archdukes Albert and Isabella. This festivity took place under the auspices of Bacchus, who was portrayed by an actor costumed so as to appear naked, with two large clusters of grapes for earrings and garlands of grape leaves entwined about his neck and limbs. Attended by eight young companions, the god made his entrance atop a wine cask. The tourney over which he presided parodied a *juego de cañas,* a kind of mock cavalry engagement that was a popular form of entertainment at the Spanish court. Adolfo de Castro (1857) introduced this event into the scholarly literature on the painting by declaring, "This bacchic *juego,* celebrated in Brussels, is the famous picture of the drunkards by Velázquez, put into action."[13] He may have intended his remark metaphorically, not literally, but the possibility that an account of the festival had inspired Velázquez was subsequently taken up by Jacinto O. Picón (1899).[14]

A few later scholars reiterated this argument, but the difficulty of explaining how Velázquez could have learned of the event moved them to caution. Thus Riggs (1947) concluded:

The accounts as given are too vague to make anything certain as to the manner in which the festival was set up and given, if, indeed, it was anything more than planned. But at least it gives a plausible account of

what may easily have been a fact, and from it Velázquez could have taken the inspiration for this amazing work.[15]

Elizabeth D. G. Trapier (1948) briefly noted the hypothesis, which she implicitly rejected by describing it as "extraordinary."[16] Martin S. Soria (1953) cited the Brussels tourney as a possible inspiration, but Soria's own findings, to be discussed later in this chapter, persuaded Francisco J. Sánchez Cantón (1961) to dismiss the festival from consideration.[17] José López-Rey (1963) listed the idea among several "secondary points" that had made recent discussion of the picture "rather unrewarding."[18] Since then the tourney hypothesis has not figured significantly in the literature on the painting.

The suspicion that *Los Borrachos* illustrated some sort of court festivity also manifested itself in speculation that the painting depicted an entertainment staged by the jesters and buffoons in residence at the royal court of Madrid. As early as 1848, William Stirling-Maxwell had remarked that "*Los Borrachos* . . . gave evidence that in painting princes he [Velázquez] had not forgotten how to paint clowns."[19] Like Castro's remark linking the painting to the Bacchic tourney in Brussels, this observation may have been intended metaphorically rather than literally, for Stirling-Maxwell went on to compare the figure reclining behind Bacchus to Shakespeare's drunken jester Trinculo, and to declare that the painting's humor "entitles Velasquez to the name of the Hogarth of Andalusia."[20]

In 1964 José Camón Aznar explicitly connected the painting to the court entertainers:

The painting of *Los Borrachos* is, simply, a scene of the Palace buffoons. And as testimony to this interpretation we have the fact that in the carnival of 1636 the buffoons of the Alcázar were assembled and were made to drink wine until becoming drunk in order to provoke their buffoonery. And some ten years earlier, Velázquez paints a similar scene.[21]

Camón Aznar's notion was later endorsed by Marianna Haraszti-Takács (1983).[22] It can be objected, however, that the picture is unlike any other known depictions of entertainers at the Spanish Habsburg court, including those by Velázquez that certainly portray jesters, dwarfs, and buffoons.[23]

Another variation on the "burlesque" interpretation was that of López-Rey (1963), who read *Los Borrachos* as a moralizing lesson with a religious undercurrent:

The picture is, of course, a baroque double-edged parody of the false world of the fable and of sinful human ways, and the laugh is made heartier, healthier, and pregnant, as the clowning tosspots vie in their

bearing with the loutish nudes of Bacchus and his attendant, thus heightening the portrayal of the clumsiness of the earthy; the underlying religious sentiment is keyed to the figure of the beggar who, lightly sketched, looms in the background over the clot of drunkards who ignore him.

The virtue of Charity, then readily identified with alms-giving, almost invariably led the Catholic mind to the contemplation of the Cross where Jesus shed His blood for the redemption of Mankind. In Velázquez's burlesque of Bacchus and his soulless fellows, the beggar is made to underplay his part in a pithy baroque manner, while the false god emphasizes his, as does his counterfigure, the drunkard, who holds up a bowl, his dull senses still responsive to the wine's pungency, his mind obviously blank to its symbolic Eucharistic meaning.[24]

Notwithstanding his considerable stature as an authority on Velázquez, López-Rey's belief that the ebullient image disguised a stern religious moral has not found wide acceptance. In particular,

10 Adriaen Brouwer, *Tavern Scene* (Rotterdam, Museum Boymans-van Beuningen).

16

the premise that the assembled drinkers deserve to be judged in such harsh, negative terms – "clowning tosspots," "loutish nudes," "soulless fellows," and a "drunkard" so inebriated that his senses are dulled and whose mind is "obviously blank" – is questionable.

As we have seen, such condemnations of the peasants are common among those who interpret *Los Borrachos* as a burlesque. But are these men really so besotted? Velázquez's peasants are poor, sunburned, and coarsely dressed, but that is no proof of moral decay. It is difficult to accept that the fellow with a drinking bowl is dull and insensate from drinking when he can react to the viewer's presence with an alert gaze and a broad, animated grin. What is more, his supposed drunkenness has left his muscle control unaffected, for he holds his bowl so steadily that a reflection of its glazed interior rim can be seen on the placid surface of the wine

11 Titian, *Bacchanal of the Andrians* (Madrid, Museo del Prado, all rights reserved).

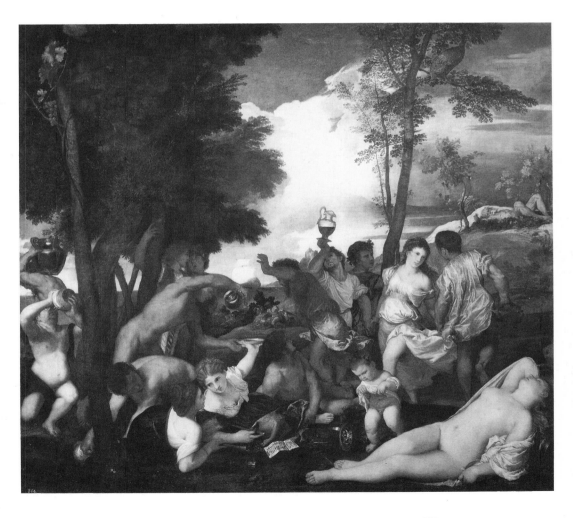

17

(see fig. 4). That he and his companions have been drinking is indisputable, but that they have fallen into a degenerate state is not. Indeed, by the standards of Netherlandish tavern scenes (fig. 10), Velázquez's company is almost sedate. As the rich vocabulary of drinking attests, the intoxicating power of wine manifests itself in many ways, from the relaxed inhibitions of the social drinker to the insensate stupor of the bibulous sot. Wine can leave one merry or sozzled, refreshed or plastered, pleasantly high or utterly wasted. One can take a drop, or a drop too much. We should keep this range of possibilities in mind as we scrutinize *Los Borrachos*.

The hazards of overestimating how intoxicated Velázquez's drinkers have become can be illustrated by comparing his picture to another work to which it has often been related: Titian's *Bacchanal of the Andrians* (fig. 11, plate 2). Painted about a century earlier, it depicts the natives of Andros, an island sacred to Bacchus on which a river flowed with wine. As a result of this unique geographical feature, the Andrians lived their lives in a state of ecstatic inebriation, which Titian represents in terms of drinking, dancing, and music-making. At the heart of his composition two women sing a canon to the words "he who drinks and does not drink again, does not know what drinking is," which attests to the centrality of wine-drinking in the Andrians' lives.[25]

The *Bacchanal* has long been esteemed as one of Titian's triumphant ventures into the realm of classical mythology; yet, when the specific actions of his revelers are compared to those of Velázquez's peasants, it is the Andrians whose behavior must be judged the more indulgent. However much Velázquez's purported drunkards may have imbibed, none of them guzzles from an upturned pitcher, urinates in public, or falls into a drunken sleep. Although those of Titian's Andrians who have kept their clothes on are better dressed than Velázquez's peasants, several of the Andrians have stripped to the buff. Velázquez's Bacchus is partly undressed, but he keeps his loins covered, as does the reclining figure behind him.[26] The others in *Los Borrachos* are fully clothed, and no one signals any intention to frolic nude across the Castilian landscape.

There is an element of facetiousness to this comparison, but the discrepancy between the actions depicted in the paintings and the conventional responses to them highlights one obstacle to coming to terms with *Los Borrachos*. In part, the discrepancy arises because twentieth-century art historians have perceived striking differences in the intellectual roots of the two pictures. Modern techniques of iconological analysis have put a premium on dis-

covering texts that inspired Renaissance and Baroque works of art, and in the case of the *Bacchanal,* such a text is known. Titian's picture freely re-creates a lost antique painting known from a description in Philostratus the Elder's *Imagines* (1.25).[27] As such, the painting has enjoyed a special place in scholars' eyes as evidence that Titian epitomized the Renaissance ideal of the learned painter, equally at home in the studio and the library.[28] On the other hand, no text has been found that a consensus of scholars has accepted as a source for *Los Borrachos,* although several have been proposed. In the absence of a generally acknowledged literary basis for the painting, it has been easier for interpretations of it as a mockery of classical mythology to flourish.

Another, more fundamental reason for the discrepancy in the way the two companies of drinkers have been perceived is that the Andrians are prettier. They are exemplary specimens of male and female beauty — handsome in aspect, trim in physique, and graceful in movement. The men are bronzed with healthy, full-body suntans, and the women enjoy creamy, unblemished complexions. The pot-bellied guzzler crouching at the extreme left and the old man sleeping in the right background are exceptions who prove the rule, for their departures from the physical norm underscore the prevalence of the body beautiful on Andros. Titian has worked squarely within the mainstream of Renaissance classicism by making his Andrians conform to a canon of idealized beauty derived from the study of ancient art. As a result, they enjoy the full authority of the classical tradition, which effectively veils their nudity and exempts them from reproach.

On the other hand, Velázquez's peasants are not conceived in accordance with any canon of classical beauty. They are plain, not handsome, and their rough skin is wrinkled and sunburned, not supple and tanned. In no way do they resemble the sort of men whom viewers accustomed to the idealizations of the classical tradition would expect to find as the companions of a Greco-Roman deity. It was the failure to meet such expectations that opened the door for proponents of classicism to interpret *Los Borrachos* as a travesty. (As we have seen, one of the earliest writers to advance such an interpretation was the neoclassical painter and theoretician Mengs.) Deprived of idealized beauty, the peasants in *Los Borrachos* offer no evidence that they belong in the remote past of Greco-Roman antiquity; rather, they look like Velázquez's contemporaries, drawn from the same society as the figures who populate his early genre paintings (compare fig. 20). This seeming anachronism — an ancient god seated amid seventeenth-century Spaniards — also facilitated interpretations of *Los Borrachos* as a burlesque.

In effect, Mengs and his successors have judged *Los Borrachos* by the standard of Italianate painting. The temptation to do so has been fueled by the fact that the seventeenth-century painters who most distinguished themselves at depicting mythological subjects include not only Italians who worked in the classical tradition like Annibale Carracci and Pietro da Cortona, but also foreigners who visited Italy and were profoundly influenced by its artistic heritage, such as Peter Paul Rubens and Nicolas Poussin. However, to hold *Los Borrachos* to that standard scrambles the chronology of Veláz-quez's career. Although he eventually made two lengthy trips to Italy, he had not set foot there when he painted his first mythology. It is preposterous to expect that the Italian heritage would

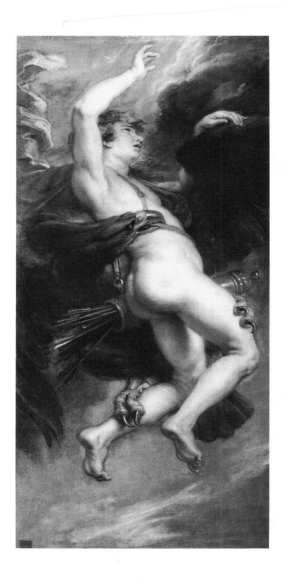

12 Peter Paul Rubens, *The Abduction of Ganymede* (Madrid, Museo del Prado, all rights reserved).

20

have had the same impact upon him before he arrived in Italy to experience it as it had upon Rubens and Poussin.

Furthermore, holding *Los Borrachos* to that standard assumes that the idealizing tendency of Italianate painting was the only manner in which mythological subjects could be rendered. Insofar as *Los Borrachos* is concerned, Velázquez is better compared not to Rubens or Poussin but to Rembrandt, who never visited Italy and who brought a pronounced realism to history painting. As the different interpretations of the myth of Ganymede by Rubens (fig. 12) and Rembrandt (fig. 13) demonstrate, there was more than one style in which a seventeenth-century painter could bring an ancient myth to life.[29]

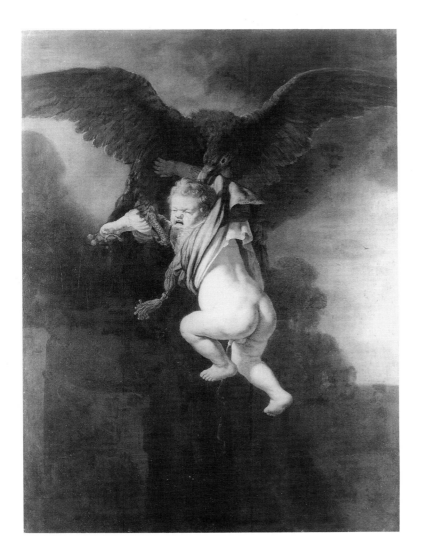

13 Rembrandt van Rijn, *The Abduction of Ganymede* (Dresden, Staatliche Kunstsammlungen, Gemäldegalerie Alte Meister).

Recognizing that a mythological subject need not be painted in a classicizing style is fundamental to a school of thought that regards *Los Borrachos* not as a burlesque but as a straightforward depiction of a bacchanalian revel in an unidealized, realistic idiom. Carl Justi (1888) was instrumental in promoting this view:

Velazquez may have read how Leonardo da Vinci occasionally got a number of boors together, and while in their cups told them facetious tales, in order to sketch their guffaws. Anyhow he gathered such a company from the populace as had never before been seen on canvas. It is a somewhat motley group – a soldier, a bagpipe player, a beggar, and certain not easily defined gentry. Are they porters, or coopers, or disbanded troopers turned footpads, just as by the reverse process the ranks were recruited from the footpads? But possibly they may be nothing more than some aged peasants, horny-handed weather-beaten children of the Sierra, for some three-score years browned by the summer heats and scourged by the biting storm. To such, and not to jaded revellers, has gone forth the wine-god's invitation, this benefactor of mankind bringing to the daily toiler a ray of light in his dark existence, "freedom in the realm of dreams."

If we consult the picture alone we find this benefactor to be a lusty youth, who, somewhat weary of his more select company, feels the need of unbending, and discovers a fresh distraction in the hilarious *Deus nobis hæc otia fecit* of this little group of poor devils swept together from all quarters – in their boisterous merriment, their grotesque gestures, and the stirred-up mud of their rustic slang. The upset goblet on the ground probably slipped from the kneeling soldier, who is just being crowned for his performance. Then will follow the toast, for which we see the glasses and cups already raised, and for which the man with the bagpipes will blow the accompaniment. The foremost of the old adepts grins in a way to show a row of still undecayed shining teeth, and in anticipation of the supreme moment when he may quaff the flowing bowl. He at the same time seems to lend an ear to the broad joke of his neighbour, whose hand rests on his shoulder. The joke itself seems to be made at the observer's expense, and could we hear it we should scarcely care to repeat it. The third, in profile, awaits the signal for the toast, with raised beaker and with the approving glance of a loyal follower directed towards his chief.

. . .

The Bacchus introduces us to our master's special Olympus. In the treatment of such materials others have with difficulty avoided the commonplace and conventional, but with him the Spanish essence here asserts itself in the most uncompromising manner. Like Cervantes, he takes the myth *au pied de la lettre*. He asks himself, What sort of spectacle should we have were the young god during his triumphal processions really to visit our valleys? What kind of worshippers would throng round him? What would this god be like who is most at home in the company of male and female wine-dressers?

In every epoch this scene has been treated by others in a far more

learned way. But who will nowadays attempt to make anything of the Cavalier Massimo's stale bacchanalian piece, with its insipid Neapolitan dancing women in the Madrid Museum [see fig. 63], or of Nicholas Poussin's studies with their processions in bas-relief? Bacchanalian scenes have lately been painted, which look like erudite archaeological dissertations. But scenes depicting man in association with the soil and its gifts, with "the spirit of the earth," as old Vilmar puts it, cannot breathe too much of a local flavour. And we may especially congratulate Velazquez that he has spared us those goat-legged monsters, which since the Renaissance have been poured out like a flood of apocalyptic plagues over the sphere of the Fine Arts. Yet this scene, which many have called a parody, is perhaps more Greek than the painter himself was aware of. The Greeks always appreciated the humour of aged revellers. In the dancing satyrs of the Villa Borghese and the Lateran we have the same coarse bones, angular skulls, small eyes, large cheek-bones, and bristly hair as in this picture. Only here everything has been translated from the *prestissimo* of the Hellenic Κῶμος to the *lento* of Spanish phlegm.[30]

This perception that *Los Borrachos* was a sincere rendering of a mythological subject in a realistic style, rather than a travesty of Renaissance idealism, eventually acquired an influential defender in the philosopher José Ortega y Gasset. In an early essay, "Three Bacchanalian Pictures" (1911), Ortega had hewn to the familiar conception of the painting as a burlesque,[31] but in his later "Introduction to Velázquez" (1943) he viewed the artist's naturalistic treatment of antique subjects differently:

Velazquez paints mythologies. Among them are *The Drinkers,* a Bacchic scene; *The Forge of Vulcan; Mars; Aesop* and *Menippus,* two semi-mythological figures; *Mercury and Argos* and other pictures on a pagan theme now lost. To all these must be added his greatest work, *The Spinners* – which, I do not know why, has not always been recognized as a mythological painting although it seems to represent the Fates weaving with their threads the tapestry of each existence. But these mythologies of Velazquez all have a curious aspect to which, whether they admit it or no, the art historians have not known how to react. They have been called tentatively parodies or jests. For Velazquez' contemporaries – painters and public alike – a mythological theme promised something out of this world. For Velazquez it is a motif which allows the grouping of figures in an intelligible scene. But he does not accompany the myth in its flight beyond this world. On the contrary; in front of any theme of this kind Velazquez asks himself what real situation, which might more or less take place here and now, corresponds to the ideal situation which is the mythological subject. Bacchus evokes any scene with drinkers, Vulcan means a forge, the Fates a tapestry workshop. Aesop and Menippus are the eternal ragged ones who pass before us, looking like beggars, scorning riches and vanities. This is to say that Velazquez seeks the root of every myth in what we might call its logarithm of reality, and that is what he paints. Thus it is no jest or parody, but the myth turned inside out; instead of letting it carry him off towards

an imaginary world, he compels it to move back towards verisimilitude. In this manner the pagan fantasy stays captive within reality, like a bird in a cage. This explains a certain painful and equivocal impression these pictures produce in us. Myths being fantasy at liberty, he invites us to contemplate them reduced to captivity.[32]

With the phrase "logarithm of reality," Ortega coined a powerful metaphor for the dignity of Velázquez's mythologies that many art historians subsequently embraced. Trapier (1948), for example, quoted from the preceding passage approvingly when she considered *Los Borrachos* in her monograph on the artist.[33]

An important stride toward understanding the painting was Soria's discovery (1953) of its likely visual source, an *Homage to Bacchus* engraved by Jan Saenredam after a design by Hendrick Goltzius (fig. 14).[34] It depicts a trio of rustic wine drinkers who kneel before Bacchus to implore his favor. The god smiles benevolently and displays clusters of plump grapes; behind him a young satyr half his size carries additional bunches of the fruit. The peasants' appeal, a Latin quatrain by the Dutch poet Cornelis Schonaeus, is inscribed at the bottom of the print:

> *Bacche pater, prono prostrati corpore cuncti,*
> *Suppliciter petimus, nobis tua dona secundes:*
> *Dona, quibus meror tristis, luctusque recedit,*
> *Nostraque sollicitis relevantur pectora curis.*

> (O, Father Bacchus, we prostrate our bodies on the ground,
> And humbly beg you to favor us with your gifts,
> Gifts which quiet our sad pains and sorrow
> And free our hearts from troubling concerns.)[35]

Bacchus appears a second time in the distance, driving a chariot drawn by two leopards across the sky while workers harvest grapes in the vineyards below.

Even though the engraving differs from *Los Borrachos* in its proportions, the number and disposition of its figures, and its background motifs, it has enough elements in common with the painting to be considered a plausible source for it. Saenredam's god, too, is younger and handsomer than the mortals on whom he bestows his favors; his presentation of grapes in the print becomes the presentation of a garland in the painting. Saenredam's Bacchus and the satyr behind him are scantily dressed, whereas his peasants are fully clothed; in *Los Borrachos* the satyr becomes the bare-chested fellow lying behind Bacchus who raises a wine glass. Although this last figure, who has often been identified as a member of Bacchus's retinue, is human in appearance, such a transformation from the print would be in keeping with Velázquez's preference for naturalism (his "logarithm of reality"). As for the

peasants, many of the props with which Saenredam provides them recur in *Los Borrachos*. Two of the three men have broad-brimmed hats, one wears a short sword in his belt, and their drinking vessels include a bowl, a pitcher, and a beaker. The engraved peasants are more inebriated, however; the first balances a beaker atop his bald pate, the second throws back his head to drain a bowlful of wine, and the third stares at the god in a besotted daze. That Velázquez omitted such evidence of deep intoxication from his painting lends weight to the argument that he did not mean his peasants to be perceived as drunkards.

After Soria published his discovery, Saenredam's print became the most widely accepted of the proposed visual sources for *Los Borrachos*.[36] It provided a basis for the entire composition, whereas

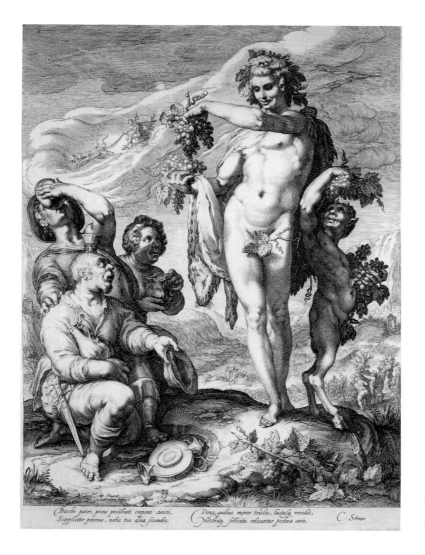

14 Jan Saenredam after Hendrick Goltzius, *Homage to Bacchus* (Amsterdam, Rijksmuseum).

25

other candidates – including those advanced after Soria announced his find – accounted for only fragments of the whole. For example, Charles de Tolnay (1961), who accepted Saenredam's print as a source for the painting, also related the man who kneels to be crowned to a kneeling figure in an *Adoration of the Shepherds* by Jacopo Bassano (Bassano, Museo Civico); whereas Madlyn M. Kahr (1976), who made no mention of Saenredam's engraving, related the kneeling man to the barefoot peasant in Caravaggio's *Madonna of Loreto* (Rome, Sant' Agostino). Tolnay also regarded Bacchus's pose as a combination of features from the *Isaiah* and the *Delphic Sibyl* on the Sistine Chapel ceiling; Kahr, however, saw in the god's crossed legs "a traditional pose for judges."[37] Similarly, Diego Angulo Iñiguez (1947) suggested that the figure behind Bacchus had been derived from the reclining woman lifting a shallow wine bowl in Titian's *Bacchanal of the Andrians* (see fig. 11 and plate 2), and Trapier (1948) followed suit.[38] Kahr, however, updated an old suggestion by Charles B. Curtis (1883) that related *Los Borrachos* to Jusepe de Ribera's *Drunken Silenus* (Naples, Museo e Gallerie Nazionali di Capodimonte) by advancing Ribera's 1626 etching after his painting (Bartsch 13) as the source for Velázquez's figure.[39]

When different scholars find different sources for the same characters within a painting, the question arises whether Velázquez's compositional methods required him to assemble *Los Borrachos* as a patchwork of individual motifs borrowed from other images. In fact, where convincing sources for Velázquez's multi-figured, narrative pictures have been found, they have been groups of figures, if not entire compositions. For his *Forge of Vulcan* (see fig. 65 and plate 8), for example, he drew upon a print by Antonio Tempesta (see fig. 66).[40] In like fashion, he derived his *Bloody Coat of Joseph* (El Escorial, Real Monasterio de San Lorenzo) from a woodcut by Bernard Salomon, and his *Landscape with Saint Anthony Abbot and Saint Paul the Hermit* (Madrid, Museo del Prado) from a woodcut by Albrecht Dürer.[41] Three of his pictures – *Christ in the House of Mary and Martha* (see fig. 37), *The Supper at Emmaus* (Dublin, National Gallery of Ireland), and *The Fable of Arachne* (see fig. 71) – feature a type of inverted composition pioneered by Pieter Aertsen and Joachim Beuckelaer, examples of which he might have known from paintings or prints.[42] On balance, it seems reasonable to conclude that Saenredam's print provided the essential inspiration for *Los Borrachos* and that Velázquez could have reworked its elements without recourse to the other pictorial sources that have been proposed.[43]

Soria's discovery was important not only because the print con-

stituted a plausible visual source for *Los Borrachos,* but also because Schonaeus's verse provided a literary basis for understanding the painting. By referring to the poem, one could read *Los Borrachos* as a celebration of Bacchus's having provided mankind with the gift of wine. As Tolnay saw the matter, in both the engraving and the painting,

> . . . the theme is not the dionysiac orgy (as in Titian, Agostino Carracci or Rubens), but the rite known as "lesser Dionysias," the festival of the vintage. Five rustics are going to drink the new wine together, and the unexpected appearance of Bacchus and a satyr elevates the festival to a mythological event. In this festival in antiquity [all] the people of the town, including the slaves, could take part, and we see repeated here the liturgy of the festival, especially the crowning of those present with the garland of ivy and vine leaves.[44]

By translating the mannerist print into a realistic idiom, he continued, Velázquez was "presenting [the event] like a scene from daily life and linking it to the spectator, who seems to participate in this festival."[45]

The new synthesis that Soria's discovery made possible was further elaborated by Angulo Iñiguez (1963), a tireless defender of the dignity of Velázquez's mythologies:

> I think the time has come for a revision of opinion on the interpretation of myths as painted by Velázquez. It is obvious, of course, that he has used the sharpest realism for the followers of Bacchus. They are certainly not gentlemen. They are poor folk who, thanks to the invention of wine, are able to drown their sorrows and even to laugh awhile. The look of veneration on the face of the man kneeling next to Bacchus with lifted glass shows no less a degree of devotion than that seen in the face of Melchor in the *Adoration of the Magi,* painted ten years before. The splendid nude god is in the finest Michelangelo tradition, and I do not think that his face with its sensual lips weakens the dashing grace of his body. It is simply the result of Velázquez's love of naturalism. Caravaggio's rendering of the feet of the dead Virgin may upset the pious, and may even be out of keeping with the dignity of the subject, but there is no flicker of mockery in his treatment. The nude figure of Bacchus' drinking companion is no less noble in aspect.
>
> It seems to me that Velázquez's attitude to this subject is not very different from that of Goltzius in his engraving *Potores ad Bacchum,* mentioned as a possible source of the composition of *The Drinkers* by the late Martin Soria. This engraving also shows some poor people, accompanied by a soldier, going humbly to beg the god to drive away care and drown their sorrows in wine. This is explained in the lettering in the engraving itself. Except for the soldier, Velázquez chose the poorest, most ragged people, and the god does not have the almost Da Vinci-like smile of the engraving. But Goltzius is still a Renaissance man working in Holland, and Caravaggio had been dead for years when Velázquez was working. It must also be borne in mind, as Charles de Tolnay points

out, that the grape harvest was a lesser Dionysiac feast at which the presence of slaves was tolerated. For Velázquez, the real purpose of the myth is to show the joy wine brings to those who have nothing to laugh at, whose lives are overburdened with poverty and miseries. This is much more moving than the effect of drink on people who still have young blood in their veins.[46]

By invoking Michelangelo, Angulo overstated Velázquez's achievement, and he wrote at a time when Caravaggio's realism was still regarded as the most likely source for that of Velázquez, a view that subsequent scholarship has refuted.[47] Nevertheless, the essential point of his synthesis — that *Los Borrachos* is no travesty, but a serious representation of the idea that Bacchus's gift of wine offers respite to those condemned to lives of toil and hardship — has proved to be of enduring value.[48]

Kahr (1976) reached a similar conclusion about the picture, which she proposed to call *Homage to Bacchus,* "a tribute to the god of wine by the country people in gratitude for the vintage," on the basis of similarities between the picture and Netherlandish paintings of that theme.[49] She also sought to explain the figures' interactions:

It appears that the kneeling soldier is being playfully inducted into the company of topers (*borrachos*). The fact that Bacchus's legs are crossed, a traditional pose for judges, may indicate that he has judged the soldier the winner of a competition (capacity for wine?) for which this coronation is the reward. The peasant in the upper right, who lifts his hat and extends his palm, has been identified as a beggar. If this is correct, he may represent a warning to the initiates that it is a dangerous game they are playing: overindulgence in wine may lead to poverty and degradation. The peasant at the far right holds bagpipes, which were widely used in seventeenth-century paintings as a phallic symbol, and which here recall the role of Bacchus as god of fertility.[50]

Reading the coronation of the soldier as the prize for a drinking contest is problematic. Presumably a drinking bout would have entailed the consumption of enormous quantities of wine; however, as we have seen, the company shows no sign of the severe intoxication that would result from so much drinking. Of course, if the company is not overindulging, then the role of the purported beggar as a cautionary allusion to temperance is likewise brought into question.

The possibility that a moralizing meaning might underlie the surface conviviality of *Los Borrachos* was also explored by John F. Moffitt (1985), who related the painting to the *Filosofía secreta* of Juan Pérez de Moya, first published in 1585.[51] This was a compilation of antique myths that Pérez de Moya interpreted in several senses — literal, allegorical, anagogical, tropological, and physical

or natural. At some point Velázquez acquired a copy of the book, which appeared in the inventory of his library that was compiled at his death.[52] Seeing correspondences between Pérez de Moya's text and *Los Borrachos,* Moffitt concluded that Velázquez knew the book in the 1620s and that it played a role in the genesis of his painting.

From Pérez de Moya's lengthy declarations on Bacchus and his myths,[53] Moffitt singled out five assertions that seemed to bear upon the painting. First, following Diodorus of Sicily, Pérez de Moya declared that Bacchus was painted in two manners: as an old, bald man with a long beard and a severe countenance, and as a handsome, merry, beardless youth.[54] These characterizations reflected the different effects that wine could produce in those who drank it. The former signified the unwelcome effects of excessive drinking, which led to aging and debilitation, whereas the latter signified that "drinking temperately is of great advantage and utility."[55] This latter Bacchus was shown as a child or youth because those who indulged in wine were carefree like children, or because they were not responsible for their acts under wine's influence, just as children were innocents.

Second, Bacchus was shown undressed because drinking too much could overheat the body, making clothes unnecessary, or because nothing could be concealed from those under wine's influence, who discovered all (hence, the adage *In vino veritas*). Third, ivy was sacred to Bacchus because it protected against drunkenness. It was also sacred to him because it was always green, just as wine would not lose its strength with age, but would become stronger and better. For that reason, poets were crowned with ivy to signify the lasting character of their verses.

Fourth, Bacchus was a god of forgetfulness because it was not fitting that those who had been eating and drinking should recall what they did or said while they were hot with wine. When men were in their cups, their judgment would be impaired and they would often say that they would do unreasonable things. Hence, it was good that they could not remember afterward what they had promised to do. Fifth, among the other names by which Bacchus was known, one was Liber Pater:

He is called Liber Pater, according to Seneca, because being a drunkard, he remains free of all care and of other affairs in which the sensible are wont to occupy themselves, and he brings freedom to men because slaves, being drunken, think themselves free from the subjection of servitude, or they imagine they have broken the ties or chains of servitude.[56]

Moffitt concluded that Pérez de Moya's text confirmed Angulo's assertion that in *Los Borrachos* "the real purpose of the myth

is to show the joy wine brings to those who have nothing to laugh at." He also identified the six figures on the right side of the composition as the mortals to whom Pérez de Moya's Bacchus brought liberty – the "slaves [who], being drunken, think themselves free from the subjection of servitude." By crowning them with ivy leaves, the god protected them against drunkenness and conferred upon them a measure of poetic, perpetual valor. Velázquez's Bacchus was to be understood not as the severe, aged deity symbolic of excessive drinking, but rather as the benevolent, youthful god who signified the benefits of drinking in moderation.

In a development parallel to Moffitt's research, Santiago Sebastián López (1985) sought to explain *Los Borrachos* by reference to three emblems devised by Andrea Alciati and to the seventeenth-century commentaries on those emblems by Diego López.[57] In the first, *Vino prudentiam augeri* ("To augment prudence with wine"), Bacchus, who gave mankind wine, is juxtaposed with Pallas Athena, who gave mankind the olive (fig. 15). As López interprets this emblem, not only is drinking wine in moderation good for one's health, but also it stimulates one's mind and thereby enhances one's capacity to learn. Thus, wine could promote one's prudence. The second emblem, *Prudentes vino abstinent* ("The prudent abstain from wine"), shows a grapevine clinging to an olive tree (fig. 16). Although its motto would seem to divorce wine from prudence, López's commentary interprets it as teaching that the prudent use wine in moderation, which is beneficial, whereas immoderate drinking disturbs one's reason, impedes one's judgment, and weakens one's spirit. The third is *In statuam Bacchi* ("On the statue of Bacchus"), for which Alciati

15 *Vino prudentiam augeri*, emblem devised by Andrea Alciati (By permission of the British Library, London).

16 *Prudentes vino abstinent*, emblem devised by Andrea Alciati (By permission of the British Library, London).

provides a lengthy dialogue between a questioner and the god (fig. 17). In the course of their exchange, Bacchus declares that drinking wine in moderation will keep one youthful and vigorous. Asked about his fiery complexion, Bacchus warns that he who drinks pure wine will inflame himself; he counsels the questioner to modify its force by diluting it (four parts wine with one part water) and to limit his (the questioner's) consumption to an amount that will please him without inebriating him.

Noting a tradition in Spanish literature of moralizing Ovidian myths (a tradition that includes Pérez de Moya's *Filosofía secreta*), Sebastián argued that *Los Borrachos* was a moralizing image inspired by Alciati's emblems, especially *In statuam Bacchi*. By this reasoning, the painting, which Sebastián proposed to call *The Rite of Bacchus,* exhorted the viewer to practice the virtue of prudence. The drinkers wearing garlands were to be understood as the adepts who were devoted to Bacchus – that is, the prudent – and who were to be distinguished from those drinkers who went uncrowned.

Moffitt acknowledged the parallels between his and Sebastián's approaches in a subsequent consideration of the painting (1989), which he proposed to call *The Brotherhood of Bacchus.* Building upon his previous arguments, he embraced two of Alciati's emblems – *Vino prudentiam augeri* and *In statuam Bacchi* – as consistent with his reading of Velázquez's picture. Furthermore, he introduced into the discussion another emblem devised by Alciati, which he held would have interested Velázquez because of its concern with artistic excellence: *Hedera* ("Ivy"), which linked ivy with Bacchus on the grounds that because "ivy is always green, it is always young, just like Bacchus; it is, therefore, 'evergreen,'

17 *In statuam Bacchi*, emblem devised by Andrea Alciati (By permission of the British Library, London).

18 *Hedera*, emblem devised by Andrea Alciati (By permission of the British Library, London).

just like the immortal fame attaching to the artistic endeavors of the great poets" (fig. 18).[58] From this Moffitt concluded,

> . . . we now see that Velázquez's painting serves to offer us a vision of that "Bacchic Brotherhood" representing a bright promise of hope for mortals on earth. That is, of course, if these mortals know how to avail themselves wisely of the gifts of the immortal Olympians at that unexpected moment in which they may choose to descend and visit the ragged beings inhabiting the lower world. At the moment of this rare epiphany, they then share their celestial joys with humans worn down by labor and misery, for such is the fate of all of us who live in the enshadowed world beneath Olympus.[59]

Moffitt also showed that Velázquez could have encountered the theme of Bacchus's benevolence toward mankind in the circle of Sevillian intellectuals who gathered around his father-in-law, Pacheco. The god's beneficence is alluded to in the sonnet "To Bacchus" by a member of that circle, the poet Juan de Arguijo:[60]

> A ti, de alegres uides coronado,
> Baco, gran padre, domador de Oriente,
> e de cantar; a ti que blandamente
> tiemplas la fuerça del mayor cuidado,
> Ora castigues a Licurgo airado
> o a Pentheo en tus aras insolente,
> ora te mire la festiva gente
> en sus combites dulce i regalado,
> O ya de tu Ariadna al alto assiento
> subas ufano la immortal corona,
> ven fácil, ven humano al canto mío;
> Que si no desmerezco el sacro aliento,
> mi voz penetrará la opuesta zona
> y el Tibre invidiará al hispalio rio.[61]

(To you, crowned with showy vines, Bacchus, great father, tamer of the East, must I sing – to you who gently allays the stress of the greatest care. Whether you are punishing wrathful Lycurgus, or Pentheus, [who is] insolent at your rites; whether the joyful people are beholding you, sweet and cherished, at their feasts; or even if you are proudly raising the immortal crown from your Ariadna to its high seat, come quickly, come agreeably to my song! For if I am not unworthy of your sacred inspiration, my voice will penetrate to the far side of the world, and the Tiber will envy the river of Hispalis [the Guadalquivir].)

Moffitt's and Sebastián's interpretations build upon Angulo's view that in *Los Borrachos* a compassionate Bacchus offers ordinary men a pleasurable release from the burdens of mundane existence through his gift of wine. However, to read the painting as a moralizing lesson on prudence or moderation requires caution. It is

one thing to demonstrate the existence of a literary tradition that assigns a moral to a mythological subject, and another to prove that an artist who painted that subject intended that literary tradition to inform his work. Although Velázquez certainly could have known Alciati's emblems and Pérez de Moya's text, that alone does not prove that he relied upon them to give *Los Borrachos* meaning.[62] Because the poem on the Saenredam engraving that was Velázquez's visual source makes no mention of the virtue of moderation, he surely knew at least one literary precedent for the god's benevolence that did not allegorize the subject; and if he knew Arguijo's sonnet, he would not have found any moral instruction on prudence in its lines.

For all Pérez de Moya says about Bacchus, nothing he describes resembles Velázquez's composition as closely as does Saenredam's engraving. Pérez de Moya need not have been Velázquez's authority for showing Bacchus as young, beardless, garlanded, and accompanied by garlanded followers, for he and his retinue were often depicted in that fashion. Saenredam's print is also a better match to the painting than is any of Alciati's emblems, including *In statuam Bacchi*. Sebastián's reliance on that emblem to explain the painting founders on the emblem's direction that those who want to drink prudently dilute their wine with water. There is no indication that the men in *Los Borrachos* have done so. Indeed, whereas the emblem calls for Bacchus to have a fiery complexion, in *Los Borrachos* he is pale. On the other hand, several of the peasants have ruddy complexions, which suggests, if one is guided by *In statuam Bacchi*, that they have been drinking undiluted wine. Where, then, is the lesson in prudence?

The search for a literary precedent for *Los Borrachos* led Marcia Welles (1986) to a different source. Noting that Velázquez's library contained a Spanish edition of Ovid's *Metamorphoses* that might have been Jorge de Bustamante's free prose translation of the poem (first published in 1543), Welles discerned an affinity between the painting and Bustamante's adaptation of *Metamorphoses* 4.18–30, in which the Theban women praise Bacchus:[63]

O, Bacchus, you always were and will be a young, merry, and handsome youth in heaven and on earth. Without a doubt, there is no god as beautiful as you . . . Old and young, poor and rich, the crippled, the maimed, the disabled – all walk behind you, and they love your company very much. All make great merriment with you. You make the mute speak, and the cripples run. All the peoples honor you, except Alcithoë and her sisters.[64]

Welles exaggerated the importance of this passage to Velázquez by declaring that in *Los Borrachos* the god finds himself surrounded

by such a company.[65] In fact, none of the assembled drinkers looks rich, and none appears crippled or maimed. Nevertheless, the passage has a place in the body of literature that characterizes Bacchus as a god who comforts mankind's afflictions.

Welles also noted the existence of moralizing interpretations of Bacchus and his myths – notably that of Pérez de Moya – but she chose not to use them to turn *Los Borrachos* into an allegory on virtue:

> It would seem that Velázquez, in his faithful rendition of the Ovidian text in the translated version, has conveyed the contradiction inherent in the worship of Bacchus, a contradiction implied in the literary text and fully developed by the commentators – the all-too transitory pleasures of wine; the silent will again cease to talk and the cripple will again cease to walk. Velázquez has captured the blissful present, the pause of illusion, pregnant with the inevitable *desengaño* of the future, unspoken, but known to all.[66]

As Welles saw it, Velázquez could draw upon the ideas of the moralizers without reducing his mythological paintings to "unidimensional, allegorical exegesis."[67] In similar fashion, Jonathan Brown (1986) perceived the two principal sources for *Los Borrachos* to have been Saenredam's engraving and Pérez de Moya's *Filosofía secreta*. Brown cited both as evidence "that Velázquez intended to represent Bacchus as the giver of the gift of wine, which freed man (temporarily) from the harsh, unforgiving struggle of daily life," but he did not impute a moralizing intention to the artist.[68]

Alciati's emblem *Hedera* (see fig. 18) was brought to bear on *Los Borrachos* in a manner different from Moffitt's by Francisco Sotomayor Román (1990), who suggested that Velázquez used *Los Borrachos* to make a bold declaration about the success of his art. Noting Alciati's identification of ivy as the plant from which are woven garlands that symbolize the eternal glory of poets, Sotomayor Román proposed that in *Los Borrachos,* the ivy garlands alluded in part to Velázquez's own achievement in the art of painting – specifically, his emergence in the 1620s as the leading painter at the court of Philip IV. In support of that claim, Sotomayor Román pointed to a form in the painting to the left of Bacchus's feet, which he read as a bird pecking at some grapes (fig. 19). This he identified as an allusion to the ancient painter Zeuxis's celebrated painting of grapes that seemed so lifelike that birds attempted to eat the fruit (Pliny the Elder, *Natural History* 35.65). By including such a motif, Sotomayor Román argued, Velázquez associated his talent with Zeuxis's virtuosity and thereby celebrated the triumph of his own naturalistic style of painting over the more conservative styles of his rivals at the Spanish court.[69]

34

Sotomayor Román's hypothesis is ingenious, but it is founded on a faulty premise. The forms he identifies as a bird pecking grapes are actually green leaves – either a weed growing in the earth, or vine leaves left over from Bacchus's having woven the garland that he awards to his companion, like the stray leaves to which his left foot points. Goya omitted the motif when he made his etching after the painting (see fig. 8), but Salvador Carmona included it in his print, where it is clearly some kind of vegetation (see fig. 9). Thus, the claim that *Los Borrachos* alludes to Zeuxis is untenable.

Were all these conflicting opinions about what *Los Borrachos* means not sufficient challenge, the effort to understand the picture has been further complicated by differing views on whether Peter Paul Rubens might have played a role in its creation. The Flemish painter visited the Spanish court from September 1628 through April 1629, and during that time he and Velázquez became well acquainted.[70] It is generally accepted that meeting Rubens was a turning point in Velázquez's career. Rubens provided him with a career model as a successful courtier-artist, and Rubens may well have encouraged him to make his first trip to Italy. There is no consensus, however, on whether Rubens inspired Velázquez to paint *Los Borrachos*. In part, the matter hinges on the date of the picture. As we have seen, Velázquez apparently delivered the finished painting to Philip IV sometime after 18 September 1628, and possibly even later, after 9 February 1629. Unfortunately, no documentary evidence establishes when he began it. If Velázquez undertook the work before Rubens arrived in Madrid, as some

19 Detail of Figure 1.

have argued, then Rubens cannot have inspired it by his presence there.[71]

On the other hand, dating *Los Borrachos* to a period overlapping Rubens's stay in Madrid opens the way to assigning Rubens some role in its genesis. Here again, opinion has divided. In the eyes of some, Velázquez was virtually impervious to Rubens's influence. Although conceding that Velázquez must have found Rubens to be a fascinating figure, Beruete (1898) nevertheless insisted,

Those who do not confine themselves to the calm analysis of facts have deduced that this fascination betrayed itself henceforward by a marked influence of the Flemish painter on the Spanish artist. Nothing, however, is more incorrect; Velazquez was not blinded by this brilliancy; he understood that his temperament and artistic aptitudes were the exact opposite of those of Rubens, that his path had been directed from childhood to the constant and faithful study of nature, and that, unprovided as he was with great imaginative resources, he could not attempt the subjects so magnificently treated by Rubens, nor manipulate such a bold palette as that of the Flemish painter. Thus it is that this meeting, which might have been fatal to an artist still undetermined as to what line to follow, in that it might have led him to lay aside his own aptitudes in order to pursue others more brilliant, acted on Velazquez as a touchstone of the firmness of his convictions.[72]

Riggs (1947) also defended Velázquez's independence from Rubens, with specific reference to *Los Borrachos:*

If any single picture were needed as an example to prove the independence of his thinking and his entirely individual execution of his ideas, this would answer every demand. . . . That Rubens had anything to do with the picture, either by way of its basic idea, criticism of it while it was being executed, color suggestions or in any other way is entirely problematical. We cannot, in fact, even be sure of its date, except that it was painted during or close to the time of Rubens' sojourn in the capital. That is probably why so many students have endeavored to trace in it evidences of the Fleming's technique, color and ideas, none of which is justified by the facts at our disposal.[73]

Interpreting the painting as a burlesque, Julián Gállego (1983) imagined Rubens being baffled by it: "Rubens (who was not Jordaens) must have found himself somewhat perplexed at seeing classical mythology, which he employed optimistically in the service of a humanist and Jesuit Christianity, reduced to a kitchen farce, to those vulgar, grotesque fables of Castillo Solórzano or Quevedo, where some lackeys and kitchen maids who bathe in the Manzanares take the roles of tritons and sirens."[74]

On the other hand, some have suggested that Rubens may have influenced the content, if not the style, of the painting. Indeed, Rubens provides a convenient answer to the fundamental question

of why Velázquez turned from portraiture to mythology – namely, that Rubens, a student of antique culture and a prolific painter of classical themes, burst onto the scene like some *deus ex machina* and inspired Velázquez, by word or example, to try his hand at a classical subject. When Picón (1899) asserted that *Los Borrachos* recreated a mock tourney at Brussels, he advanced Rubens as a possible source from whom Velázquez might have learned about the event.[75] The tourney hypothesis has faded from consideration, but a broader view that Rubens's interests in subject matter fired Velázquez's imagination has proved more enduring. As Kahr (1976) put it, "It would not be surprising if it were Rubens, learned and reverent as he was toward antiquity, who turned the Spanish painter's thoughts to legendary and allegorical subjects."[76] Welles (1986) was more specific, finding in Rubens's approach to illustrating themes from Ovid "as human dramas, with narrative rather than allegorical significance," the key to what she argued was Velázquez's Ovidian conception of *Los Borrachos*.[77]

Such explanations are neat, but unproved. For a picture presumed to have been inspired by Rubens, *Los Borrachos* shows little influence of his style; in fact, we might just as easily cite Rubens's talent at bringing ancient narratives to life as an argument *against* assigning him a role as Velázquez's inspiration. With his command of classical texts, his gift for dramatic compositions that capture the climactic moments of his chosen themes, and his repertory of telling gestures and revealing facial expressions, Rubens was a superb storyteller. The action in his paintings can usually be read without difficulty, and the paintings from his hand whose subjects have yet to be identified are few. The same claim of narrative clarity cannot be made for *Los Borrachos,* as the disagreement over its subject attests. If Rubens's achievement as a painter of classical antiquity was a lesson for Velázquez, it was a lesson to which the Spaniard paid superficial attention when he painted *Los Borrachos*.

To sum up, on the basis of the evidence that has been brought to light thus far, the case for Rubens's influence on *Los Borrachos* remains speculative. Given the uncertainty surrounding the dating of the picture, it is entirely possible that Velázquez began to paint it before Rubens arrived at the court.

Further complicating the attempt to understand *Los Borrachos* have been efforts to relate it directly to the art of Titian, many of whose works were available for Velázquez to examine in the royal collection. Kahr (1976), for example, suggested,

Ambition to depict the nude may also have been stimulated by the paintings by Titian that he [Velázquez] studied in Madrid. Specifically, Titian's Bacchic scenes may have given the impetus for the unusual composition combining semi-nude male figures from ancient legend and

fully clad peasant types of the sort that always interested Velázquez, in the enigmatic picture known as *Homage to Bacchus* or "*Los Borrachos*."[78]

Moreover, the availability of Titian's paintings has been noted by those who see Rubens's influence at work in *Los Borrachos*. During his aforementioned visit to Madrid, Rubens undertook an intensive study of Titian's art and copied many of his pictures in the royal collection. To those who have held that *Los Borrachos* reflects a knowledge of Titian's bacchanals, the suggestion that Rubens's fascination with Titian heightened Velázquez's interest in the Venetian master has made an attractive hypothesis. Thus, Enriqueta Harris (1982) concluded that "it was no doubt Rubens's presence in Madrid and their shared love of Titian that inspired the Spanish artist to paint, or the King to commission, his first mythological subject," and that "Velázquez's painting of Bacchus . . . also owes something to the many Venetian Bacchanals in the royal collection."[79]

Attempting to specify the nature of Velázquez's debt to Titian in *Los Borrachos* invites objections like those raised to claims that Rubens influenced it. *Los Borrachos* is not reminiscent of Titian's style. It differs from his example in coloring, lighting, brushwork, and figure types. It lacks his openness of composition and his capacity to suggest his figures' freedom of movement, and it does not measure up to his standards of narrative clarity. Moreover, it has not been established which Venetian bacchanals Velázquez might have known in the 1620s. None of those by Titian, for example – the *Feast of the Gods* begun by Giovanni Bellini (Washington, National Gallery), the *Bacchus and Ariadne* (London, National Gallery), and the *Bacchanal of the Andrians* (see fig. 11 and plate 2) – was in Spain.[80] If any of these is to be accounted a source for *Los Borrachos*, Velázquez would have to have known an as yet undocumented copy of an original that was unavailable to him. On the basis of the evidence that has been brought forward, the case for Titian's influence on *Los Borrachos* remains unproved.

* * *

As the preceding review makes plain, a consensus on what *Los Borrachos* depicts, why Velázquez painted it, and what he intended it to mean has proved elusive. In the hope of resolving such questions, we must undertake a more detailed examination of the professional context within which Velázquez created his picture. There has been a tendency to consider *Los Borrachos* in isolation, as an anomaly that stands apart from the rest of the work that Velázquez carried out during his early years at court. To be sure,

painting a mythological subject departed dramatically from his efforts as a portraitist. Nevertheless, there are grounds for assigning the picture a central place, not a peripheral one, within the context of Velázquez's life at court. *Los Borrachos* was the climactic product of a turbulent, six-year period in Velázquez's career, from August 1623, when he was appointed painter to the king, to August 1629, when he departed Spain for Italy. He spent those years embroiled in professional infighting within the royal household, struggling to make a name for himself in competition with older, more established rivals who resisted his ascent. It is in those years of conflict that our quest to understand *Los Borrachos* resumes.

THE RISING STAR

LTHOUGH VELÁZQUEZ IS NOW regarded as the preeminent painter of the Spanish Golden Age, his climb to artistic supremacy was by no means smooth. His early years in Madrid were marked by setbacks as well as triumphs, for talent alone could not ensure success in the competitive world of the court. At the outset, he required the assistance of influential sponsors who provided him with the introductions and support that a young, little-known painter needed if he was to attract the king's attention and make a career in royal service.

The primary source of information about Velázquez's campaign to win a court appointment is Pacheco, who writes of his son-in-law's initial effort,

> Desirous, then, of seeing the Escorial, he left Seville for Madrid around the month of April in the year 1622. He was very well received by the two brothers don Luis and don Melchior de Alcázar, and in particular by don Juan de Fonseca, His Majesty's *sumiller de cortina* (an admirer of his painting). He made, at my request, a portrait of don Luis de Góngora, which was very much praised in Madrid, and at that time there was no opportunity to portray the King and Queen, although it was attempted.[1]

Both Luis de Alcázar and Juan de Fonseca y Figueroa were former members of Pacheco's "academy" – a circle of artists, intellectuals, and men of letters who assembled informally in Seville to discuss their common interests in art, literature, history, and theology.[2] Fonseca, in particular, seems to have committed himself to Velázquez's cause. An enthusiast for painting, he was the first recorded owner of Velázquez's early masterpiece, the *Waterseller* (fig. 20), and the author of a treatise on antique painting, *De Veteri Pictura,* that has since been lost.[3] As *sumiller de cortina* (a chaplain with important ceremonial duties in the Royal Chapel), he enjoyed access to the upper reaches of the court hierarchy.[4]

In spite of Fonseca's backing and the success of his portrait of Góngora (fig. 21), Velázquez's bid to paint the king and queen

failed. The obstacle blocking his ascent may have been that the king already employed six other painters. Santiago Morán the Elder occupied the senior post of *pintor de cámara* (painter to the privy chamber), and five others served in the lesser office known as *pintor del rey* (painter to the king) or *pintor real* (royal painter): Eugenio Cajés, Vicente Carducho, Bartolomé González, Francisco López, and Rodrigo de Villandrando. To the court bureaucracy that stood between Velázquez and the king there may have seemed no need to add a seventh painter to the royal payroll.

Velázquez withdrew to Seville, where his presence was recorded on 25 January and 7 July 1623,[5] but later that summer he returned to Madrid, where circumstances had shifted in his favor. For one thing, Villandrando had died in December 1622, leaving

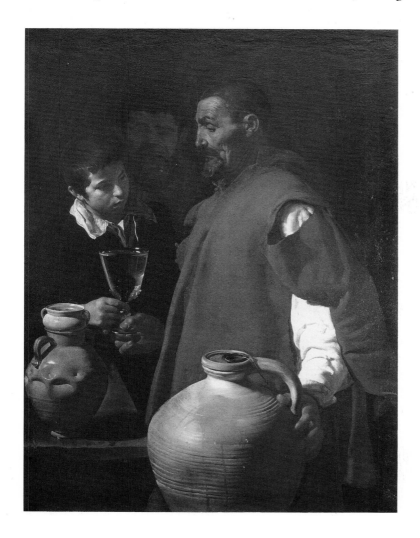

20 Diego de Velázquez, *Waterseller* (By courtesy of the Board of Trustees of the Wellington Museum, London).

41

a vacancy in the ranks of the king's painters.[6] More important, a powerful ally had joined the effort to promote Velázquez's fortunes at the court: the royal favorite, don Gaspar de Guzmán, count of Olivares, later styled count-duke of Olivares after Philip IV raised him to the dukedom of San Lúcar la Mayor in 1625. Again, let Pacheco recount his son-in-law's progress:

In 1623 he was summoned by the same don Juan [de Fonseca] (by order of the Count-Duke); he was lodged in his house, where he was entertained and looked after, and he painted his portrait. That night a son of the Count of Peñaranda, chamberlain to the Cardinal-Infante, took it to the Palace, and in one hour everyone in the Palace saw it, [including] the Infantes and the King, which was the greatest honor that it had. He was ordered to portray the Infante, but it seemed more convenient to make one of His Majesty first, although it could not be [done] so quickly owing to [the king's] many concerns. In fact, it was made on 30 August 1623, to the delight of His Majesty, of the Infantes, and of the Count-Duke, who affirmed that the King had never been portrayed

21 Diego de Velázquez, *Luis de Góngora* (Courtesy Museum of Fine Arts, Boston, Maria Antoinette Evans Fund).

until then – and all the gentlemen who saw it felt the same. He also made in passing a sketch of the Prince of Wales, who gave him one hundred *escudos*.

His Excellency the Count-Duke spoke to him for the first time, encouraging him for the honor of his native city, and promising him that he alone would portray His Majesty and that the other portraits [of the king] would be withdrawn. He ordered him to move his household to Madrid and confirmed his title on the last day of October of 1623, with a salary of twenty ducats per month and payments [for] his works, as well as medical care and medicines.[7]

The picture most likely to have been the one that earned Velázquez his position is a bust-length *Philip IV* (fig. 22).[8] Its modest format is in keeping with Pacheco's claim that Velázquez painted the king in a single day. Moreover, its having been his first likeness of Philip would be consistent with what became his customary practice of making an initial, bust-length study of a royal sitter upon which he could base a more formal portrait, and upon which

22 Diego de Velázquez, *Bust of Philip IV* (Algur H. Meadows Collection, Meadows Museum, Southern Methodist University, Dallas, Texas).

members of his shop could base copies and variants. (Olivares's promise to Velázquez, reported above by Pacheco, should be understood as meaning that only Velázquez would be allowed to paint the king *from life*.)

Contemporary documents corroborate Pacheco's account of Velázquez's appointment.[9] On 6 October 1623 Philip IV ordered the Royal Works to admit Velázquez to his service at a salary of twenty ducats per month. However, upon reviewing the terms of three earlier *cédulas* (letters patent) by which painters to the king had been appointed, the Royal Works found itself confronted with conflicting precedents. In two cases, painters had been appointed on terms providing that in addition to their regular salaries, they were to receive separate payments for the pictures they made for the king. In the other case, the terms of appointment provided only for a regular salary and denied the painter separate payments for his pictures; the artist in question was Bartolomé González, who had been named a royal painter in 1617 at a monthly salary of 16 ducats.[10] Because the king's order did not specify whether Velázquez was to receive payments for his pictures distinct from his salary, the Royal Works requested that the king clarify his intentions. Philip responded that Velázquez was to receive separate payments. Resolving the matter delayed issuance of the *cédula* confirming Velázquez's position until the end of the month, which accounts for Pacheco's dating the appointment to 31 October.

Olivares's recruitment of this promising young artist was one splash in the tumultuous sea change that had been transforming the court since 31 March 1621, when the unexpectedly early death of Philip III had brought Philip IV to the Spanish throne eight days before his sixteenth birthday.[11] Lacking the experience and the discipline to rule the empire he had inherited, the new king had turned to Olivares for guidance. For his part, Olivares stood ready to devote his life to the king's service. Spain's power and reputation were widely perceived to have declined under Philip III, and Olivares was determined to restore them to their former stature. To do so he proposed ambitious schemes to reorganize the governance of the king's realms and to reinvigorate the flagging Spanish economy. He anticipated that when his measures had restored prosperity, Spain would be able to pursue more effectively its traditional missions of defending the territories of its empire and protecting the Catholic faith.

Essential to Olivares's vision of a revivified Spain was a monarch who exemplified the splendor and virtues of good kingship. Because Philip's training for this role was far from complete, Olivares

assumed the task of grooming him to meet the responsibilities of his
office and to present himself to the world as a paragon of royal mag-
nificence. To that end, the count-duke initiated Philip into the
techniques of statecraft and encouraged his interest in pastimes that
would add luster to his reputation, from hunting and horsemanship
to the appreciation of literature and the fine arts. On the assumption
that a glorious monarch deserved a glorious setting, Olivares also
watched for opportunities to use the visual and performing arts as
instruments for exalting the king and his regime.

THE RISING STAR

To bring Velázquez into royal service, Olivares made use of
what has been dubbed his "Sevillian connection."[12] As third count
of Olivares, he had inherited estates in Andalusia from his father
in 1607, and from then until 1615 he had spent considerable time
in Seville. There he had acquainted himself with the city's intel-
lectual elite, had attended meetings of Pacheco's academy, and
had distinguished himself as a generous patron of artists and po-
ets.[13] Years later, he drew upon the contacts he had made in Se-
ville to fill positions in the royal household and the government
bureaucracy with men of talent. One beneficiary of the Sevillian
connection whom we have already encountered was Velázquez's
early sponsor in Madrid, Juan de Fonseca y Figueroa, a relative of
Olivares and a fellow participant in Pacheco's academy. Fonseca
owed his appointment as *sumiller de cortina* to his kinsman's inter-
vention, and we have it on Pacheco's authority that it was Oli-
vares who prompted Fonseca to recall Velázquez to Madrid in
1623. Thus, when he recruited Velázquez to paint for the king,
Olivares was once again using his connections to tap the reservoir
of Sevillian talent.

One undesirable consequence of Olivares's reform campaigns
was jealousy and factionalism. He realized that to accomplish his
ambitious goals he would have to take control of the royal bu-
reaucracy, and to that end he replaced many officials of the old
regime with men on whose loyalty he could rely. Those whom
he had displaced from authority and those whose ambitions he
had blocked were predictably hostile to him, and their resentment
manifested itself in opposition to his reforms and repeated efforts
to dislodge him and his creatures from their privileged positions.
Something similar happened in the artistic sphere of the court:
Older, established painters who had achieved prominence as court
artists under Philip III saw their status decline under Philip IV,
whereas Velázquez's star was in the ascendant. As a result, Veláz-
quez became a lightning rod for jealous attacks from those whom
he threatened to supplant.

When Velázquez entered the king's service, five other painters

45

already held royal appointments. We are ignorant of his relations with the *pintor de cámara,* Santiago Morán the Elder; the sole document that connects them is dated 7 March 1626, and it records Velázquez's attempt (which proved unsuccessful) to obtain a position as a royal painter for Pacheco in the wake of Morán's death.[14] On the other hand, there is significant evidence that Velázquez's relations with three of the *pintores del rey* – Vicente Carducho, Eugenio Cajés, and Bartolomé González – were strained.[15] Their rivalry with Velázquez merits careful attention if we are to understand the circumstances that led him to paint *Los Borrachos.* The remaining *pintor del rey,* Francisco López, is a cipher insofar as Velázquez is concerned because there is no record of any contact between them.[16] If López took sides in the conflicts that divided the others, he probably stood with Velázquez's rivals, to whom he had familial and professional ties. He was González's father-in-law; he seems to have derived his painting style from the example of Vicente Carducho's brother Bartolomé; and before he died in 1629, he engraved five plates that Vicente had designed to illustrate the *Diálogos de la pintura,* a treatise on painting that Vicente published in 1633.[17]

From the beginning, Velázquez enjoyed better terms of employment than his three rivals. Olivares's promise that only he would be permitted to paint the king from life gave him an immediate advantage over González, who was a portraitist. We have already seen that Velázquez's monthly salary of 20 ducats (90,000 *maravedís* annually) exceeded González's 16 ducats per month (72,000 *maravedís* annually), and that unlike González, Velázquez was entitled to separate payments for the pictures he made for the king. Carducho's and Cajés's appointments also entitled them to separate payments for their pictures, but they received annual salaries of only 50,000 *maravedís* (a little more than 11 ducats per month).[18]

Velázquez also received preferential treatment when he was provided a studio on the main floor of the king's principal residence, the Alcázar of Madrid. It appears on a plan of the palace dated 15 July 1626, and an accompanying key describes it as a "room in which one of the painters has a workshop, and he is regularly present in it" (fig. 23, room 21).[19] It is not known when Velázquez first occupied the studio, but he was at work there by 16 June 1625.[20] Located virtually at the point where Philip's apartments (rooms 4–38) adjoined those of Olivares (rooms 75–85), the studio was readily accessible to both the king and the count-duke. According to Pacheco, Philip gave Velázquez a studio "in his gallery" and kept a key to it so that he could sit there at leisure and watch the artist paint "nearly every day."[21] To the other royal

painters, this striking display of royal interest in Velázquez's work could not have boded well.

The latent tensions between Velázquez and his colleagues erupted into the open in the mid-1620s when the king needed pictures to decorate a newly constructed hall in the Alcázar. Late in the reign of Philip III, efforts to reform the irregular southern front of the palace had culminated in the architect Juan Gómez de Mora's erecting a screen facade across its length, thereby concealing the old exterior from view.[22] The screen enclosed the gap between two towers that had projected from the center of the old facade, and within that space Gómez de Mora created a large, two-story chamber above the main entrance to the palace (fig. 23, room 26). Unimaginatively called the "New Room over the Main Entrance," or simply the "New Room," it soon evolved into a prominent showroom for treasures from the royal art collection.[23] This became the arena in which Velázquez and his rivals confronted one another.

The pictures that figured in their struggle have been lost, but

23 Juan Gómez de Mora, *Plan of the Main Floor of the Alcázar of Madrid in 1626* (Vatican, Biblioteca Apostolica).

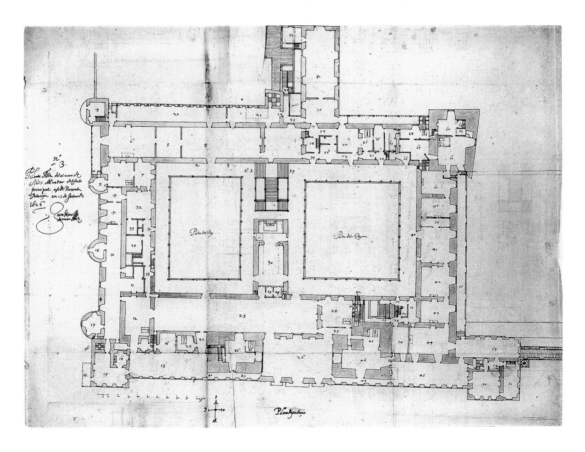

it is possible to reconstruct a chronology of the critical events from contemporary records.[24] In December 1622 the painter Domingo de Breyra was paid for gilding the cornice in the New Room, which suggests that construction was nearing completion and that the chamber could soon be hung with pictures. Initially it was decorated with works drawn from the king's existing collection. Prominent among the early selection were three canvases by Titian: an allegory of *Religion Aided by Spain* (see fig. 57) and monumental portraits of two of Philip IV's ancestors, the *Equestrian Portrait of Charles V at Mühlberg* (fig. 24) and the *Allegorical Portrait of Philip II after the Battle of Lepanto* (fig. 25). All three were brought to the Alcázar sometime after 18 May 1623, when they had been inventoried in the Pardo Palace. The *Charles V* probably went on view in the New Room around 11 September 1624, when the painter Bartolomé Saiz was paid for having gilded its frame. The two other works most likely were installed there at about the same time or shortly thereafter.[25]

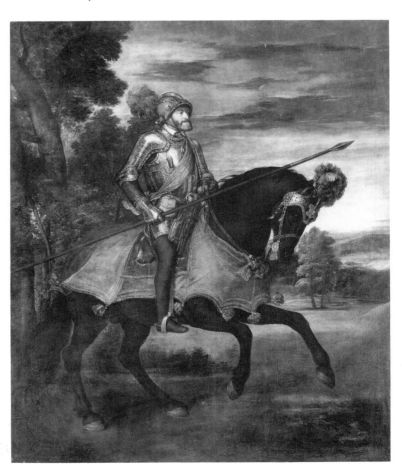

24 Titian, *Equestrian Portrait of Charles V at Mühlberg* (Madrid, Museo del Prado, all rights reserved).

48

The first of Philip IV's painters to be represented in the New Room may have been González, the author of a lost *Portrait of Philip III* that depicted its subject as he had dressed for his entry into Lisbon in 1619. The portrait was recorded hanging in the New Room on 8 June 1626, and more ambiguous evidence suggests it might have been in place as early as 1624. The picture was a commission from the old regime, for González had agreed to make it while Philip III was still living.[26] Whether it was intended for the New Room from the very beginning or shifted there from a different setting is not recorded.

It comes as no surprise to find that the first artist whom the new regime commissioned to make a picture expressly for the New Room was Velázquez. In 1625 he painted an *Equestrian Portrait of Philip IV* to hang as a companion piece to Titian's *Charles V at Mühlberg*, to which it compared in size. As a visitor to the room on 29 May 1626 described it, "Opposite the portrait of Charles V on the other end wall of the room is a portrait of the

25 Titian, *Allegorical Portrait of Philip II after the Battle of Lepanto* (Madrid, Museo del Prado, all rights reserved).

49

present king in armor on horseback shown from life. There is a beautiful landscape and sky, and it is also by the hand of a Spanish painter."[27] This, too, has been lost.

Apparently Velázquez's picture was controversial. Pacheco, who visited Madrid for several months in 1625 and 1626,[28] describes how an equestrian portrait of the king that his son-in-law had painted received a mixed reception when it was displayed to the public:

> . . . [Velázquez] having finished the portrait of His Majesty on horseback, all painted from life, even the landscape, it was put – with his [the King's] permission and pleasure – in the Calle Mayor, opposite San Felipe, to the admiration of all the court and the envy of the painters, of which I am a witness. Very elegant verses were written about it . . . His Majesty ordered Velázquez to be given payment of three hundred ducats and a pension of another three hundred, for which His Holiness Urban VIII granted a dispensation in the year 1626 so that he could receive it.[29]

This account is partly corroborated by a letter of 14 October 1626 from the papal nuncio in Madrid to Urban VIII's nephew, Cardinal Francesco Barberini, forwarding a request from Velázquez for a dispensation necessary for him to receive an ecclesiastical benefice he had been awarded. It seems likely that the portrait to which Pacheco refers was the one Velázquez painted for the New Room.[30]

The artists most likely to have envied the portrait were the other painters to the king, who may have resented Velázquez's having been awarded a plum commission. Carducho, Cajés, and González evidently pressed for the opportunity to create pictures for the New Room, because in December 1626 three paintings by them were added to the ensemble, which was rehung to accommodate the new works. Their canvases were the same monumental size as the *Equestrian Portrait of Philip IV,* which suggests that they were consciously competing with Velázquez.

None of their pictures has survived, but the subjects of those by Carducho and Cajés have been recorded. Carducho painted an episode from ancient history that was inventoried in 1636 as follows: "In it Scipio is dressed in the Roman manner in armor. In his right hand is a raised sword, and his left hand entreats. Tullio Cicero is below with a laurel crown, and there are many soldiers on the other side."[31] Unfortunately, that description is insufficient for determining whether his *Scipio Addressing the Romans* depicted Scipio the Elder or Scipio the Younger, both of whom were also known as Scipio Africanus. Publius Cornelius Scipio Africanus (236–184/183 B.C.) fought Hannibal and Hasdrubal in the Second

Punic War; his adopted grandson, Publius Cornelius Scipio Aemilianus Africanus Numantinus (185/184–129 B.C.), destroyed Carthage in the Third Punic War. Because both Scipios were victorious warriors, either could plausibly have been shown addressing his troops. The identification of a subsidiary figure as "Tullio Cicero" is of no help because it is surely a mistake. Both Scipios were dead long before Marcus Tullius Cicero (106–43 B.C.) was born.[32]

Cajés painted an *Agamemnon and Chryses,* which illustrated the episode in the *Iliad* (1.8–52 and 364–85) in which Chryses, a priest of Apollo, sought to ransom his daughter Chryseis from her captor, the Greek commander Agamemnon, who had become infatuated with his prisoner. When Agamemnon refused to make the exchange, Apollo avenged the affront to his priest by slaying Greeks until Agamemnon relented. According to the inventory of 1636, Cajés showed Chryses pleading for his daughter's release while Apollo flew overhead: "In it the king of the Greeks is seated, and her [Chryseis's] father is petitioning for her. In the background there is a battlefield, and in the sky there is a figure with a bow in his hand in a golden chariot drawn by four white horses."[33]

Hanging the three pictures in the New Room failed to put the rivalries among the king's painters to rest, for criticism of Velázquez persisted. In order that Velázquez might respond to these attacks, Philip IV ordered a competition in which Velázquez and three others were to paint the same subject, thereby providing an unambiguous basis for comparing their talents. The theme to be depicted was "Philip III and the Expulsion of the Moriscos" – that is, Philip III's decision to expel from Spain the ethnic minority of Moorish descent who had claimed to have converted from Islam to Christianity, but whose sincerity as converts and whose loyalty to the crown had come under suspicion. Velázquez's opponents in this trial by paintbrush were Carducho, Cajés, and Angelo Nardi, the latter having been appointed an unsalaried painter to the king in 1625.[34] It is not known why González did not take part. As a lesser talent, he may not have been invited to compete.[35] Another possibility is that declining health prevented his participation because he died sometime before 3 November 1627.[36]

The king also named two judges to decide the competition: Juan Bautista Maino and Giovanni Battista Crescenzi. Maino, a gifted painter who had become a Dominican friar, had been the king's drawing master in the years prior to his accession. Crescenzi, an Italian painter and architect of noble birth, had come

to Spain in 1617 to pursue a career in royal service. By 1626 he had been granted a Spanish title (marquis of la Torre) and in that year he became a knight of the Order of Santiago, one of the most prestigious military confraternities in Spain. Because Maino and Crescenzi had allied themselves with Olivares's circle at the court, their selection as judges gave Velázquez, the competitor most closely associated with Olivares, a distinct advantage over his rivals.[37]

Velázquez won the contest, but whether his victory depended upon the merits of his picture or the bias of the judges cannot be determined. His *Philip III and the Expulsion of the Moriscos* was lost in the 1734 fire that destroyed the Alcázar, and no copy of it is known. (Nor have any of the pictures by his opponents survived; in fact, the only known work related to the competition is a drawing by Carducho that is thought to be a study for his version of the subject.)[38] Two descriptions written before its destruction provide some sense of its appearance. An inventory of 1636 summarizes its content as follows: "In it is King Philip III wearing armor and dressed in white. To his right is a seated figure of Spain with spoils of war. A multitude of Morisco men and women are leaving, and there is a Latin inscription below."[39] Palomino provides a more detailed account:

In the center of this picture is King Philip III in armor, pointing with the baton in his hand to a troop of men, women, and children, being led away in tears by some soldiers; in the distance are some carts and a stretch of seascape with some vessels to transport them. . . . To the right of the King is Spain, represented by a majestic matron seated at the foot of a building, holding in her right hand a shield and some arrows, and in the left some blades of wheat. She is dressed in Roman armor, and the following inscription is written on the socle at her feet: *Philippo III / Hispan. Regi Cathol. Regum Pientissimo, / Belgico, Germ afric. Pazis, & Iustitiae / Cultori; publicae Quietis assertori; ob / eliminatos foeliciter Mauros, Phili- / pus IV robore ac virtute ma- / gnus, in magnis maximus, ani- / mo ad maiora nato, propter / antiq. tanti Parentis, & / Pietatis, observantiae- / que, ergo Trophaeum / Hoc erigit / anno / 1627.* [Philip III, Catholic King of Spain; most pious King of Belgium, Germany, and Africa, fosterer of peace and justice, preserver of the public order; in recognition of his successful expulsion of the Moors, Philip IV, great in strength and in virtue, greatest among the great, with a spirit born for the higher things by reason of the antiquity of his great lineage, his piety, and his reverence, erected this monument in the year 1627.]

Velázquez finished it that year, as is attested by the signature that he placed on a piece of simulated parchment that he painted on the lowest step, which says thus: *Didacus Velazquez Hispalensis. / Philip. IV Regis Hispan. / Pictor ipsiusque iusu, fecit, / anno 1627.* [Diego Velázquez of

Seville, Painter to Philip IV, King of Spain, by whose command he made this in the year 1627.][40]

As a prize for winning the competition, Velázquez's picture, which was comparable in size to his *Equestrian Portrait of Philip IV* and to Titian's *Charles V at Mühlberg* and *Allegorical Portrait of Philip II,* was hung in the New Room. According to Pacheco, the king also rewarded Velázquez by making him an usher to the privy chamber, a post to which he is elsewhere recorded to have been appointed on 7 March 1627.[41] Assuming that Pacheco's assertion is correct, that establishes the *terminus ante quem* for the contest.[42]

At some point following the competition, Philip IV acknowledged Velázquez's superior talent by appointing him painter to the privy chamber, which office had remained vacant since the death of Santiago Morán the Elder in 1626. The king must have acted sometime before 18 September 1628, the date of a royal order that identifies Velázquez as *pintor de cámara*.[43] With that promotion, Philip explicitly recognized Velázquez as the foremost painter in his service.

We can bring into sharper focus the antagonism between Velázquez and the other painters to the king during these years by examining Carducho's treatise on the theory and practice of painting, the *Diálogos de la pintura*.[44] Published in 1633, it consists of eight dialogues in which a master (the spokesman for Carducho's views) discusses the art of painting with his disciple. Remarks scattered through its pages suggest that Carducho's opposition to Velázquez arose not only from their competition for royal commissions, but also from his theoretical principles, which led him to reject Velázquez's stylistic innovations and to regard the history painting that he himself practiced as morally superior to the portraiture and genre painting with which Velázquez had achieved success.

Carducho dedicates the book to Philip IV, and his opening address is an exercise in florid humility:

My Lord,
The favors that Your Majesty has granted with your great benignity to the ingenious Art of Painting, the imitator of the beauties and regalia of the common Mother, Nature – not contenting yourself with adorning her [Painting] with new honors and glories, but [also] taking up the brush, signifying to so many Worlds how God has placed [her] in the eminence of your great Crown, because only she merits having Kings, Emperors, and Princes for disciples – gave me the courage to approach the Throne of your greatness and, prostrate at the Royal feet of the felicity of Your Majesty, to humbly beg you, as a true servant of your Royal and powerful Household, to hearken kindly to that which is said in these eight Dialogues, which have been constructed from meditation

on my subject, revealing the divine secrets that it comprises and the treasures of inestimable value that are contained within it, which are so many, that they cannot be reduced to a specific number. I beg Your Majesty to receive them with the splendor of your marvelous clemency, which will suffice to leave my care and desire completely rewarded. May God protect Your Majesty for the good of Christianity![45]

Notwithstanding the groveling posture he adopted, it is fair to say that Carducho had a greater reward in mind than the courtesy of a polite reading – namely, the restoration of the royal favor that he had enjoyed under Philip III, but that had ebbed under Philip IV.[46] This is implicit in the Seventh Dialogue, "On the Differences and Modes of Painting Events and Sacred Histories with the Decorum that is Required." In it the Disciple remarks upon a drawing made by the Master:

> *Disciple:* . . . I am thinking of that drawn plan that, if I remember rightly, is the one that you made to carry out in the South Gallery of this Alcázar of Madrid, the execution of which was stopped by God's having carried off His Majesty for Himself.
>
> *Master:* It was a concept suitable for that place, all of it being an epilogue of the events in the ages of the world from the Creation to these our times with the most celebrated and best known persons in each age. It made allusion to the ages of mankind. Shown in each one of them was an heroic deed of that by famous persons, and it was all accommodated with much moral history and with much erudition and example.[47]

The South Gallery was created when Gómez de Mora erected a screen facade across the southern face of the Alcázar (see fig. 23, room 13), and Philip III intended to have it decorated according to a plan that Carducho had devised. He and Cajés were to paint frescoes of figures and historical subjects, Fabrizio Castello was to paint grotesques, and all three were to work on accompanying half-relief stuccoes and gilding.[48] The project was apparently canceled upon Philip III's death, and the gallery was subsequently decorated in a much different fashion.[49]

Another of Carducho's projects fared little better. On 30 April 1622 the Royal Works authorized payment to Carducho for a variety of tasks he had carried out for the crown. Among them was painting a canvas depicting two kings of Castile to serve as a model for a series of pictures that were to decorate the Great Hall of the Alcázar (see fig. 23, room 23). It is not recorded when he made the model – possibly it was as early as 1612 or 1613 – but sometime thereafter the project was suspended. Not until 1639 was it revived and assigned to a team of artists, and by then, Carducho was dead.[50]

The cancellation of the scheme for the South Gallery and the

suspension of the project for the Great Hall were early signs of the decline in standing that Carducho and Cajés were to suffer under Philip IV. To be sure, the new king made use of their talents at the outset of his reign: When he staged royal exequies in memory of his father on 3 and 4 May 1621, about five weeks after the late king's death, Carducho and Cajés provided important paintings for the decorative ensemble that adorned the church in which the rites were celebrated.[51] Once Velázquez entered royal service in 1623, however, their opportunities to carry out prestigious commissions for the king diminished.

Another measure of Carducho's and Cajés's declining fortunes is that each had difficulty collecting payment for the picture he had painted for the New Room in 1626. As we have seen, the king rewarded Velázquez promptly for both the *Equestrian Portrait of Philip IV* and the *Philip III and the Expulsion of the Moriscos*.[52] In contrast, Cajés was not paid for his *Agamemnon and Chryses* until 9 March 1633.[53] Carducho died in 1638 without having been paid for his *Scipio Addressing the Romans;* in fact, it was not even appraised to determine how much the king would pay his heirs until sometime after 12 August 1641.[54] (If we can regard the relative promptness with which painters to the king were recompensed as a valid reflection of their standing at the court, then González's fall from grace was the most spectacular. In 1689, sixty-two years after his death, his heirs were still owed money for portraits that he had painted for Philip III from 1619 to 1621.)[55]

To return to Carducho's Seventh Dialogue, the Master's remarks on his plan for the South Gallery lead him to expound upon the importance of making the decoration of a building appropriate to its function and to the patron who uses it. After identifying the kinds of subjects that are fit for religious establishments, the Master lists those that are suitable for royal dwellings.[56] Then, to demonstrate the application of his principles, he describes how the Pardo Palace outside Madrid was adorned for Philip III.[57] He begins by considering four projects in some detail: the decoration of the palace chapel by Vicente Carducho; that of the king's audience chamber by Eugenio Cajés; that of a gallery in the king's quarters, begun by Bartolomé Carducho and finished by his brother Vicente; and that of a gallery in the queen's quarters by Patricio Cajés (Eugenio's father). The Master then makes briefer references to other parts of the palace decorated by Gaspar Becerra, El Bergamasco (Giovanni Battista Castello), Jerónimo de Cabrera, Luis de Carvajal, Fabrizio Castello, Bartolomé González, Pedro de Guzmán, Francisco López, Jerónimo de Mora, Teodosio de Mingot, Alessandro Semini, Juan de Soto, and an unnamed Fleming.

This roll call of artists who are little remembered today does more than illustrate the Master's precepts on decoration. It also serves Carducho's hidden agenda by reminding Philip IV that there had been a time when the crown had employed his talents on major projects. Not surprisingly, the Master's most detailed description of the Pardo decorations is his account of Carducho's work in the chapel. The argument is revealing: In order to make a case for his worthiness in 1633, Carducho refers to a commission from Philip III, whose reign ended twelve years earlier. During the intervening years he received no commission of like importance from Philip IV that he could trumpet to his advantage.[58]

Carducho does allude to his picture for the New Room elsewhere in his treatise, but he papers over the defeat he suffered there. In the Eighth Dialogue, the Master and Disciple discuss notable art collections in Madrid, and when the Master lists paintings by Titian in the Alcázar, he mentions the *Charles V at Mühlberg* and the *Allegorical Portrait of Philip II*. That prompts him to digress on the New Room:

These two [paintings] adorn the newly constructed great room that has balconies facing the plaza . . . In the same room there are other pictures of similar size by the hand of Peter Paul Rubens, Eugenio Cajés, Diego Velázquez, Jusepe de Ribera (whom they call the Little Spaniard), Domenichino, and Vicencio Carducho, and below them are others of smaller size. Above all these are the four *Furias* that, as we said, are by Titian. These are the ones that I can recall from what I stored in my memory when I saw them, although I know there are many others that I was able to see, which I have forgotten because they were less singular.[59]

This is the only passage in the *Diálogos* that mentions Velázquez by name. Because the Master says nothing of the circumstances in which pictures by Carducho, Cajés, and Velázquez entered the New Room, the three artists are reduced to equal notice on a list of painters. Although the "Moriscos" contest may have established Velázquez's artistic supremacy in the eyes of many at the court, Carducho was unwilling to concede the point. (As it turned out, not long after he published the *Diálogos,* Carducho had another opportunity to paint significant works for Philip IV in circumstances that enabled him and others to test their skills against Velázquez's. Because that episode lies beyond our immediate concern, it is considered in the Epilogue to this study.)

Velázquez's rivalry with Carducho was more than a competition for commissions. They practiced markedly different styles of painting, and style was a subject on which Carducho had strong opinions. Carducho belonged to an artistic generation rooted in the "reform" style of later sixteenth-century Italian painting, in-

troduced into Spain by Italian painters whom Philip II had hired to decorate the royal monastery of San Lorenzo at El Escorial in the 1570s and 1580s.[60] Rejecting the artificiality of *maniera* painting, the reformers had sought to restore the ideals of central Italian High Renaissance painting – in particular, the simulation of rational, three-dimensional space and the rendering of monumental, idealized figures according to a canon of natural proportions – in combination with effects of light and color derived from sixteenth-century Venetian painting. Spanish artists who adopted this style enriched it with greater individualization of the human figure and with greater attention to still-life details in subordinate passages, which foreshadowed the fascination with realism that would come to dominate Spanish painting in the first half of the seventeenth century.

Carducho's adaptation of this style is typified by *Saint Bruno Renounces the Archbishopric of Reggio* (fig. 26, plate 3), one of fifty-six paintings he made for the Cartuja of El Paular (Segovia) from 1626 to 1632. It is a balanced, lucid composition in which dig-

26 Vicente Carducho, *Saint Bruno Renounces the Archbishopric of Reggio* (Madrid, Museo del Prado, all rights reserved).

57

nified, imposing figures interact by means of emphatic gestures within a well-defined architectural setting. A sense of order prevails, but Carducho pays a steep price to achieve it. The restraint of his figures verges on stasis, which undercuts the emotions their gestures are meant to express. Carducho seldom infuses his pictures with the dramatic urgency characteristic of the most powerful classicizing artists of his time, such as Domenichino, and his timid ventures into naturalism (most evident in the individualized faces he gives his characters) never generate the emotional intensity of forceful realists like Caravaggio. Instead, Carducho settles for a middle-of-the-road style that results in competent, but unexciting, storytelling.

Two other rivals of Velázquez also followed paths originating in the reform of Italian mannerism. Starting from comparable roots, Eugenio Cajés synthesized a style that resembled Carducho's but fell short of the latter's facility. As his *Virgin and Child with*

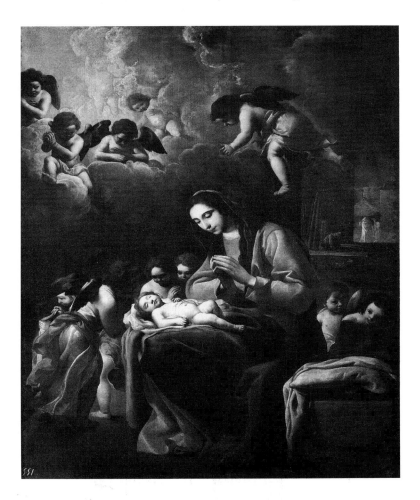

27　Eugenio Cajés, *Virgin and Child with Angels* (Madrid, Museo del Prado, all rights reserved).

58

Angels (fig. 27) from around 1618 reveals all too plainly, the blandness of Cajés's figures robs his pictures of emotional power. Angelo Nardi, who trained as a painter in Tuscany and who spent time in Venice before settling in Spain, developed a more successful style infused with drama and emotional conviction. His *Apparition of the Virgin to Saint Bernard* (fig. 28) of 1620 displays the level of accomplishment that qualified him to compete in the "Expulsion of the Moriscos" contest.

The affinity of Cajés's style to Carducho's suggests that the two would have been natural allies against Velázquez in the 1620s, and other circumstances bear out that view.[61] Vicente Carducho was born in Florence around 1576 and went to Spain with his older brother Bartolomé Carducho (1560–1608) in 1585; Vicente derived his style from Bartolomé's example. Eugenio Cajés,

28 Angelo Nardi, *Apparition of the Virgin to Saint Bernard* (Alcalá de Henares, Iglesia de las Bernardas; photograph coutesy of Arxiu Mas).

born in Spain in 1574, was the son of Patricio Cajés (ca. 1540–1612), a Tuscan painter who went to Spain in 1567 to work at the Escorial; Eugenio first apprenticed with Patricio, then studied painting in Rome in the mid-1590s before returning to Spain. Both Bartolomé Carducho and Patricio Cajés were painters to the king; following their deaths, their positions were occupied by Vicente and Eugenio respectively. Over the course of their careers, Vicente and Eugenio collaborated on several projects: Together they decorated the *Sagrario* of Toledo Cathedral, made pictures for the high altar of the royal monastery at Guadalupe, and provided paintings for the royal exequies for Philip III.

Vicente and Eugenio also served on the team that Philip III employed to decorate the Pardo Palace, which the Master describes in the Seventh Dialogue of the *Diálogos de la pintura*. As we have seen, the Master's most detailed account of that campaign is devoted to Vicente's decoration of the chapel. The next most prominent place is assigned to Eugenio's decoration of the king's audience chamber, after which the Master cites a gallery that Bartolomé Carducho began to paint and that Vicente finished, and a gallery painted by Patricio Cajés. Only then does the Master reel off his list of briefer references to those who decorated other parts of the palace. Thus, we can elaborate the argument that the passage is meant to remind Philip IV that Vicente used to receive major commissions from the crown. It is also intended to remind the king of the accomplishments of Vicente's ally, Eugenio, and of the lengthy record of service to the crown by both the Carducho and Cajés families.[62]

Vicente Carducho, Eugenio Cajés, and Angelo Nardi occasionally ventured into portraiture, but that tended to be the preserve of specialists. The portraitists among the king's painters who were active just prior to Velázquez's arrival at the court were likewise grounded in a style that had originated decades earlier. Rodrigo de Villandrando – whose death in 1622 created the vacancy that Velázquez filled in 1623 – and Bartolomé González both painted in imitation of the ornamental, linear style practiced by earlier masters like Alonso Sánchez Coello and Juan Pantoja de la Cruz. As is suggested by a comparison of Villandrando's *Philip IV as a Prince with the Dwarf Soplillo* (fig. 29) of ca. 1616 to González's *Margarita of Austria* (fig. 30) of 1609, Villandrando was the more accomplished of the two. The *pintor de cámara* Santiago Morán the Elder also made portraits, but not one of his likenesses is known today.

As opposed to the conservative tendencies of Carducho, Cajés, and Nardi, and the linear styles of Villandrando and González,

Velázquez practiced a boldly realistic style of painting founded upon an uncompromising fidelity to natural appearances.[63] Beginning around 1617 in his native Seville, he had painted pictures – religious subjects, portraits, and genre scenes – whose common

29 Rodrigo de Villandrando, *Philip IV as a Prince and the Dwarf Soplillo* (Madrid, Museo del Prado, all rights reserved).

denominators were an unidealized treatment of the human figure, dramatic chiaroscuro, and painstaking attention to the surface appearance of whatever he chose to depict. In the *Old Woman Cooking* (fig. 31) of 1618, for example, an intense beam of light falls from an unseen source into a dark kitchen, picking out a young boy, an old woman, and an array of foodstuffs, containers, and cooking utensils. Dramatic contrasts of light and shadow model both the figures and the objects, which take on the look of three-dimensional solidity. Working within a somber color scheme dominated by earth tones, Velázquez puts on a bravura show of his ability to render textures and light effects, from the metallic luster of a mortar and pestle, to the glazed and matte finishes of earthenware pitchers, to the ribbed, blemished rind of a melon. In the picture's most astonishing passage, he captures the look of transparent albumen hardening into an opaque white as two eggs cook in a ceramic bowl. The two figures are a deliberate contrast of physical types, and neither has been prettified in accordance with any classicizing ideal.

30 Bartolomé González, *Margarita of Austria* (Madrid, Museo del Prado, all rights reserved).

This is not to say that the *Old Woman Cooking* is flawless. Although Velázquez demonstrates his skill at rendering the individual components of his composition, he fails to unite them in a coherent whole. The boy and woman do not interact in any meaningful way – she looks past him, and he seems lost in his own thoughts. The woman's voluminous sleeves betray another shortcoming of Velázquez's early work, a tendency to simplify the challenge of rendering the human figure by concealing it beneath bulky garments. Moreover, his treatment of perspective is unconvincing. The tabletop appears to be tilted forward, and the mortar is warped so that the viewer can see into its interior. By leaving the background in shadow, Velázquez spares himself the task of additional perspective drawing that would reveal the depth and shape of the kitchen. Carducho would have had no difficulty constructing such an interior, but he would not have populated it with such ordinary figures, he would not have made the still-life details so prominent, and he would not have modeled the figures and objects with such dramatic chiaroscuro.

31 Diego de Velázquez, *Old Woman Cooking* (Edinburgh, National Gallery of Scotland).

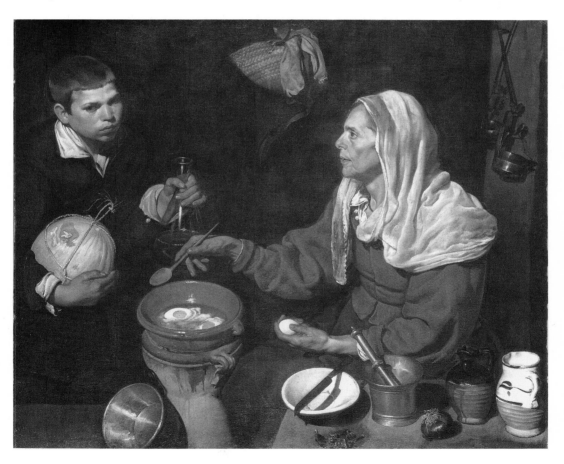

A more mature example of Velázquez's early style is the *Waterseller* (see fig. 20), in which a middle-aged street peddler hands a glass of water to a young man while another customer stands in the shadows directly behind them, quaffing the drink he has just purchased. Once again Velázquez confines his figures to a shallow foreground space; however, he unifies this composition more successfully, and his mastery of linear perspective (in the table at the lower left) is improved, though not yet complete. Here, too, brilliant light rakes over the foreground, modeling figures and objects with an intense chiaroscuro within a somber color scheme. The still-life passages are exercises in showmanship. Beads of dew run down the side of the large, earthenware jug containing the peddler's supply of water, and the light that refracts through the young man's glass picks out the silhouette of a fig intended to sweeten his drink. All three men are unidealized, and Velázquez contrasts the waterseller's wrinkled skin and sunken cheeks with the young man's smoother, more padded features. He again skirts the challenge of anatomical drawing, this time by concealing the waterseller's frame with bulky, heavy garments and by using deep shadows to obscure the two customers from view.

Velázquez treated other kinds of subjects in this same realistic, tenebrist style. Its strengths and weaknesses are apparent in the history paintings that he produced in Seville, such as the *Adoration of the Magi* of 1619 (fig. 32, plate 4). His dramatic chiaroscuro, sculptural modeling, unidealized figure types, somber coloring, and intensive scrutiny of surface appearances are all apparent. So, too, are his reliance on weighty garments to simplify the figure drawing and his awkwardness at rendering space in depth. A wall directly behind the Holy Family closes the right side of the composition, while the Magi and their servant conceal the abrupt transition from the foreground to the distant horizon on the left.

Similarly, in *Mother Jerónima de la Fuente* (fig. 33), a full-length portrait from 1620, Velázquez scrutinizes the hands and face that emerge from a Franciscan nun's habit with the same attentiveness to color and texture that he brought to bear on the still-life motifs in his genre paintings. The room in which she poses is shallow, dark, and ill defined. Required by the full-length format to show her feet in contact with the ground, Velázquez paints a bare floor that seems to tilt up at the viewer, like the tabletop in the *Old Woman Cooking*. (The later addition of an inscription superimposed on the floor exaggerates the problem, but even without it, the perspective of the room would appear distorted.) Such difficulties in defining a setting are avoided in the *Luis de Góngora* (see

fig. 21), in which the close-up view permits Velázquez to place the sitter against a bare wall in a shallow space and to concentrate upon mapping the contours of his features.

This was the style that Velázquez brought to royal service in 1623. The *Bust of Philip IV* (see fig. 22), for example, is cast from the same mold as the *Luis de Góngora*. A full-length portrait like the *Philip IV Standing* (fig. 34) sets a convincing likeness of the

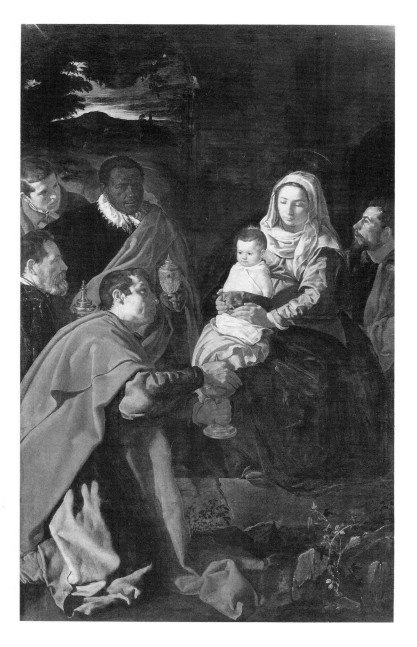

32 Diego de Velázquez, *Adoration of the Magi* (Madrid, Museo del Prado, all rights reserved).

65

king within a simply furnished space that forces Velázquez into the same struggle with linear perspective as in his *Mother Jerónima de la Fuente*. Here he obscures the boundary where another tilted floor meets a rear wall, and he spreads Philip's cape far enough to the right to conceal the corner of the table behind the king. Such limitations notwithstanding, the full-blooded realism of Velázquez's early style constituted a dramatic improvement over the work of other painters at the court.

Velázquez's early style put him in the vanguard of realists who transformed Spanish painting in the early seventeenth century.[64]

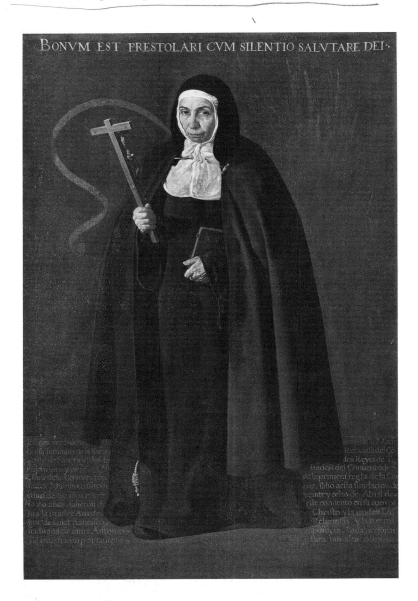

BONVM EST PRESTOLARI CVM SILENTIO SALVTARE DEI.

33 Diego de Velázquez, *Mother Jerónima de la Fuente* (Madrid, Museo del Prado, all rights reserved).

66

Another of the early proponents of naturalism was already present in Madrid when Velázquez arrived at court: the Dominican friar Juan Bautista Maino.[65] Sometime before 1608, Maino had studied painting in Italy, where the works of Caravaggio and his early followers had made a lasting impression on him. Upon his return to Spain, Maino was active in Toledo and Madrid, painting in a brightly colored, Caravaggist style, as in his *Adoration of the Magi* (fig. 35, plate 5) of 1613. When Maino was named one of the judges of the "Expulsion of the Moriscos" competition in 1627, it was to Velázquez's advantage not only because they

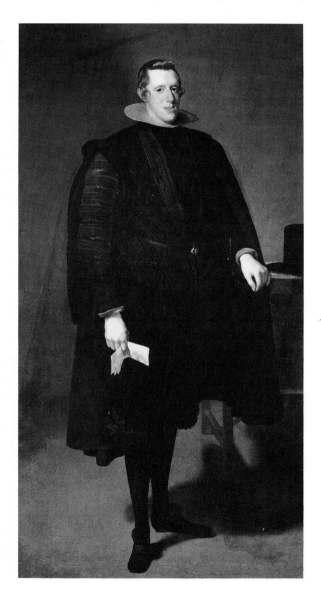

34 Diego de Velázquez, *Philip IV Standing* (Madrid, Museo del Prado, all rights reserved).

both belonged to Olivares's circle, but also because Maino's painting had more in common with Velázquez's vigorous naturalism than it had with the *retardataire* styles of Carducho, Cajés, and Nardi.

Passages in the *Diálogos de la pintura* confirm that stylistic differences were a likely point of contention between Velázquez and his rivals. In the Sixth Dialogue, Carducho fires a salvo at naturalism when he has the Master compare the styles of different painters to "a banquet of excellent dishes":

> In our times, Michelangelo da Caravaggio arose in Rome with a new dish, prepared with such a rich, succulent sauce that it has made gluttons of some painters, who I fear will suffer apoplexy in the true doctrine. They don't even stop stuffing themselves long enough to see that the fire of his talent is so powerful . . . that they may not be able to digest the impetuous, unheard-of, and outrageous technique of painting without any preparation. Has anyone else managed to paint as successfully as this evil genius, who worked naturally, almost without precepts, without doctrine, without study, but only with the strength of his talent, with nothing but nature before him, which he simply copied in his amazing way? I heard a devoted follower of our profession say that the coming of this man to the world was an omen of the ruin and demise of painting, and compare it to how at the end of this world the Anti-Christ, with false miracles and strange deeds, will lead to perdition great numbers of people, who will be moved by seeing his works, apparently so admirable but actually deceiving, false, and transitory, to say that he is the true Christ. Thus this Anti-Michelangelo, with his show and superficial imitation, his stunning manner, and liveliness, has been able to persuade such a great number and variety of people that his is good painting, and his method and doctrine the true ones, that they have turned their backs on the true way of achieving eternity, and of knowing the certainty and truth of this matter. . . . I do not consider it prudence but rather madness to attempt to achieve perfection by blind chance when I can with science and art avoid going off the path, thus earning praise and rewards because of my understanding, not my luck. For without them, not even a chance success can be called art.[66]

Although Caravaggio is the only artist whom Carducho names in this passage, his target is realist painting in general, and it has long been assumed that one of the realists at whom he aims is Velázquez.[67] (This might also be a swipe at Maino, the Caravaggist who ruled against him in the "Moriscos" competition.) Implicit in Carducho's attack is a charge that academic painters have often leveled against realists: that they are mere imitators of nature who copy whatever is placed before them without resorting to intellectual deliberation and preliminary studies to prepare their compositions.

This does not mean that Carducho has no use for realism. To the contrary, the reform style in which his art is grounded rejects

mannerist invention in favor of a return to more natural appearances. Carducho addresses the artist's relationship with nature in his Fourth Dialogue.[68] There the Master argues that merely imitating nature is an insufficient basis for making the best art; rather, the artist must study and understand nature. Since the Fall of Man the mundane world has been a corruption of a perfect

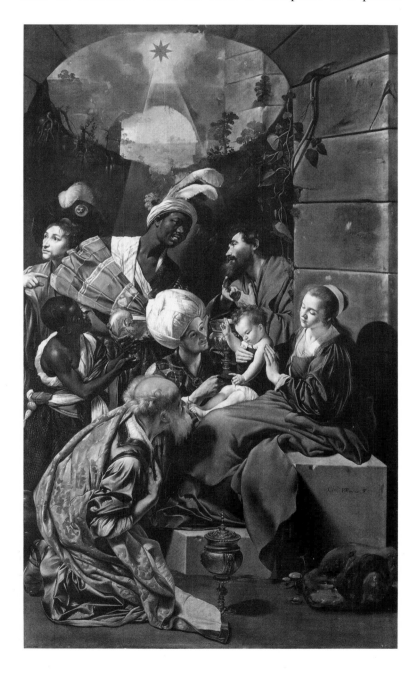

35 Juan Bautista Maino, *Adoration of the Magi* (Madrid, Museo del Prado, all rights reserved).

nature whose order and perfection cannot be seen, but by careful study of this corrupt world of appearance, the artist can acquire an understanding of that perfect nature with which to inform his art. Therefore, transforming visible reality into great art requires the artist to select judiciously from the models available in corrupt nature, and to filter what he chooses through his understanding, in order to arrive at the higher truth on which great art might be based. The Master concedes that there is some interest to the illusionism found in pictures that only imitate nature, but he holds that such pictures are not informed by the kind of study and insight that are characteristic of the best painting.

Thus, Carducho should not be caricatured as a rabid antinaturalist incapable of seeing any good in realism. In essence, the charge he has the Master bring against Caravaggio's followers in the Sixth Dialogue is that they have copied without understanding. What is more, in attacking the followers, the Master acknowledges Caravaggio's talent — "evil genius" though he may have been, he painted successfully "in his amazing way."[69] Later in the same dialogue, when the Master discusses how the temperaments of different painters manifest themselves in the painters' works, he remarks of an unnamed artist, "I know another, so audacious, so favored in painting, that we may say of him that he was born a Painter, whom brushes and colors obey, working more out of natural frenzy than on the basis of study."[70] Some have seen this passage as a veiled reference to Velázquez, and if it is, it can be taken as a grudging admission that there was some merit to Velázquez's work.[71]

At the heart of the preparation and study that Carducho deemed essential to good painting was drawing — drawing as the means of working out the composition of a picture, drawing as the means of mastering the pose of a figure, and drawing as the essential element of a finished painting.[72] That Carducho himself used drawings extensively as preliminary studies for his paintings is confirmed by the substantial body of graphic work from his hand.[73] He may have seen this as something that distinguished him from Velázquez. Few drawings by Velázquez are known, but whether that reflects an accident of preservation or a working method that made little use of preparatory studies is difficult to determine. To the extent that Velázquez devised his compositions as he painted, instead of preparing them beforehand with drawings, he practiced his art in a manner of which Carducho disapproved.[74]

Another danger Carducho perceived in realism was that it lent itself to inappropriate treatment of certain kinds of subject matter.

When, in the Seventh Dialogue, the Master discusses the principles of good history painting, he warns against devotional pictures that violate the prescriptions of the Council of Trent:

It is also just that one refrain [from making] other devotional Paintings that are painted with such profaneness and lack of respect, that they are scarcely recognizable. I saw some days ago a painting of that holy visit of Christ to the sisters of Lazarus, the devout [Mary] Magdalene and the diligent Martha, all surrounded with such a supply of provisions for eating – of mutton, capons, turkeys, fruit, dishes, and other kitchen utensils – that it seemed more an inn of gluttony than a hospice of holiness and of careful goodness. I am astonished by the lack of judgment of the Painter, who brings forth such a work from his imagination [*idea*] and hands.[75]

This describes a kind of painting that Netherlandish artists such as Pieter Aertsen (fig. 36) and Joachim Beuckelaer had popularized in the later sixteenth century. Velázquez knew such compositions, and when he painted his *Christ in the House of Mary and Martha* (fig. 37) in 1618, he, too, subordinated the religious theme to a foreground kitchen scene.[76] When Carducho castigated such pictures, Velázquez may have been one of the offending painters he had in mind.

Carducho's concern for proper decorum in religious painting points to what may have been another significant difference between Velázquez and some of his rivals: a perception that the kinds of subject matter they painted differed in prestige and importance. Carducho and Cajés were primarily history painters. Although they occasionally ventured into other categories of subject matter (portraiture for the most part), it was in history painting that they made their careers. Pictures of religious subjects – drawn from both the Old and the New Testaments, as well as from the later history of the Catholic church – constituted the largest part of their production. From time to time they also painted episodes from classical history and mythology, as well as notable events from more modern times.

Velázquez, in contrast, was known during his early years at court as a portraitist. It was his skill at rendering likenesses that won him his initial appointment, and the great majority of his surviving works from 1623 to 1629 are, in fact, portraits.[77] Where other subjects were concerned, he may have been perceived as a genre painter because one of his finest genre scenes, the *Waterseller,* belonged to his supporter Fonseca, the king's *sumiller de cortina.*[78] On the other hand, there seems to have been little in Madrid that he could point to as evidence of his capacity as a history painter. The *Philip III and the Expulsion of the Moriscos* depicted a historical subject, of course, but it was a work in which

a portrait figured prominently. A few pictures by him with religious subjects are sometimes assigned to these years, but none is securely dated or recorded as having been on view in Madrid.[79]

It is apparent from the *Diálogos* that Carducho believed certain kinds of subjects were best suited to achieving greatness in painting. In the Second Dialogue the Master discusses the kinds of nobility that painting possesses as a human endeavor, of which the most important is its "moral nobility." This manifests itself in what he holds to be the motive and objective of painting: the promotion of virtue and decency. His proof is that the Catholic church has used art to convert souls to the faith

. . . as has been experienced in conversions made by means of sacred Images, and other acts of devotion, as many Saints relate. The Councils have ordered that this Art be used to this end. And in order to defend this position, I shall only relate the words of the holy Tridentine Council, from which complete satisfaction will be brought out. It says thus: Benefit is brought forth from all sacred images, not only because they advise the people of the benefactions, gifts, and graces that Christ has granted them, but also because the miracles of God, wrought by means of the Saints, and examples that are salutary to the eyes of the Faithful are represented, so that they [the Faithful] give thanks to God, compose their lives and habits in imitation of the Saints, and practice the adoration of God and the embracing of piety.[80]

36 Pieter Aertsen, *Christ in the House of Mary and Martha* (Vienna, Kunsthistorisches Museum).

The preceding excerpt locates Carducho in the mainstream of Counter-Reformational thinking about art as a means of pro-

moting Catholic piety.[81] This argument for the "moral nobility" of painting also fits within the broader context of Renaissance art theory that assigns to painting an instructional role and a moral purpose: to inspire the viewer to virtuous behavior. Carducho's adherence to that position informs the Seventh Dialogue, in which the Master advances his ideas on how to relate the decoration of a building to its use and its patron:

And whenever one proposes to adorn some building, one must attend to the character of it in general, to the use of each part in particular, and the person who is to occupy it and who has it [the decoration] made. Because if it is a Temple, Cloister, or Oratory, it is clear that all that is to be painted for its use and adornment should be stories of the life and death of our Lord Jesus Christ, of his most holy Mother, and the Saints who are enjoying and attending God in that beatific, celestial abode. One has to attend to the advocation of the Church and the devotion of the Patron. If it is a house of Women Religious, no stories will be more appropriate than those of the life of the sovereign Queen of the Angels, [and] the favors and miracles that she has practiced with her devotees. Also appropriate would be the lives and miracles of Virgins who have suffered and worked in the service of their Spouse, offering Him their purity at the expense of penances, seclusions, retreats, and ultimately of their temporal life, improving upon it with the eternal one, and all should be disposed with propriety, modesty, gravity, and religion. And if some grotesques are necessary for decoration, one endeavors to compose them with modest decorum, and not [with] profaneness unsuitable to that place, using them as a very grave person could use grace and elegance in speaking or relating some event (so that the grotesque

37 Diego de Velázquez, *Christ in the House of Mary and Martha* (London, National Gallery of Art).

becomes graceful amid divine histories or grave histories); and thus one should use them carefully and sparingly, permitting them for other places that are more festive and secular [*humanas*].

If it is royal galleries [that are being decorated], it is historical subjects that are to be painted – grave, majestic, exemplary, and worthy of imitation: such as prizes that great monarchs have given to those who are constant in valor and virtue, just punishments of evil deeds and treachery, feats of illustrious Heroes, exploits of the most celebrated princes and captains, triumphs, victories, and battles. [Paint] Scipio against Hannibal, Aeneas against Turnus, Caesar against Pompey, Xerxes against the Lacedaemonians, and other similar deeds. And of the many modern [subjects] that there are, those of Charlemagne and the Emperor Charles V, whose victories were excellent, and whose battles were mighty. And if, perhaps, it is convenient, or to the taste of the donor, to paint the works of Virgil, Homer, and the myths of Ovid, try to make evident, with lively feeling and propriety, the virtuous morality that they contain, hidden from the ignorant, and not their impure and immodest outward appearance [*corteza*], attending to the beneficial and not inviting damage.

And if it is the dwelling of a Queen, or lady, they should be stories of Prudent matrons, chaste and valiant, of which Holy Scripture will give us an abundance with spiritual and moral exhortation. [Paint the story] of Sarah, Rachel, Rebecca, Judith, Esther. And if we want them [taken] from the Gentiles, [paint] the celebrated and chaste Penelope; Lucretia, as brave as loyal to her spouse; Marcia, daughter of Varro, who was so prized for [her skill with] the needle (a suitable activity for a chaste woman), and who, although such a great Painter, never found it possible to paint men unless they were dressed; [and] Gaia Caecilia, wife of the King Tarquinius Priscus, who (although a Queen) always occupied herself spinning with her women, her caution not trusting in idleness. [Paint the stories] of these and of many others in whom one can find example and wisdom.

If it is a country house for recreation, it will be very appropriate to paint hunts, fowling, fishing, landscapes, fruits, various animals, costumes of different nations, Cities and Provinces. And if it were all composed subject to some ingenious fable, metaphor, or historical subject that imparts pleasure to the understanding[82] and wisdom to the intellect, with some natural Philosophy, it will be of greater praise and esteem. And in all this one must maintain a certain, prudential decorum, not matching the theme of the private person with that of the Lord, nor that of the Lord with that of the great Prince, nor that of the Prince with the sovereignty of the King or Monarch.[83]

The Master goes on to illustrate these precepts by describing the decoration of the Pardo Palace for Philip III – a passage to which we have previously referred.[84] In the Pardo chapel Carducho painted a ceiling fresco of heavenly glory consisting of the Holy Sacrament on an altar, the Holy Trinity, the Virgin, angels, and saints. Subsidiary frescoes illustrated four Old Testament prefigurations of the Eucharist, the four Latin Doctors, and the four

Greek Doctors. Seraphim and various ornaments completed the ensemble.[85] The imagery not only suited the function of the chapel as a place of Christian worship, but also reflected the patron's interests — that is, the special devotion to the Sacrament of the Eucharist that had been a hallmark of Habsburg piety for generations.

Other rooms at the Pardo illustrated the Master's precepts for royal chambers with secular functions. Bartolomé Carducho was to have painted the exploits of Charles V in the South Gallery of the king's quarters, but he died before carrying out the work. The project was reassigned to Vicente Carducho, who was ordered to paint the life of Achilles instead. The Greek warrior provided a worthy example of heroic virtue for a royal gallery. More complicated in conception was the suite of frescoes Eugenio Cajés painted in the king's audience hall. He depicted the Judgment of Solomon on its ceiling, decorated its lunettes with landscapes, and illustrated virtues (probably personifications) elsewhere on its walls. Famed for his wisdom, Solomon, the greatest king of Israel, provided another exemplary model for a royal patron, and his most celebrated act of justice befitted a room in which Habsburg kings conducted affairs of state. The virtues surely comprised other traits considered desirable in a ruler. The landscapes would have suited the hall because the Pardo was not an urban dwelling, but a country residence. Located outside Madrid, it was not only a palace from which the king could govern, but also a retreat where he could engage in hunting and other pastimes.[86]

The same moralizing attitude toward palace decoration informed the two pictures that Cajés and Carducho painted for the New Room in 1626. Cajés's *Agamemnon and Chryses* provided a counterexample of royal behavior to be avoided. By showing how Agamemnon's infatuation with his prisoner Chryseis brought the wrath of Apollo upon the Greeks, Cajés's painting warned that when a king put self-indulgence before piety, he would bring disaster upon his subjects. In contrast, whether Carducho's *Scipio Addressing the Romans* depicted Scipio the Elder or Scipio the Younger, showing a celebrated general in command of his troops provided a positive model of heroic virtue worthy of royal emulation.[87]

To Carducho, this capacity to offer moral guidance made historical themes the most important subjects that artists could render; as a consequence, he held that the greatest painters were history painters.[88] Portraiture, in his view, suffered limitations that prevented it — and its practitioners — from attaining such heights. His objection emerges in the Fourth Dialogue when the Master

compares the "theoretical painter" (*pintor teórico*), who has mastered drawing and the intellectual foundations of art, to the "practical painter" (*pintor práctico*), who is an empirical colorist. As an example, the Master tells of an unlearned, practical painter who set about to copy a disproportioned, imperfect head from life. Because all that he represented depended on what he perceived with his physical senses, he

> ... copied it with precision, but it was unavoidable that that copy turned out with the imperfections that the original had – which would not happen if the Painter were learned because he would correct and amend its natural appearance with the reason and the learned habit of understanding that he possessed. And this is the reason, without doubt, why the great and eminent Painters were not portraitists, because he who has to be one, has to submit to the imitation of the object, bad or good, without more invention or learning, which he who has accustomed his intellect and vision to good proportions and forms will not be able to do, without doing much violence to his Minerva [i.e., to his learning].[89]

If portraiture had a saving grace for Carducho, it was that portraits of virtuous persons provided models of exemplary behavior. In the Seventh Dialogue the Master considers the kinds of sitters who are fit subjects for such art:

> [Having portraits painted] is a pious thing, and more so when the licit love of parents, siblings, kinsmen, or friends inspire them; and so much more so when they are of holy and virtuous persons, in order to motivate the imitation of those virtues with which they were adorned. And we can presume ... that the practice of portraiture was born with the art, to the end of making false gods to idolatrize. Later, as Lactantius writes, only Kings and Princes were permitted to be portrayed, when they had done great things and governed well – this serving as a kind of honorable prize for their great valor, and this inspiring those who succeeded in governing so that in their imitation [of those portrayed] they would proceed with goodness and with justice. The ancients used to cast the faces of their deceased in wax and preserve them in certain boxes on shelves, together with their virtues and exploits written in books, and they hung arms and trophies of their victories in their courtyards and vestibules. Eusebius writes in the *Ecclesiastic History* that among the Gentiles, being portrayed was conceded only to he who had discovered or invented something for the benefit of the Republic, and this was by order and mandate of the same Republic, or of the Prince. The Athenians portrayed Socrates after his death, and the Romans Aesculapius and a few others who were similar, and no other for no other reason, not even if he was mighty in riches. O, how just that law seems to me! And how it would be well to execute it rigorously, and defend the decorum and respect of such persons.[90]

Acknowledging that in his own time persons of lesser social rank (such as captains and artisans) have their portraits painted, the Master calls for such works to depict their subjects with the bearing, costumes, and attributes appropriate to their station, and he rails against portraits that violate that standard of decorum.[91] When the Disciple refers to antique portraits of even less worthy sitters, the Master attacks modern painters of such works for

> . . . debasing noble Art into ignoble thoughts, as are seen today in those pictures of eating places [*bodegones*] with low and most vile ideas, and others of drunkards, others of sharpers, gamblers, and similar things, without any more invention nor any more matter, than it having occurred to the Painter to portray four insolent rogues and two slovenly wenches, to the disgrace of that same Art and to little credit to the Artist.[92]

Although Carducho regarded it as portraiture, this sort of work would now be considered genre painting. His objection to its subject matter was probably intertwined with his reservations about naturalism because low-life scenes were among the subjects investigated by early proponents of seventeenth-century naturalism. If Carducho was aware of Velázquez's early work as a genre painter – work that included scenes of lower-class men and women eating, drinking, and cooking – his disapproval of such subjects may have contributed to the tension between them.

In any event, it is clear that Carducho judged portraiture, however broadly defined, to be a lesser art than history painting. When the Master finishes his discussion of portraiture in the Seventh Dialogue, he describes his remarks as a great digression from his principal subject, which proves to be a lengthy discourse on how to make good history paintings.[93]

There is some confirmation that Velázquez was criticized for being a portraitist. Jusepe Martínez, an Aragonese painter who knew him, writes that Velázquez's early success as a court portraitist inspired envious critics to declare that he did not know how to paint anything but heads, and that when Philip IV heard the charge, he ordered the "Expulsion of the Moriscos" competition as a means for Velázquez to vindicate himself.[94] Palomino tells a variation of this story, which he does not associate with the competition: "One day His Majesty said to him that there was no lack of those who said that all his ability was confined to knowing how to paint a head; to which he replied, 'My Lord, they flatter me very much, because I do not know of anyone who knows how to paint one.' "[95]

Of course, Carducho and like-minded critics in the mid-1620s were incorrect if they believed that Velázquez was merely a por-

traitist and not a history painter. Velázquez would have received thorough training in history painting when he studied with Pacheco. It is clear from the *Arte de la pintura* that Pacheco, too, regarded history painting – in particular, Christian history painting – as the highest category of subject matter owing to its capacity to inspire virtuous behavior.[96] Furthermore, religious subjects constituted a substantial part of Velázquez's production during his years as an independent master in Seville.[97] If his output of such pictures declined after he moved to Madrid, it was not because he did not know how to paint them, but because portraiture offered him a more promising route to royal favor.

Velázquez would also have learned from Pacheco that mythology could be used to express moral values. In 1601 one member of Pacheco's academy, the poet Juan de Arguijo, had had an unidentified painter decorate the ceiling of his library with a suite of pictures (fig. 38) in which a central *Jupiter Judging Good and Evil* was surrounded by *The Fall of Phaëthon, The Rape of Ganymede, Envy,* and *Justice.* The allegorical program informing this ensemble taught that "the virtuous possessor of true knowledge attained by prudent study achieves the Olympian heights, while the vain and evil pretender to knowledge rises briefly, only to fall."[98] In 1603 and 1604 Pacheco had painted a similar suite of ceiling paintings for the study of another member of the academy, Fernando Enríquez Afán de Ribera, third duke of Alcalá, in his Sevillian palace, the Casa de Pilatos. Its central image was an *Apotheosis of Hercules* (fig. 39), and six surrounding pictures (*The Fall of Icarus, The Fall of Phaëthon, The Rape of Ganymede, Perseus, Justice,* and *Envy*) made contrasting allusions to virtue and vice. As a whole, the ensemble was intended to inspire the duke to a life of virtue, for which he, like Hercules, would be rewarded with eternal glory.[99] By the time Velázquez began his apprenticeship with Pacheco (1 December 1610),[100] the meanings and implications of both ensembles would have been familiar to the learned circle into which the teacher would introduce his pupil.

Given the fragmentary evidence for assessing the rivalries among the king's painters in the 1620s, care should be taken not to overstate the extent of their differences, because the temptation to reduce the situation to melodrama can be great.[101] For that reason, let us note that on at least one occasion, Velázquez and two of his rivals reached a measure of agreement. Following González's death in 1627, twelve artists applied to replace him as a painter to the king. Philip IV ordered Carducho, Cajés, and Velázquez to evaluate the candidates, and on 1 December all three recommended Antonio Lanchares as the most qualified.

Even so, complete agreement eluded them. Carducho and Cajés ranked Lanchares first, Félix Castelo second, Angelo Nardi third, and Pedro Núñez del Valle fourth. Velázquez reported separately, agreeing on the first and fourth rankings, but placing Nardi second and Castelo third. In the end, however, no one benefited because the crown left the position unfilled as a money-saving measure.[102]

That Velázquez could rank Nardi, one of his opponents in the "Moriscos" competition held earlier that year, more highly than Carducho and Cajés did signals that artistic rivalries at the court were more complex than a simple division between those for and against Velázquez. Carducho and Cajés need not necessarily have regarded Nardi as an ally; after all, by participating in the "Moriscos" contest, Nardi had also competed against them. Because he was another appointee of the new regime, having been named an unsalaried painter to the king in 1625, Carducho and Cajés may have regarded him, like Velázquez, as a threat to their standing at court. On the other hand, by ranking Castelo ahead of Nardi, Carducho and Cajés promoted the cause of a natural ally – Castelo had been Carducho's pupil. In the end, the three judges' unanimous agreement on Lanchares (a pupil of Cajés) suggests that aesthetic criteria prevailed in the selection of their first choice, but whether other criteria affected their rankings of the runners–up remains open to speculation.[103]

Velázquez and Carducho also worked together on 3 October 1633, once again as arbiters of other painters' skills. In an effort to discourage the production of royal portraits that failed to meet acceptable standards of accuracy, quality, and decorum, town officials in Madrid had assembled eighty-four portraits of the royal family from the studios of six local artists for the two painters to inspect. Velázquez and Carducho deemed only twelve of the portraits satisfactory and ordered changes in the rest.[104] Whatever the differences between the two men, their collaboration on the task reveals they had some capacity to work together on a professional basis. Whether their discussion of the pictures under review was cool and formal, or warm and relaxed, we cannot say.

On balance, the evidence for Velázquez's relations with his fellow painters to the king during the 1620s suggests that at least some of his nominal colleagues stood among the envious critics who challenged his position at the court. In the eyes of the old guard that had risen to prominence under Philip III, Velázquez posed a triple threat: He benefited from favoritism that helped him win important commissions from Philip IV; he painted in a boldly realistic style based on untutored imitation of nature, rather than on the learned precepts of great art; and he founded his court

career on portraiture, rather than on the more prestigious, and more morally edifying, field of history painting.

By no means were the painters in the king's employ the only competitors about whom Velázquez had to be concerned. There was a significant community of artists practicing independently in Madrid, and the more talented among them were potential rivals for important commissions and public acclaim. One such painter was Juan van der Hamen y León. Three years older than Velázquez, Van der Hamen was a native Madrilenian born to a well-to-do noble family that counted several scholars and writers

38 Anonymous, *Ceiling from the Library of Juan de Arguijo* (Seville, Dependencia de la Junta de Andalucía; photograph courtesy of Arxiu Mas).

among its members.[105] He, too, was well educated, and he enjoyed a respected place among Madrid's intellectuals. The earliest record of his practicing as a painter dates from 1619, when he worked at the Pardo Palace, but apparently he had completed his training sometime before his marriage in 1615. Van der Hamen was best known in his time, as he is today, as a painter of still lifes. Inspired in large part by the austere still lifes of Juan Sánchez Cotán, he developed more elaborate compositions that incorporated more elegant objects, an apparent reflection of the upper-class society in which he moved. As is evident from his *Still Life with Fruit and*

39 Francisco Pacheco, *Apotheosis of Hercules* (Seville, Casa de Pilatos; photograph courtesy of Arxiu Mas).

81

Glassware (fig. 40) of 1626, by the mid-1620s he possessed a sophisticated capacity to render naturalistic detail.

Van der Hamen also practiced history painting and portraiture.[106] His surviving history paintings, which date from the mid-1620s, include a group of religious subjects painted in 1625 for the royal convent of La Encarnación in Madrid, among them a large altarpiece depicting a *Vision of the Apocalypse* (fig. 41).[107] Although the vision itself is somewhat dry, the assembly of saints who witness it is painted in an unidealized, tenebrist style that establishes Van der Hamen's place among the vanguard of realists who transformed Spanish figure painting in the early seventeenth century. An affinity for realism is evident as well in two mythological subjects. His *Vertumnus and Pomona* (fig. 42) of 1626 depicts Vertumnus, the god of the changing seasons, wooing Pomona, the goddess of gardens and fruit trees, with a basket of fruit, and his *Offering to Flora* (fig. 43, plate 6) of 1627 shows a young man presenting a basket of roses to Flora, the goddess of flowers and courtesans. The precisely rendered still-life attributes of fruits and flowers that fill the foregrounds of these pictures remove all doubt as to the goddesses' identities.[108]

40 Juan van der Hamen y León, *Still Life with Fruit and Glassware* (The Museum of Fine Arts, Houston, Samuel H. Kress Collection).

To judge from contemporary accounts, Van der Hamen was a respected portraitist. Few likenesses by him have survived, but it is clear from his *Portrait of a Dwarf* (fig. 44) of ca. 1625 that he could imbue his portraits with a convincing sense of the physical and psychological presence of his subjects.[109] That made him one of the two most accomplished portraitists in residence at the court in the 1620s; the other was Velázquez. In 1626 the two were put in *de facto* competition with each other, and Van der Hamen emerged the victor.[110] The circumstances were recorded by an Italian antiquarian and connoisseur, the Cavaliere Cassiano dal Pozzo, who served in the retinue that accompanied Cardinal Francesco Barberini on a legation to Spain that year. Cassiano's journal of the embassy reveals that while the papal delegation was in Madrid, Velázquez painted portraits of Barberini and Olivares, which the two statesmen were to exchange. (The idea was probably the

41 Juan van der Hamen y León, *Vision of the Apocalypse* (Madrid, Real Convento de la Encarnación, Museo; reproduced courtesy of the Patrimonio Nacional).

count-duke's – another instance of the "Sevillian connection" at work.) The portrait of Barberini, which Velázquez completed on 13 July, displeased the cardinal, who accepted Cassiano's suggestion to commission one from Van der Hamen. As the cavaliere wrote on 28 July,

After I had asked my lord and patron the Cardinal whether he would be pleased to have himself portrayed by Giovanni Vander Gumen de Gualdarama [*sic*], a native Spaniard of Madrid, who obtained excellent results in the painting of portraits, of flowers, and of fruit; and after he had seen that the portrait done by Giovanni [*sic*] Velasquez for my lord the Count of Olivares had achieved a melancholy and severe air, he was pleased that he [Van der Hamen] should come, and in half an hour, or

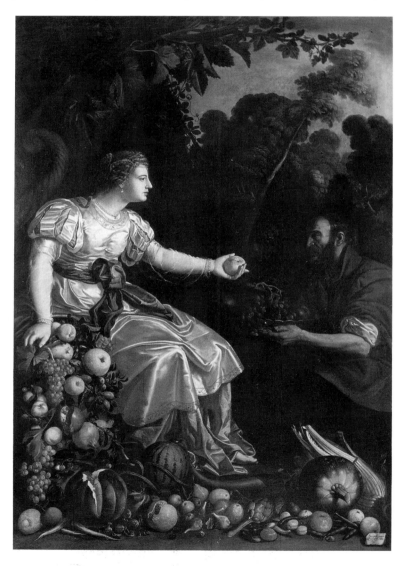

42 Juan van der Hamen y León, *Vertumnus and Pomona* (Madrid, Banco de España).

84

a little more, he did it very well, not, however, having completely finished it. . . . [111]

Another journal entry dated 1 August reports the completion of this picture. Because neither painting of the cardinal has survived, it is impossible to assess the justness of the Italians' judgment, but in the competitive environment in which Velázquez found himself, he cannot have regarded the cardinal's preference for Van der Hamen's portrait as a welcome development.

What might relations between Velázquez and Van der Hamen have been like? They were close in age, and both were from noble families and well educated. As painters, they practiced realistic

43 Juan van der Hamen y León, *Offering to Flora* (Madrid, Museo del Prado, all rights reserved).

styles of portraiture and history painting. Each had also mastered a relatively new kind of subject matter early in his career: genre painting in Velázquez's case, and still-life painting in Van der Hamen's. Whether these affinities reduced – or heightened – any sense of competition between them is open to speculation. A possible source of tension was that Van der Hamen's friends among the intellectuals of Madrid included friends of Carducho.[112] On the other hand, many of the implicit criticisms that Carducho expressed about artists like Velázquez in the *Diálogos de la pintura* would have applied to Van der Hamen as well.

One judgment that Velázquez made of Van der Hamen's work has been preserved. Van der Hamen was one of the twelve artists who applied for the position of painter to the king that fell vacant upon González's death in 1627. When the king ordered Velázquez, Carducho, and Cajés to evaluate the candidates, none of them included Van der Hamen on his list of the four most qualified.[113] The reason Van der Hamen fared so badly is not recorded, but it may have been that his reputation as a still-life painter worked against him. (He was the only still-life painter among the twelve candidates.) In the hierarchical view of subject matter to which academic theoreticians like Carducho subscribed, still-life painting ranked low. Pacheco gives voice to the same kind of thinking in the *Arte de la pintura,* in a passage on painting fruit:

I have also tried this exercise, as well as flower painting, and I do not judge it to be very difficult. Juan de van der Hamen did it extremely well, and was even better with sweetmeats, surpassing in this part the figures and portraits that he did. Thus he became more renowned for this, much to his displeasure. For this reason it seems to me that perhaps the great painters can make use of these genres in their history paintings. But they should try to put greater care in painting living things, such as figures and animals, which are more highly thought of. And because there are no set rules for this type of painting, except the use of fine colors and exact imitation, let us pass to another matter.[114]

If Velázquez regarded Van der Hamen as a significant rival, it is possible that Pacheco's identification of still-life painting as the best part of Van der Hamen's art – in the same passage in which he dismisses still-life painting as not very difficult – reflects not only Pacheco's disdain for what he regarded as a lesser kind of subject matter, but also the partisanship with which he followed Velázquez's efforts to succeed at court. In any case, Pacheco's assertion that Van der Hamen was frustrated by his fame as a still-life painter rings true, for implicit in his seeking the appointment was a desire to paint the more esteemed subjects – history paintings and portraits – that were expected of artists in the king's

service. As it turned out, Van der Hamen never obtained an appointment as a royal painter, and his early death in 1631 removed him permanently from the ranks of the competitors with whom Velázquez had to contend.

With the considerable resources at his disposal, Philip IV was not confined to local talent as a source of new paintings. He also acquired works from abroad. In the later 1620s, for example, he ordered eight history paintings from Italy to decorate the New Room of the Alcázar.[115] During the period 1627–28 he had his ambassador in Rome, the count of Oñate, commission four paintings: an *Abduction of Helen* from Guido Reni, a *Hercules and Omphale* from Artemisia Gentileschi, and a *Sacrifice of Isaac* (fig. 45) and a *Solomon and the Queen of Sheba* from Domenichino. Reni never delivered his canvas, but the other three were

44 Juan van der Hamen y León, *Portrait of a Dwarf* (Madrid, Museo del Prado, all rights reserved).

87

shipped to Madrid before Oñate completed his embassy in 1628. Sometime between June 1626 and August 1629 (probably in 1627) the king instructed the governor of Milan to commission paintings of *Cain Slaying Abel* and *Samson Drinking from the Jaw-bone* from the best painters in that city; these pictures, which seem to have been begun by Camillo Procaccini and finished after his death by someone else, were not dispatched to Madrid until 1634. Perhaps it was also around 1627–28 that the king ordered two pictures of *Jael and Sisera* and *Samson and Delilah* from Jusepe de Ribera, the leading painter in Naples, which arrived at the court no later than 1633. It is not known whether any of these paintings reached Madrid before Velázquez began *Los Borrachos,* but given the importance that the New Room played in artistic politics at the court, it is likely that he was aware early on that the king was ordering history paintings from Italy.

Philip also acquired history paintings for the New Room from the Spanish Netherlands – in particular, from Peter Paul Rubens. Among the pictures Cassiano dal Pozzo saw when he viewed the room in 1626 was a *Ulysses Discovers Achilles Among the Daughters of Lycomedes* (fig. 46) that had been painted in Rubens's studio.

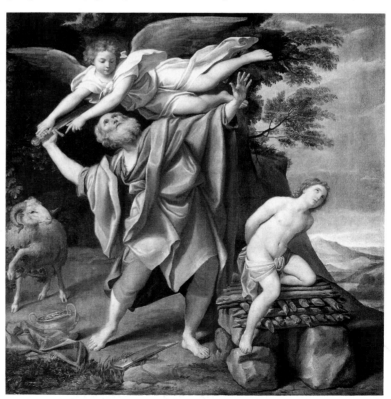

45 Domenichino, *The Sacrifice of Isaac* (Madrid, Museo del Prado, all rights reserved).

When Rubens had offered this picture for sale to an English collector, Sir Dudley Carleton, in 1618, he had described it as "done by the best of my pupils, and the whole retouched by my hand"; it is generally accepted that the pupil in question was Anthony Van Dyck. How the picture subsequently came into Philip's possession is unknown.[116]

Sometime in the 1620s – perhaps about the time he began to commission the pictures from Italy – the king ordered from Rubens another eight history paintings for the New Room. Either Rubens shipped these canvases from Antwerp to Spain in July 1628, a month before his own departure for Madrid, or he had them with him when he arrived at the court in early September.[117] Three illustrated Old Testament stories (*David Killing a Bear, Samson Breaking the Jaws of a Lion,* and *The Reconciliation of Jacob and Esau*), one depicted an episode from Roman history

46 Peter Paul Rubens and Anthony Van Dyck, *The Discovery of Achilles Among the Daughters of Lycomedes* (Madrid, Museo del Prado, all rights reserved).

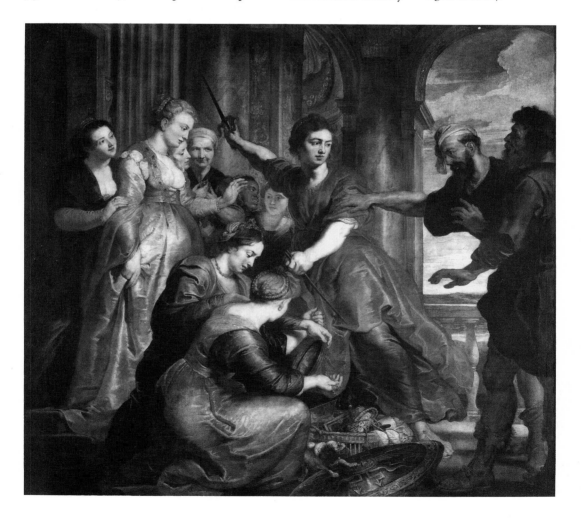

(*Gaius Mucius Scaevola before Porsenna*), and four illustrated mytho-logical subjects (*The Calydonian Boar Hunt, Diana and Nymphs Hunting Deer, A Satyr Squeezing Wine from Grapes,* and *Three Nymphs Filling the Horn of Plenty*).[118] Together they constituted an impressive demonstration of Rubens's ability to bring all manner of narrative subjects to life, capturing moods ranging from serene repose to turbulent violence in a style distinguished for its vivid naturalism and brilliant palette. They can be represented here by the *Samson* (fig. 47) and the *Three Nymphs* (fig. 48, plate 7).

No review of Velázquez's relations with other painters in the 1620s would be complete without considering his friendship with Rubens during the latter's visit to Madrid, which lasted until 29 April 1629. The king had summoned Rubens for consultations to determine whether the contacts the painter had established with English collectors in positions of power could be used to bring about peace with England, with which Spain had been at war

47 Peter Paul Rubens, *Samson Breaking the Jaws of a Lion* (Madrid, private collection).

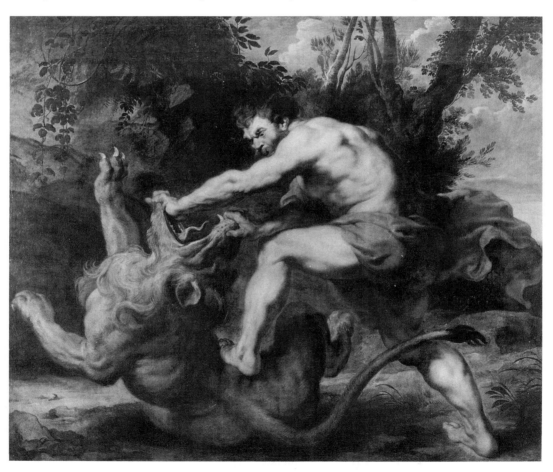

since 1625. After prolonged deliberations, it was decided to send Rubens to London, where he successfully negotiated the Anglo–Spanish peace of 1630.[119] During the eight months that Rubens spent in Madrid, Velázquez was able to observe the most accomplished courtier-artist of the day at work, and the example that Rubens set decisively influenced Velázquez's perception of the heights to which he, too, might aspire.

Rubens was provided with a suite of rooms in the Alcázar, including a studio, where the king visited him almost daily. Pacheco, who is the principal source for what Rubens painted in Madrid, records that he executed two original history paintings (an *Immaculate Conception* for the Marquis of Leganés and a *Saint John the Evangelist* for a brother of the Duke of Maqueda) and that he enlarged and retouched his 1609 *Adoration of the Magi*, which Philip IV had acquired early in his reign.[120] Rubens also painted a substantial number of portraits, among which were half-lengths

48 Peter Paul Rubens and Frans Snyders, *Three Nymphs Filling the Horn of Plenty* (Madrid, Museo del Prado, all rights reserved).

91

of the royal family, including the king, that he made to take back to Flanders. Evidently the royal promise that only Velázquez would be permitted to paint the king from life was suspended, for Rubens painted another five portraits of Philip in a variety of formats. The most important of these was an *Equestrian Portrait of Philip IV* that he completed by 2 December 1628. It has not survived, but its appearance is known from a copy showing the king at an older age (fig. 49). Conceived as a pendant to Titian's *Charles V at Mühlberg* (see fig. 24), Rubens's portrait replaced the *Equestrian Portrait of Philip IV* in the New Room that Velázquez had painted three years earlier.[121]

Although the temporary loss of his monopoly on the king's likeness and the removal of his equestrian portrait from the New Room must have disconcerted Velázquez, these setbacks did not deter him from befriending Rubens. According to Pacheco, "He [Rubens] had little to do with painters; only with my son-in-law (with whom he had previously corresponded by letter) did he make friends. He praised his works very much for their modesty, and they went to see the Escorial together."[122]

One topic Rubens and Velázquez may have discussed was Rubens's desire to return to Italy, where from 1600 to 1608 he had studied the artistic heritage of classical antiquity and the Italian Renaissance. For a time he hoped to sail from Barcelona to Genoa in March 1629, but the outcome of his diplomatic consultations forced him to abandon those plans.[123] Nevertheless, Rubens managed to renew his acquaintance with the legacy of one Renaissance master by making copies of paintings by Titian in the Spanish royal collection. Pacheco's claim that Rubens copied all the king's Titians cannot be confirmed,[124] but it is clear from the copies that survive that Rubens studied the Venetian's portraits and history paintings intensively (compare, for example, figs. 50 and 51). His investigations into Titian's handling of color, composition, and brushwork led him to transform his own style into the fluid, painterly manner that distinguishes his work from the 1630s.[125]

Watching the most celebrated artist in Europe apprentice himself to Titian's works must have come as a revelation to Velázquez. He had had access to the same paintings since 1623; yet, their impact on his work had been modest.[126] It seems likely that it was Rubens who, by word and deed, inspired Velázquez to seek Philip's permission to make his own artistic pilgrimage to Italy. On 28 June 1629, two months after Rubens left Madrid, Velázquez obtained the king's consent, and six weeks later, on 10 August, it was Velázquez, not Rubens, who set sail from Barcelona for Genoa.[127]

* * *

This review of Velázquez's career from 1623 to 1629 sheds new light on the circumstances that prompted him to paint *Los Borrachos*. The events of those years may have persuaded him that to consolidate his position at the court he would have to prove himself at history painting. If that was the case, then *Los Borrachos* should be regarded as a response to his contacts with other artists – rivals and allies – during his early years in service to Philip IV.

Consider first his rivals: Conservatives like Carducho and Cajés disparaged him as a portraitist whose style consisted of an untutored imitation of nature. He had triumphed over his critics in 1627, but he had done so with his *Philip III and the Expulsion of the Moriscos,* a picture that fused portraiture with historical narrative. Undertaking a mythological subject would challenge his crit-

49 Copy after Peter Paul Rubens, *Equestrian Portrait of Philip IV* (Florence, Uffizi; photograph courtesy of Alinari/Art Resource, New York).

ics on their own ground – all the more so if it were painted in the realistic style that the conservatives deplored. Such a work would also respond to the challenge posed by Van der Hamen, a competitor who not only rivaled him at portraiture but also made religious and mythological scenes in which realism and history painting proved compatible.

Consider, too, his allies: Pacheco's visits to Madrid in 1624 and 1625–26 would have reminded Velázquez of his training in the studio – and the academy – of an artist who believed that history painting was the highest branch of their profession, and who in 1604 had created an ensemble of mythological ceiling paintings for an important noble patron in Seville, the duke of Alcalá. Observing Rubens at work, Velázquez would have seen that the most celebrated courtier-artist of the day was a master of both portraiture and history painting. The king, for his part, had shown him-

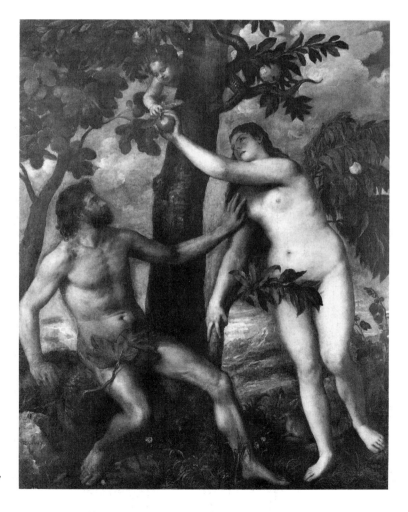

50 Titian, *Adam and Eve* (Madrid, Museo del Prado, all rights reserved).

self to be enthusiastic about Velázquez's portraits, but it would have been apparent from the commissions he gave to foreign artists for pictures to adorn the New Room that his taste inclined to history painting as well.

If it is valid to conclude that one or more of these circumstances prompted Velázquez to paint *Los Borrachos* as a demonstration of his talent as a history painter, then it remains to be explained why he chose a Bacchic subject as the vehicle for proving his skill. The attitude toward history painting shared by Carducho and Pacheco – that it was the most noble branch of painting because of its capacity to teach morally edifying lessons – suggests a line of inquiry. Pacheco's ensemble in Alcalá's study encouraged the duke to dedicate his life to virtuous pursuits, by which means he might achieve eternal renown. Similarly, Carducho was a proponent of palace decoration that provided royal patrons with models of com-

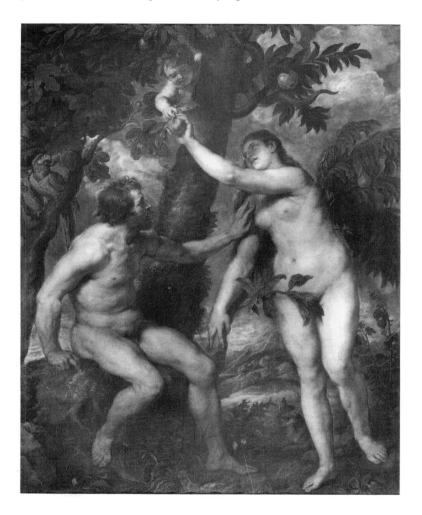

51 Peter Paul Rubens, *Adam and Eve* (Madrid, Museo del Prado, all rights reserved).

95

portment. Two pictures that filled his prescription were the positive example of his *Scipio Addressing the Romans* and the negative example of Cajés's *Agamemnon and Chryses,* both of which had been painted for the New Room after Velázquez's *Equestrian Portrait of Philip IV* had gone on view there. Because Velázquez would have recognized that history painting had this capacity to offer moral instruction, we should consider whether there was something about Bacchus that lent itself to making an exemplary statement on the nature of kingship – in particular, the kingship of Spain. In fact, there was. According to the historians of Velázquez's day, Bacchus had conquered and ruled in Iberia.

BACCHUS AND THE HISTORIANS

HE TRADITION THAT BACCHUS had visited Iberia is not well known today, but in the seventeenth century it was a commonplace of Spanish history. The story had been revived in the fifteenth and sixteenth centuries by humanists who, in combing the writings of classical authors for clues to the history of ancient Spain, had encountered references to Bacchus and other mythic beings. Subjecting these references to euhemeristic interpretation, the humanists sought to explain them as legends based on actual events with human protagonists.[1] For Bacchus's presence in Iberia, the most important of the ancient authorities were taken to be Pliny the Elder, Silius Italicus, and Plutarch.

In the case of Pliny, scholars cited – and misinterpreted – a passage from the *Natural History* (3.1.8): *in universam Hispaniam M. Varro pervenisse Hiberos et Persas et Phoenicas Celtasque et Poenos tradit; lusum enim Liberi patris aut lyssam cum eo bacchantium nomen dedisse Lusitaniae, et Pana praefectum eius universae.* A standard twentieth-century translation renders this as, "Marcus Varro records that the whole of Spain was penetrated by invasions of Hiberi, Persians, Phoenicians, Celts and Carthaginians; for he says that it was the sport (*lusus*) of Father Liber, or the frenzy (λύσσα) of those who revelled with him, that gave its name to Lusitania, and that Pan was the governor of the whole of it."[2] As we shall see, in Velázquez's time the passage was understood differently because historians misinterpreted *lusus* and *lyssa* as proper names for a presumed follower of Bacchus who gave his name to Lusitania.

Silius Italicus refers to Bacchus's conquest of Spain in the *Punica,* an epic poem about the Second Punic War (3.101–102):

> *tempore quo Bacchus populos domitabat Hiberos,*
> *concutiens thyrso atque armata Maenade Calpen*

> (When Bacchus was conquering the Spanish peoples and attacking Calpe with the staves and spears of his Maenads. . . .)[3]

Calpe was the ancient name for Gibraltar. Elsewhere in the poem (3.391–95) Silius writes:

> *Fulget praecipuis Parnasia Castulo signis*
> *et celebre Oceano atque alternis aestibus Hispal*
> *ac Nebrissa dei Nysaeis conscia thyrsis,*
> *quam Satyri coluere leves redimitaque sacra*
> *nebride et arcano Maenas nocturna Lyaeo.*

> (Bright beyond the rest shone the ensigns of Delphian Castulo; and of Hispalis, famous for its ocean and the run of its tides; and of Nebrissa which knows the Nysaean thyrsi of the god – Nebrissa haunted by nimble Satyrs and nightly Maenads, who wear the sacred fawn-skin and the mystic vine-leaf.)[4]

The Nysaean god is Bacchus, who is said to have been raised on Mount Nysa, and Castulo, Hispalis, and Nebrissa are towns in Baetica, the Roman province in southern Iberia named for the River Baetis (the Guadalquivir). Silius here identifies Nebrissa with the *nebris* (fawn-skin) worn by the god's followers. Renaissance humanists took this to mean that Bacchus had founded Nebrissa. One reason Silius enjoyed authority with the Spanish historians of Velázquez's time was that many of them believed he had been born in Italica, an ancient town near Hispalis (Seville), in the very region where the *Punica* situates Bacchus's conquests.[5] Italica is no longer accepted as his birthplace, and both Padua and Capua have been proposed as more likely sites.[6]

Plutarch's purported contribution to the tradition is found in *De fluviorum et montium nominibus,* a treatise on the names of rivers and mountains that is spuriously attributed to him. A chapter on the Nile and its environs declares:

> The neighboring mountain is called Argillus for this reason: Jupiter, full of amorous desire, after having ravished the nymph Arge from the Cretan city called Lyctus, transported her to the Egyptian mountain named Argillus, and there fathered on her a son named Dionysus, who, when he was in the flower of his youth, named the peak Argillus in honor of his mother. The same, having raised an army of Pans and Satyrs, put the Indians under his power, and then having won victory in Iberia, he established as governor the god Pan, who named the region Pania after himself, from which it was called Pania. His later successors, taking up the derivation, ended by calling it Spania, as Sosthenes recounts in the thirteenth book of his *Rerum Ibericarum.*[7]

A survey of Renaissance historians who considered the evidence for Bacchus's presence in Iberia can begin with Joan Margarit i Pau, cardinal bishop of Gerona, who referred to the matter in the *Paralipomenon Hispaniae,* a history of ancient Spain that he left unfinished at his death in 1484. It was first printed from a

defective manuscript version in 1545.[8] Margarit knew the myth from reading Pliny:

But Lusitania is called that from the river Ana, which today is called Gaudiana, which from its rise running through the whole province embraces whatever lies between the two rivers Baetis and Tagus, with the river running through the middle, from which the province has its appellation, for the reason that by that [river] father Liber and Lisias played, and Pan his prefect, as pleases Pliny in the third book of the *Natural History,* although the same Pliny says in the same place that the river Anas bisects and divides the province Lusitania, in which he spoke not rightly, since the province Lusitania itself contains whatever lies between the two rivers Baetis and Tagus, with the river itself Ana running through the middle of the province, all the way to Nearer Spain and Celtiberia.[9]

The critical figure in reviving the myth was the philologist and historian Antonio de Lebrija, better known as Antonio de Nebrija, who took particular interest in Bacchus's having founded Nebrissa because it had survived as the modern town of Lebrija, where he was born.[10] One expression of that interest is the name by which he is commonly known. Born Antonio Martínez, he adopted a Latin form of his name, as did many humanists of his age: Aelius Antonius Nebrissensis. The toponymic "Nebrissensis" refers to the identification of his birthplace with the ancient Nebrissa.[11] When this adopted name was translated into Castilian, it became Elio Antonio de Nebrija, from which the shorter Antonio de Nebrija was derived.

Nebrija expresses pride in the antiquity of his birthplace in *De Patriae Antiquitate,* an elegy that recounts the founding of Nebrissa. The complete poem is transcribed in Appendix A; for our purposes the critical lines are:

> *Haud procul hinc colitur muro Nebrissa uetusto*
> *Quam Bacchus posuit littus ad Oceani.*
> *Namque ferunt Semele genitum Gangetide uicta*
> *Inuasisse feros Hesperiae populos.*
> *Et socio amisso a quo Lusitania nomen*
> *Duxerat in Calpes littora uertit iter.*
> . . .
> *Hic promissa pater fundauit moenia Bacchus*
> *Nebrissamque uocat nebridis auspicio.*

(Not far from here they dwell in Nebrissa, inside the old wall, a town that Bacchus placed by the Ocean shore. For they say that the son of Semele, after he conquered India, attacked the fierce peoples of the western lands. When he lost the comrade from whom Lusitania took its name, he turned his course to the shore of Calpe. . . . Here father Bacchus founded the city he had promised and called it Nebrissa in honor of the fawn-skin.)

99

Nebrija also incorporated the legendary founding of Nebrissa in his pioneering study of Castilian grammar, the *Gramática sobre la lengua castellana,* first published in 1492.[12] Taking up the question of how the invention of writing was brought to Spain, he declares:

> Much could be advanced on this question: Who first brought letters to our Spain, or from where could the men of our nation have received them? And yet, a thing that is very akin to the truth is that Bacchus, son of Jupiter and Semele, daughter of Cadmus, could have brought Boeotian ones from Thebes when, almost two hundred years before the Trojan War, he came to Spain, where he lost a friend and companion of his, Lisias, after whose name all that stretch of land that is between the Duero and the Guadiana was named Lisitania, and later Lusitania. He [Bacchus] founded Nebrissa, which was called by another name, Veneria, [and] located, according to Pliny's account in the third book of the *Natural History,* between the estuaries and the salt marshes of the Guadalquivir. The which he named Nebrissa, from the *nebrides,* which were hides of does that they used in their sacrifices, which he instituted here, according to what Silius Italicus writes in the third book of the *Second Punic War.* Therefore if we are willing to believe the histories of those who have authority, no one can show me anything in Spain more ancient than the founding of my native land and birthplace because the coming of the Greeks from the island of Zacynthus and the founding of Saguntum, which now is Murviedro, was either at the same time or a little later, according to what Bocchus and Pliny write in the sixteenth book of the *Natural History.*[13]

Nebrija probably cited the founding of Nebrissa again in the *Muestra de la historia de las antigüedades de España,* an essay on the early history of Spain known from an incomplete version that was published around 1499.[14] Unfortunately, the missing chapters include the one in which Bacchus and Nebrissa would have figured.[15]

In 1509 Nebrija was appointed royal historian to the crown of Castile, and in that capacity he undertook to write the *Decades,* a Latin history of the reign of Ferdinand and Isabella derived from Hernando del Pulgar's *Crónica de los Reyes Católicos.*[16] Nebrija left the project unfinished at his death in 1522, but a manuscript version discovered among his papers was published by his son Sancho in 1545.[17] It is of interest here for its prefatory *Exhortatio ad Lectorem,* which reviews the early history of Spain, including the role played by Bacchus:

> About two hundred years before the destruction of Troy, at which time Deborah was judging the Israelite people along with Barak, which was about 1,400 years before the Christian salvation, Dionysus, who is also called Liber Father, with his army came to Spain, not so much out of

desire for domination as that he might bring back glory equal to that which he had brought back from conquered India. And so as victor he left no other trace of his coming with us than that in Baetica between the estuaries of the Baetis river he founded Baetis my fatherland, and that from Lysia, the companion and ally of his journey, he named Lysitania, and as in many other [cases], with the upsilon turned into a vowel u, it was afterwards called Lusitania.[18]

Another royal historian, Lucius Marineus Siculus (Luca di Marinis), named Bacchus as the founder of Nebrissa in his *De rebus Hispaniae memorabilibus* of 1530, which appeared in Castilian the same year as *Cosas memorables de España.*[19] Describing the ancient province of Baetica, Marineus writes, "But turning to Nebrissa, which the writers called Veneria, I believe it took its name from the god Bacchus. Because 'Nebris' means 'skin of a small deer,' dressed in which the priests of Bacchus made sacrifices to him."[20] When Marineus describes Lusitania, however, he cites two conflicting explanations of how the province received its name: "Pliny writes that Lusitania took [its] name from Lusu, by which is meant the game and festival that the god Bacchus with his captains Lisa and Pan held there in memory and in honor of their victories. Others say that Lusitania is named for Luso, who, as we say in another place, was the sixteenth King of Spain."[21]

This last reference is to a later passage in the same book in which Marineus declares, "After Siceleo completed his life his son called Luso reigned in Spain, after whom some contend Lusitania was named, and also many other old towns in Spain. And so Luso left as King of Spain another called Siculo."[22] Siceleo, Luso, and Siculo belonged to a line of twenty-four legendary kings whose rule was said to have begun six hundred years before the Trojan War. They were in large part the invention of an Italian humanist, Annius of Viterbo (Giovanni Nanni), who had introduced them into the historiography of Spain in his *Commentaria super opera auctorum diversorum de antiquitatibus loquentium* of 1498.[23] As a consequence, later scholars who believed that Lusitania had been named after an ancient personage had to evaluate the conflicting claims on behalf of Luso, King of Spain, and Luso, companion of Bacchus.[24]

Nebrija's publications did not bring to light all his thoughts on Bacchus's deeds in Iberia. Some of his ideas were preserved by one of his pupils, Florián de Ocampo, in the *Crónica general de España,* a history of Spain begun by Ocampo and later continued by Ambrosio de Morales.[25] The *Crónica* is divided into twelve books, the first four initially published by Ocampo in 1553. Book

One describes the geography of Iberia and traces the history of its earliest rulers, beginning with the arrival there of Tubal, a grandson of Noah, in 2163 B.C., 142 years after the Deluge. Ocampo dates Bacchus's presence there to the reign of Romo, another of the legendary kings of Spain, in a chapter that constitutes the fullest exposition of Bacchus's conquests in Iberia. Because Ocampo's arguments depend upon phonetic similarities in proper names, it has been necessary to retain the Castilian forms "Baco" (Bacchus) and "Dionisio" (Dionysus) in the following translation of Ocampo's text:

In that same season in which King Romo, of whom the preceding chapter spoke,[26] was said to reign in Spain, about the 1325th year before our Lord and Redeemer Jesus Christ was born, we know that a great abundance of people entered Andalusia with an infinite multitude of women who followed a Greek Captain named Dionisio, whom the Greeks his countrymen later called by the surname Yaco. The origin of this surname was that all the company that followed him always had the custom of roaming through the country shouting very loudly, with howls and frantic shaking, not less at times of rejoicing than [at times] of anger or of devotions and sacrifices – which clamoring those Greeks in their common language were wont to call Yaco. In the same manner they call such frantic clamoring Yachima, and for this same reason they also named him Bacho, wanting to convey a sense of [*queriendo dar a sentir*] the so disorderly howling that they called Bachin. Seeing the strangeness of these people who followed Dionisio and considering as well his numerous accomplishments, his excessive beauty, his grace, and his marvelous disposition, the pagans came to take him for a God and to venerate him with temples and sacrifices. They were also greatly moved to this by the many notable things that he did throughout the world, in the Indies as in other parts where he roamed, winning battles, conquering tyrants, subjugating provinces, and suppressing armies and injustices [*quitando fuerzas y desafueros*] wherever he found them. [This was] consistent with what Osiris – that one of whom we have already told in the ninth chapter of this book[27] – had done before, so much so that for the similarity of the deeds of the one with those of the other, the Greek people called them both Dionisios, as they did in the case of the Herculeses, when they attributed the name and victories of Oron Libio the Egyptian to their Greek Hercules, the son of Amphitryon.[28] It is true that besides this Baco Dionisio, of whom we now treat, and besides the other one also called Osiris, we find another Baco Dionisio, who was a very esteemed person, the son of Pyrrha and Deucalion, the ones whom we said had escaped the flooding of Thessaly in chapter twenty-four.[29] This one before anyone else showed the Greeks the advantage and the art of planting fig trees, and the way in which they produce wine from grapes, and many other good skills for maintaining vines and preserving them, with more diligence than anybody had had in those lands until those times. For that reason the Greeks said he was the first inventor of everything relating to the making of wine, and they

made sacrifices and temples to him as to a God, in which, at the season of his festival, they venerated the statues that they had of him outside the temples, adorned with vine branches and clusters of grapes, and rubbed their faces with crushed grapes and green figs. But they never had that Dionisio in Spain – granted that a long time later in that age of paganism they also raised temples to him here, and they deputed sacrifices to him with the same aforesaid solemnity. Only the last of all these Dionisios is the one who now concerns us. He was the son of Jupiter and of a lady named Semele, and grandson of another important man in the country of Phoenicia named Cadmus. This Dionisio came to Spain in the time when King Romo was said to reign in it. We know for certain that he visited principally the provinces bordering upon the sea, and much more than any other that of Andalusia, which, on account of being so fertile and so pleasing, detained him more than any of the others. Here he left part of his people with some sages and priests from those who took charge of the prayers and sacrifices that his companions and people were commonly accustomed to make to the gods, according to the practice of Greece. These founded near the river Guadalquivir a place that we now call Lebrija, which the ancients later called by the surname Veneria, although now we find this town more than eight thousand *pasos* from that river, which is almost two Spanish leagues. The reason was that (as we already said in another place)[30] after the Guadalquivir reached Seville and before it was swallowed by the sea, it used to divide into two branches, making an island with them, of which past Writers made notable report in many places in their works. The one of these two branches that went to the East is not found now because the waters have all shifted into the other branch to the West, as is seen clearly today near the town of Rota, and in other places where the river bed is exposed where it used to flow. In such manner, this town of Lebrija, being on that now-spent eastern branch of the Guadalquivir, ended up much removed from the water, with a different site, as it would appear to those who do not know this, from that which it had when those companions of Dionisio founded it. The Histories say of these [founders] that when they performed their prayers and ceremonies, they wore some skins of fallow deer, the most mottled that they found. For this reason the town had renown as Lebrija, or Nebrissa, because Nebris in the language of such Greeks means "skin of the fallow-deer," in which they went about dressed and covered. The name endured until our time in the said town, which was always among the most honored in Andalusia for its great antiquity – and much more for having come forth from it the Master Antonio de Lebrija, restorer of good letters in Spain. It also seems from the foregoing that those who contend that this place had been founded by a grandson of Ulysses, as those who composed the *Crónica de España* by order of the Lord King Don Alfonso say,[31] along with other Castilian Historians who follow it, are deluded. I remember that, when I was a young man studying at Alcalá de Henares, many times I heard the Master Antonio de Lebrija, a native (as I said) of this town, say that that Dionisio also founded a certain town in Spain, near the Pyrenees mountains, which he ordered to be called Yaca, on account

of his surname, of him whom they called Yaco – which town Pliny, Strabo, Titus Livius, and many other Latin and Greek Cosmographers and Chroniclers keep in lasting memory.[32] Also, the peoples in its territory were formerly called the Yacetan Spaniards. Although there is no lack of Authors who call the town Laca and the peoples its inhabitants the Lacetans, as I said, Strabo names them Yacetan, and the city Yaca. And we, too, and its natives today call it Yaca [Jaca], conforming with the surname of this Yaco Dionisio – which city is placed near the rough terrain and the mountains of the Pyrenees as we already indicated in the second chapter of this book,[33] preserving the same features [*facción*] that the ancient Authors indicated, and with the same name. Verily, if I were to read some trustworthy chronicle in which was found what Antonio de Lebrija said, it would seem to me that it takes a good path, and I would esteem its opinion much more, as I repute it certain – and not the judgment of our modern Chroniclers, who, treating the Histories of the Aragonese Kings, have dared to affirm this city was called Jaca because it lies [*yace*] in an open valley, surrounded by mountains all around, which does not satisfy me because if that were so, all the towns in the world would have to be called Jacas because they all lie where they are. Some writings also state that after the aforesaid journey, there remained in the hindermost part of Spain certain persons from Arabia, named Cenitas, who settled the hindermost shores of the Ocean Sea, neighboring the cape that we now call that of San Vicente, although many others affirm they had remained since the time of Osiris, as we have written in the eleventh chapter.[34] Therefore, returning to the true intention of our Chronicle, we find in the ancient records that when that Yaco Dionisio roamed through the Spanish lands, among the persons of importance whom were known there was one called Mylico, son of Myrica, an inhabitant of the eastern borders of the province named Baetica – although not within it, [he was] so respected and illustrious in all those territories, [it was] as if he were King of them. A little later in that region and domain his sons and successors built a very magnificent city, which the ancients called Castulon [Castulo], not far from where today we find the town of Baeza, as we shall see in the twenty-sixth chapter of the second book,[35] whose good and bad fortunes as happened in different times, which were many, we shall relate farther on in some parts of this Chronicle. The Historians and Poets say as well, particularly when they discuss the journey of Dionisio through Spain, that, roaming through it, among the other regions where he traveled, he also came to that of Lusitania, which we have already set landmarks to and delineated [*rayada*] in the twenty-three preceding chapters. Here they assert he had established as special governor a Captain of his named Luso, or as others state it, Lisia, who dwelt before anyone else in this province, although Juan de Viterbo always attributes it to his King Luso of Spain, as we have written before now.[36] Plutarch also affirms with other Greek authors that Dionisio on this trip left over all these as principal administrator and procurator of all the land in general a companion of his, called Pan, who was afterwards held and venerated as a God in the time of paganism, and that out of respect for this Pan the entire land started to be called Pania. Time passing, that name was corrupted, and the peoples who

followed, adding to the beginning a letter or syllable, named it Spania. Later they came to say España [Spain], although regarding this article we have already written what other Histories recount of Seville and King Hispan, its founder, to which our Spaniards are wont to give more authority.[37] All these deeds concluded, Dionisio, with his multitudes and with those women who followed him, left the Spanish realms. King Romo was obliged to remain in his city of Valencia, as he was wont to do before, as the place where he would dwell in repose for the time that he lived, until the thirty-three years of his reign were completed, when it is said he reached the end of days, leaving as a successor a male issue, called Palatuo, of whom there will be an account presently in the following chapter.[38]

One detail of Ocampo's account seemingly calls into question whether the tradition of Bacchus's travels in Iberia can be related to *Los Borrachos:* He identifies the Bacchus who came to Spain as the son of Jupiter and Semele, but he identifies the Bacchus who instructed men in winemaking, an activity that seems more directly related to *Los Borrachos,* as the son of Deucalion and Pyrrha.[39] There are two replies to this objection. First, many of the historians who wrote after Ocampo did not adopt his distinction between different men with the same name. Second, although euhemerist historians distinguished among mythic deeds wrought by several men with the same name, Renaissance and Baroque artists who illustrated ancient myths generally simplified matters by treating such deeds as the works of a single hero.

That is what happened to Hercules. Humanists who evaluated ancient myths frequently distinguished several ancient heroes with that name – there were the Theban Hercules, the Egyptian Hercules, the Tyrean Hercules, and others. Ocampo refers to two such personages in the lengthy passage quoted above, and he cites others elsewhere in his text.[40] However, artists generally fused these different men into one personality – in effect, a generic, all-purpose Hercules.[41] For example, among the ten episodes from the life of Hercules that Francisco de Zurbarán painted for Philip IV in 1634 and 1635 are scenes of *Hercules Separating the Mountains of Calpe and Abyle* (fig. 52) and *Hercules Fetching Cerberus from Hades* (fig. 53).[42] According to Ocampo, the former was a deed of the Egyptian Hercules;[43] the latter, on the other hand, was one of the Twelve Labors ascribed to the Theban Hercules. For Philip's purposes, it sufficed to fuse them into one man.

Ocampo's different heroes named Bacchus would have been susceptible to the same kind of artistic conflation. What is more, although there was classical authority for there having been several Bacchuses, there was also classical authority in two epigrams by

Ausonius for Bacchus having been a single figure who went by many names. One, "An Outlandish Medley to a Marble Statue of Liber Pater in My Country House, Having the Attributes of Various Gods," declares, "The sons of Ogyges call me Bacchus, Egyptians think me Osiris, Mysians name me Phanaces, Indians regard me as Dionysus, Roman rites make me Liber, the Arab race thinks me Adoneus, Lucaniacus the Universal God." The other, "To Liber Pater," states, "I am Osiris of the Egyptians, Phanaces of the Mysians, Bacchus among the living, Adoneus among the dead, Fire-born, Two-horned, Titan-slayer, Dionysus."[44]

With the authority of scholars like Nebrija, Marineus, and Ocampo behind it, the story of Bacchus's conquests spread through the literature on ancient Iberia. Among other books published before 1629 (the year in which Philip IV paid for *Los Borrachos*), eight general histories of Spain[45] and four general histories of Portugal[46] consider the myth. It also turns up in local histories of Cádiz, Carmona, and Valencia.[47] Other references to it appear in books on the ancient language of Spain, the origin of the Castilian tongue, world geography, Spanish saints, and the war to recapture Granada from the Moors.[48] Sebastián de Covarrubias Orozco cites the tradition and quotes the opening lines of Nebrija's *De Patriae Antiquitate* to explain the derivation of "Lebrija" in his dictionary of Castilian, the *Tesoro de la lengua castellana o española*.[49]

52 Francisco de Zurbarán, *Hercules Separating the Mountains of Calpe and Abyle* (Madrid, Museo del Prado, all rights reserved).

106

Thus, by 1629 Bacchus's conquest of Iberia was common knowledge among those who shared an interest in the antiquity of Spain. That included the men who frequented Pacheco's academy, two of whom incorporated the myth in their writings. Velázquez would have known them both. One was Juan de Pineda, who in 1609 published a mammoth volume in Latin on the life and times of Solomon.[50] At one point Pineda argues that Osiris, whom he identifies as "either the friend of Dionysus or Dionysus himself," visited Spain, and that leads him to cite Pliny and Silius Italicus on Bacchus's presence in Iberia.[51] The passage is a small part of a wide-ranging study of the ancient world, but it establishes that the myth was known in Pacheco's circle before Velázquez began his apprenticeship. The other author was Rodrigo Caro, who wrote an important study of the early history of Seville and its environs, the *Antigüedades y principado de la ilustríssima ciudad de Sevilla*.[52] In passages that address the origins of Seville and Lebrija, Caro, too, refers to Bacchus's Iberian conquests.[53] Although the *Antigüedades* did not appear until 1634, it was the product of a lifetime of research that Caro discussed with his friends in Pacheco's academy, where he and Velázquez surely became acquainted before the latter moved to Madrid in 1623. (Caro's researches held sufficient interest for Velázquez that he acquired a copy of the *Antigüedades,* which was listed in the inventory of his library compiled after his death.)[54] Given this docu-

53 Francisco de Zurbarán, *Hercules Fetching Cerberus from Hades* (Madrid, Museo del Prado, all rights reserved).

107

mented awareness of the myth in Pacheco's academy, as well as its widespread dissemination into books on Iberian history and culture, we may reasonably conclude that when Velázquez painted *Los Borrachos,* he knew the tradition that Bacchus had ruled in Iberia.[55]

BACCHUS IN IBERIA

THE MATERIAL ASSEMBLED in the preceding chapters makes possible a new hypothesis that explains *Los Borrachos* as one of Velázquez's responses to the opposition he encountered in his efforts to advance himself at the Spanish court. As the 1620s progressed, he would have become increasingly aware that he needed to prove himself as a history painter if he was to secure his position as the king's chief painter. To that end, he looked for a subject with which he could comment upon kingship – especially the kingship of his patron, Philip IV – and settled upon the myth of Bacchus's conquest of Iberia. He then fused that legend to Bacchus's traditional role as the benefactor whose gift of wine brought mankind relief from the burdens of everyday life. The result was a potent image that depicted a former ruler of Spain acting benevolently to ease the lot of his subjects. In other words, in keeping with the theoretical ideal that court art should provide exemplary models of royal comportment, Velázquez made Bacchus a paradigm of good kingship for the edification of his Habsburg successor. Because the nineteenth-century nickname *Los Borrachos* fails to convey the seriousness of this purpose, let us identify the picture hereafter as *Bacchus in Iberia*.

Velázquez surely knew the two traditions of Bacchic rule over Iberia and Bacchic benevolence toward mankind. As we have seen, the myth that Bacchus triumphed in Iberia was a commonplace among Spanish historians and antiquarians, including those in Pacheco's academy, and the tradition of Bacchus's generosity in giving wine to mankind was familiar from texts like Ovid's *Metamorphoses*, Pérez de Moya's *Filosofía secreta,* and, to turn again to Pacheco's circle, Juan de Arguijo's sonnet "To Bacchus." Combining those traditions enabled Velázquez to overcome the chief obstacle that he faced in representing Bacchus as a conqueror of Iberia: the lack of descriptive details in the accounts of the god's travels through Spain (even in Ocampo's lengthy text) on which he could base an illustration of a specific event. By turning to the

tradition of the god's benevolence, Velázquez gained access to the body of images that showed Bacchus as a wine-giver, and in one of them, Saenredam's *Homage to Bacchus* (see fig. 14), he found the compositional model that he needed to give his conception form.

To meet his special requirements, Velázquez had to rework Saenredam's composition. The little satyr in the print, for example, became the human character who reclines behind Bacchus in the painting. This can be viewed as a consequence of Velázquez's preference for realism, but the change may also have been intended to cast the figure as one of the companions to whom Bacchus entrusted political authority: either Luso, whom he sent to rule what became Lusitania, or Pan, who remained as governor of Spain after Bacchus departed the realm. Other changes – making the peasants merry rather than drunk, replacing the god's display of grapes with his presentation of a garland, and introducing the figure who approaches from the right rear – will be considered later in this chapter. Here we should note that to facilitate these changes, Velázquez found it necessary to give *Bacchus in Iberia* different proportions from those in Saenredam's print. Whereas the height-to-width ratio of the engraving is 1.38 (44.5 × 32.2 cms.), the ratio for the painting is only 0.73 (165 × 225 cms.). This transformation may have been inspired by two other prints of Bacchic subjects, Andrea Mantegna's *Bacchanal with Silenus* (fig. 54) and *Bacchanal with a Wine Vat* (fig. 55), both of which have height-to-width ratios of 0.74 (33.5 × 45.4 cms.).[1] Although the physical types and raucous actions of Mantegna's revelers differ markedly from those of Velázquez's company, it is possible – but by no means certain – that Velázquez derived the proportions of his composition and the arrangement of his figures in a frieze across the foreground from Mantegna's example.

Velázquez most likely painted *Bacchus in Iberia* sometime between the end of the "Moriscos" competition in March 1627 and Philip IV's payment of 100 ducats toward the cost of the *Bacchus* on 22 July 1629. One clue to its date is Pacheco's silence about the picture in his *Arte de la pintura*. Pacheco had visited Madrid in 1624 and in 1625–26,[2] and it is unlikely that he would have omitted mention of a major picture for the king of such distinctive character if he had seen it. Furthermore, to judge from Pacheco's account of the "Moriscos" contest, Velázquez must have informed him in detail of the circumstances pertaining to the event.[3] If Velázquez had painted *Bacchus in Iberia* in the months preceding the competition, we might reasonably expect that he would have told Pacheco about it and that Pacheco would have referred to it in his treatise.

Dating the picture after March 1627 is consistent with seeing it as a response by Velázquez to criticisms from conservative rivals like Vicente Carducho and Eugenio Cajés, for by then the issues dividing them would have been clear. Such a dating would also accommodate seeing the painting as a response to the challenge posed by Juan van der Hamen y León. By March 1627 Cardinal Francesco Barberini and the Cavaliere Cassiano dal Pozzo had expressed their preference for Van der Hamen over Velázquez as a portraitist, Van der Hamen had completed his *Vertumnus and Pomona* (see fig. 42) of 1626, and he may have begun (and even have finished) his *Offering to Flora* (see fig. 43 and plate 6) of 1627. If *Bacchus in Iberia* was painted in reaction to Van der Hamen's activities, it may be significant that all three pictures incorporate botanical gifts: Vertumnus presents fruit to Pomona, the young man brings roses to Flora, and Bacchus provides wine to the peasants.

This dating leaves undetermined the extent, if any, to which Velázquez was prompted to undertake the work by Philip's commissioning pictures for the New Room from foreign artists and by Peter Paul Rubens's arrival at Madrid in 1628. If those events preceded Velázquez's conceiving the picture, they may have contributed to his sense that he needed to prove himself as a history painter. On the other hand, if he had already begun the picture, then at most those developments may have spurred him to bring his canvas to completion.

How, then, would Philip and his court have perceived *Bacchus in Iberia* as an edifying commentary on the kingship of Spain? To begin with, the god's gift of wine, which the peasants so enjoy, would allude to the king's duty to see to the well-being of his subjects. It was a fundamental tenet of Spanish political theory that he had such a duty.[4] His subjects, in turn, rewarded him with their loyalty. As Philip himself told the Council of Castile in 1627, " . . . it is better to tax the rich than to oppress the poor and miserable vassals of Castile, who with their blood, love, and sacrifices have made us masters of all we possess, and who preserve us among them as the head and principal member of the whole body of the Monarchy."[5] Interpreting the picture in this light accounts for one of Velázquez's significant departures from Saenredam's print – the painted peasants are merry, but they are not besotted clowns. The reverence and appreciation that Velázquez's peasants show Bacchus is the deserved homage that rational men pay their sovereign, not the folly of drunkards whose judgment has been clouded. In this vein, Velázquez's figure who approaches Bacchus's company from behind and doffs his hat is more likely to be asking for a

drink than pleading for alms. Wine, not money, is the tangible symbol of the god's beneficent rule.[6]

Other aspects of the painting reinforce its sense as a metaphor for a sovereign and his subjects. The division of the composition into two halves – with the god dominating one side enthroned on a wine cask, and with the kneeling peasants dominating the other – suggests the hierarchical relationship between a ruler and the ruled.[7] In addition, the hats worn by the grinning peasant with the wine bowl and the standing figure at the right recall a feature of the elaborate etiquette that governed life at the Spanish court. Male courtiers were expected to go bareheaded in the king's presence, with the exception of the highest-ranking noblemen, the grandees, whose best-known privilege was their right to remain hatted. By providing only two of the peasants with hats, Velázquez hints at the subtle gradations in status that can prevail within a ruler's circle of intimates.

The way that Philip IV governed his empire resonated with echoes of the Bacchic conquest of Iberia. In the seventeenth century Iberia was divided into three great crowns, each of which the king ruled by separate title: the crown of Portugal, the crown of Aragon (comprising the principality of Catalonia and the king-

54 Andrea Mantegna, *Bacchanal with Silenus* (New York, The Metropolitan Museum of Art, Harris Brisbane Dick Fund, 1929 [29.44.15]).

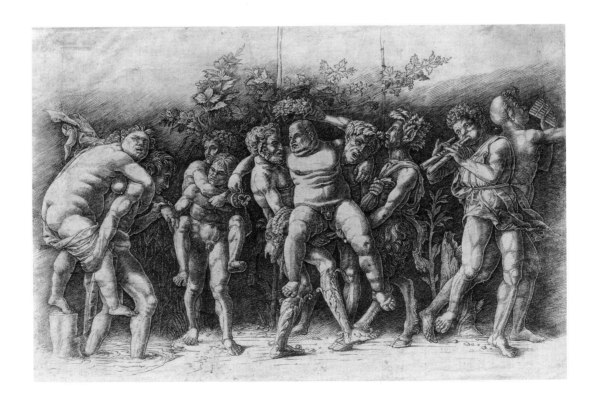

doms of Aragon and Valencia), and the crown of Castile (comprising the remaining realms of the peninsula). Each could be associated with Bacchus, who established Luso as ruler of Lusitania (the crown of Portugal) and who founded Jaca (in the crown of Aragon) and Lebrija (in the crown of Castile).

Just as Bacchus had traveled throughout Iberia, so had Philip. His journeys afforded his subjects a rare opportunity to see him in person, and some of these trips enabled him to perform legal ceremonies that secured his authority to rule. Philip was born in Valladolid and had been raised there and in Madrid, two of the great cities of the crown of Castile. As a prince he had accompanied his father, Philip III, on a trip to Lisbon in 1619, where his father had been crowned belatedly as king of Portugal and where he had been confirmed as the heir to its throne.[8] As king he had toured Andalusia (another region of the crown of Castile) from February through April of 1624, on a trip that was intended to build support for his regime.[9] Two years later, from January to May of 1626, he had traveled in the crown of Aragon, where he had sworn to uphold the *fueros* (traditional rights) of its three constituent realms, thereby confirming his sovereignty over them. The oath-takings were obligations that he had been expected to

55 Andrea Mantegna, *Bacchanal with a Wine Vat* (New York, The Metropolitan Museum of Art, Purchase, Rogers Fund and The Elisha Whittelsey Collection, The Elisha Whittelsey Fund, 1986 [1986.1159]).

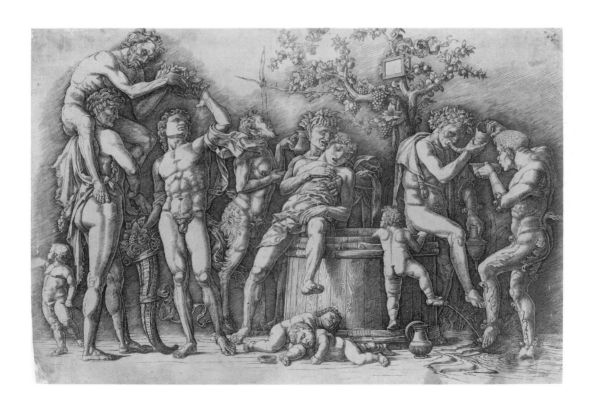

meet as a prince, and because he had not done so before his father's early death, the realms had been provided with legal grounds for resisting his authority.[10] Philip was never as itinerant a ruler as Bacchus, but in the years preceding the completion of Velázquez's painting, he had traveled extensively in Iberia.

This geographic parallel can be taken further. By the conflation of the Iberian Bacchus with the other heroes named "Dionysus," the god was identified with the being who had roamed the world and had established a vast empire, most notably by his conquest of India. Diodorus of Sicily recounts that campaign at length (*Library of History* 2.38) and declares that Dionysus had "visited all the inhabited earth" (3.3.1).[11] Silius Italicus writes of "Liber, whose chariot was drawn through the cities by Caucasian tigers when he came back in triumph from the conquered East, after subduing the Chinese and the Indians" (*Punica* 15.79–81), and of Liber "when he drove his car, wreathed with vine-leaves and drawn by tigers, down from the incense-breathing land of the Indians" (17.647–48).[12] For his part, Philip ruled a global empire encompassing territories in Europe, Africa, Asia, and America. Like Bacchus, Philip governed with the aid of substitutes, who administered his realms in his absence. Bacchus had put Luso in charge of Lusitania and had entrusted Spain to Pan. Philip, by one count, depended upon the services of nine viceroys and seventeen governors to administer his far-flung realms.[13]

Viewing the painting as *Bacchus in Iberia* clarifies the role of the kneeling man with a sword whom Bacchus crowns with a garland. He is a real soldier, not a drunkard pretending to be one, and the god's action is not some idle jest, but a reward to a loyal follower who has helped him to triumph in Iberia. According to Pliny the Elder (*Natural History* 16.4.9–10), Bacchus was intimately associated with the practice of awarding garlands as prizes for victories:

> In olden times indeed no Civic Wreath was presented save to a diety – that is why Homer assigns a wreath only to heaven and to a whole battle-field, but to no man individually even in combat – and it is said that father Liber was the first to set a crown on his own head, a wreath of ivy. Afterwards persons performing sacrifices in honour of the gods assumed crowns, the victims being adorned with wreaths as well. Most recently of all they were also brought into use in ritual competitions, but in these and at the present day they are not bestowed on the winner, but an announcement is made that by him a wreath is conferred upon his native place; and from this has arisen the custom of also bestowing wreaths on victorious generals about to go in a triumphal procession, for them to dedicate as offerings in the temples, and also subsequently the practice of presenting wreaths at the games.[14]

It will be recalled, moreover, that Alciati's emblem *Hedera* (see fig. 18) associated ivy with Bacchus and identified it as the plant from which garlands that symbolize the eternal glory of poets are woven.[15] Ivy, then, would be an appropriate vine for Bacchus to weave into a garland as a reward for one of his followers, and the small, heart-shaped leaves visible among those in the crown that he sets upon the soldier's head are consistent with the appearance of ivy. (On the other hand, the leaves in the garland that Bacchus himself wears are larger and have serrated edges. Velázquez has apparently given Bacchus a garland woven from grapevines, which alludes to his role as wine-giver.)

By crowning the kneeling soldier as a reward for military service, Bacchus performs a deed that academic theoreticians regarded as a fit subject for court art. As Carducho prescribes in the *Diálogos de la pintura,* "If it is royal galleries [that are being decorated], it is historical subjects that are to be painted – grave, majestic, exemplary, and worthy of imitation: such as prizes that great monarchs have given to those who are constant in valor and virtue. . . ."[16] Like his provision of wine, Bacchus's reward to his follower is an act of good kingship to be emulated by his modern successor. The crowning of the soldier may be only one in a series of such commendations because the two characters at the left also wear such prizes. The implication seems to be that a good ruler will have many victories to celebrate.[17]

During the later 1620s there were ample grounds for perceiving Bacchus's action as a metaphor for a modern king's rewarding his victorious armies. Although Philip IV's reign ultimately proved to be an era of military disaster, his armies triumphed repeatedly over his enemies during the early years of his rule. This resurgence of Spanish might peaked in 1625, the *annus mirabilis* in which the regime won a string of celebrated engagements: the recapture from the Dutch of San Salvador de Bahía in Brazil and of Breda in the Netherlands; the successful defense of an ally, the Republic of Genoa, from a Franco–Savoyard invasion; the repulse of a Dutch attack on Puerto Rico; and the defeat of an English assault on Cádiz.[18] A few months later the Treaty of Monzón (concluded 5 March 1626) confirmed Spain's victory over France and Savoy in a struggle for control of the Valtelline.[19]

For a time, it appeared that the imposition of a *pax hispanica* upon Europe was genuinely attainable. Over the long run, however, Spain lacked the resources necessary to sustain military activity on so many fronts, with the result that the king's armies were not able to maintain the momentum of victory. In fact, the last years of the 1620s witnessed a dramatic reversal of Spanish

fortunes. On 31 January 1627 the government found it necessary to suspend payments to its bankers (in effect, declaring bankruptcy), and on 7 August 1628 it had to devalue the *vellón,* a copper currency that it had minted to excess, by fifty percent.[20] On 22 December 1628 word reached Madrid that the Dutch had captured that year's silver fleet in the Bay of Matanzas on 8 September, a disaster that impoverished the crown while enriching the Dutch, who went on to enjoy significant gains in their war for independence from Spain in the spring and summer of 1629.[21] Another reason for the Dutch resurgence of 1629 was that Philip had diverted much of his remaining resources to Italy, where Spain again found itself pitted against France, this time in the War of the Mantuan Succession. That war had broken out in 1628, and Spanish hopes for a swift victory had proved unfounded. The conflict was to drag on until 1631, when it was settled on disappointing terms by the Peace of Cherasco.[22]

Bacchus in Iberia, which was completed during these years, contains no hint of these setbacks, for it is the nature of court art to ignore failure and to celebrate success. In 1629 the memory of Spanish victories from earlier in the decade remained fresh enough to provide a modern analogue for Bacchus's ancient conquests. When Velázquez delivered his painting to the king, it was still possible to relate the god's triumphs to recent developments optimistically, in the hope that Philip's armies would once more prevail against his enemies, just as Bacchus's followers had won glory for their leader centuries before.

But if Velázquez's Bacchus bestows a reward for martial prowess, why does he look away from its recipient? His averted gaze cannot be a sign of disapproval because awarding the garland is a congratulatory act. It follows that something else merits his attention. To judge from his upward gaze, the object of his interest cannot be the man sitting in the left foreground, nor can it be the fellow lying behind him. By a process of elimination, all that is left for him to look at are the tree branches in the upper right corner of the composition. Unlikely as this conclusion may at first seem, it makes sense if vines of ivy have entwined themselves around the branches so that the foliage we see consists of both tree leaves and ivy leaves. Unfortunately, Velázquez shows too little of the branches and their foliage for us to determine whether any of the leaves belong to vines rather than the tree. Some leaves are discernible in the shadows at the base of the tree trunk, but owing to the damage to that part of the canvas, it is difficult to make out whether those leaves belong to a vine clinging to the tree or to weeds growing beside it. When Francisco de Goya etched his version of the composition, he omitted the leaves and

all but eliminated the tree trunk (see fig. 8), but Manuel Salvador Carmona included a vine clinging to the tree when he reproduced the painting (see fig. 9). In the end, the matter remains speculative, but if Bacchus is glancing at ivy in its natural state at the same time that he bestows an ivy garland on the soldier, that would explain the seeming discrepancy of his actions.[23]

Recognizing the allusions within the painting to victories won on Bacchus's behalf clarifies why the god's companions are identified as his *cofrades* in the inventory that Velázquez's son-in-law Mazo helped to compile in 1666.[24] There the conventional sense of *cofrades* – members of a confraternity dedicated to pious, religious acts – becomes a metaphor for the reverent service that Bacchus received from his followers in pagan Iberia. Displaced from its familiar, seventeenth-century Christian context, *cofrades* characterizes the men gathered around Bacchus as a virtuous company that champions the cause of a higher being – a being who, in turn, rewards them for their devotion.

Depicting Bacchus in a history painting also lent itself to Velázquez's efforts to consolidate his position as the king's chief painter by recalling an episode from antiquity in which a painting won royal admiration. Pliny the Elder (*Natural History* 35.8.24) describes the extraordinary appreciation that Attalus II of Pergamum showed for a picture by Aristides of Thebes:

> The high esteem attached officially to foreign paintings at Rome originated from Lucius Mummius who from his victory received the surname Achaicus. At the sale of booty captured King Attalus bought for 600,000 denarii a picture of Father Liber or Dionysus by Aristides, but the price surprised Mummius, who suspecting there must be some merit in the picture of which he was himself unaware had the picture called back, in spite of Attalus's strong protests, and placed it in the Shrine of Ceres: the first instance, I believe, of a foreign picture becoming state-property at Rome.[25]

Elsewhere Pliny remarks that Aristides "was so able an artist that King Attalus is said to have bought a single picture of his for a hundred talents" (*Natural History* 35.36.100).[26] Pacheco draws upon these passages when he recounts the honors and favors that celebrated painters have received from great kings and princes in the *Arte de la pintura:* "Also the king Attalus bought for six thousand sesterces another painting, of Bacchus by the hand of Aristides, and another for one hundred talents."[27] If Pacheco was familiar with the story of Aristides's *Dionysus,* it is likely that Velázquez knew it as well. Accordingly, when Velázquez conceived *Bacchus in Iberia* to elicit Philip's appreciation, he may have had the antique precedent in mind. What would have mattered to Velázquez was not so much the specific content of Aristides's pic-

ture (Pliny says only that it depicted Dionysus), as Attalus's enthusiastic response to it.

At some point Velázquez would have explained the meaning of his painting to the king. It might have been before he set to work on the canvas, if he sought Philip's approval to paint such a picture; it might have been while the canvas was in progress, during one of Philip's visits to his studio; or it might have been as late as the day that he presented the finished picture to the king. Whatever the case, Philip had the necessary background to appreciate the unique content of the work. As part of his training in the arts of kingship, Philip had read history (especially Spanish history) extensively, and he had developed an abiding interest in the field.[28] As a result, he, too, would have been familiar with the Bacchic tradition upon which Velázquez drew. From inventories of the royal library, it can be established that Philip owned many of the books published before 1629 that refer to the legend of Bacchus in Iberia, including Nebrija's *Decades,* Marineus's *Cosas memorables de España,* Ocampo's *Crónica general de España,* and at least fifteen other titles cited in the preceding chapter.[29] Because the inventories postdate 1629, it is not possible to determine which of these books the king had acquired by then, but it is likely that some were already in his possession.

Others in the king's service would also have known Bacchus's role in Spanish history. Among the works that Philip was likely to have read by 1629 was the *Historia general de España* by the Jesuit scholar Juan de Mariana, which includes an account of Bacchus's activities in Iberia.[30] In 1622 the king had awarded Mariana a thousand ducats for the publication of a revised edition of the *Historia general,* and in 1623 the king had appointed him chronicler of Castile (that is, royal historian), an office in which he served only a short time before his death in 1624.[31] Mariana's successor in that post was yet another veteran of Pacheco's academy, the poet and classical scholar Francisco de Rioja, who had come to Madrid in 1621 to serve as the count-duke of Olivares's librarian (the "Sevillian connection" again).[32] Thus, the royal historian at the time that the king acquired *Bacchus in Iberia* belonged to the same intellectual circle as Velázquez.

The manner in which Philip had the painting displayed corroborates our hypothesis that it referred to the kingship of Spain. When his collection of paintings and sculptures in the Alcázar of Madrid was inventoried in 1636, the *Bacchus in Iberia* was listed as one of twenty paintings hanging in the bedroom of his summer apartments.[33] (See Appendix B for the inventory text.) The fact that the *Bacchus* was installed where Philip would see it on a daily basis for several months of the year attests that it pleased him, but

that was not the only reason for its presence there. The selection of paintings that decorated the summer bedroom was governed by a program in which *Bacchus in Iberia* played a significant part.

Eleven of the twenty paintings were portraits of Habsburgs and their spouses drawn from four generations of the royal dynasty. The first generation was represented by a double portrait of Emperor Charles V and Isabella of Portugal, and a portrait of one of the emperor's sisters, Catherine of Austria. The second generation was represented by two portraits of Philip II — one showing him as a youth and the other as an adult — and by portraits of two of his wives, Mary Tudor and Isabella of Valois. Likenesses of four of Philip II's children represented the third generation: Philip III, Prince Carlos, Prince Ferdinand, and Infanta Isabella Clara Eugenia. The fourth generation was represented by Philip IV, shown as a youth. The authors of these works ranged from celebrated masters like Titian and Anthonis Mor to lesser lights whom the inventory compilers left unidentified.

Bacchus in Iberia found its place among these portraits in conjunction with two other paintings. The first, *The Act of Devotion of Rudolf I* by Peter Paul Rubens and Jan Wildens, illustrates a celebrated act of Habsburg piety (fig. 56). One day when Rudolf, count of Habsburg, was hunting, he encountered a priest who was carrying the Viaticum to a dying man. Dismounting from his horse so that the priest could ride in his place, Rudolf conducted the Host to the dying man on foot. The Habsburgs credited this deed with earning the divine favor that enabled Rudolf to become the first of his line to be elected Holy Roman emperor.[34] The other picture, Titian's *Religion Aided by Spain,* is an allegory that proclaims the Habsburg commitment to deploy Spanish might in defense of the Catholic faith (fig. 57). It shows the personification of Spain leading her forces to the assistance of Religion, who is depicted as a woman menaced by heresy (a tangle of writhing snakes at the right) and Islam (a Turk riding a sea chariot across the background).[35]

Together the subjects of these three pictures described the royal family's mission to govern the Spanish empire and to defend the Catholic faith. The *Act of Devotion* demonstrated the fundamental connection between their piety and their power, the *Religion Aided by Spain* acknowledged their spiritual duty, and the *Bacchus in Iberia* signified their secular responsibility for their subjects' well-being and the defense of their dominions. Displaying these pictures with the eleven portraits testified to the permanence of the mission, which was handed on from one generation to the next.

The remaining six pictures in the bedroom constituted a medley of subjects that neither portrayed the royal family nor referred

directly to Habsburg power or Spanish kingship: Titian's *Venus Looking at a Mirror Held by Cupid;* two paintings, of *Moses and Aaron in the Desert* and *Shepherds,* by one of the Bassani; a *Saint George and Saint Margaret* by a monk from the chapter at the royal monastery of El Escorial; and two paintings of festoons of fruit and flowers, one by Van der Hamen, and one by Rubens and Frans Snyders. Four of these subjects can be interpreted in ways relating them to the decorative program described thus far. The *Moses and Aaron,* which depicted the spiritual and secular leaders of the Jews during the Exodus, could have been understood as an Old Testament model for the Spanish Habsburgs, who saw their spiritual and secular duties as intertwined. As for the *Saint George and Saint Margaret,* the two saints' legends held that each had overcome a dragon, which was a conventional symbol of sin and heresy. Accordingly, their presence could have referred to the Spanish Habsburgs' determination to put down Protestant heresy within their dominions. The two festoons of fruit and flowers could have been viewed as decorations hung to celebrate the triumph of Habsburg power and piety referred to by other paintings in the room.

It is on turning to the *Venus* and the *Shepherds* that this effort

56 Peter Paul Rubens and Jan Wildens, *The Act of Devotion of Rudolf I* (Madrid, Museo del Prado, all rights reserved).

to analyze the decoration of the bedroom encounters the difficulty that is the bane of students of palace decoration as it was practiced under Philip IV. Time and again, the inventories of the king's art collection describe ensembles of paintings in which a majority of pictures conforms to some organizing principle governing their selection (shared traits of authorship, national school, or genre; or a program of meaning expressed by the combination of themes illustrated in the individual pictures), but a minority of pictures does not. Such flaws in otherwise unified ensembles resulted from the improvisational manner in which Philip's royal dwellings were usually decorated. Seldom was the adornment of a royal chamber conceived and carried out in a single, unified campaign of work. More often, an ensemble evolved over an extended period, possibly years in duration, during which the desire to express a programmatic idea might be only one of the criteria governing the choice of works. Other considerations – such as the king's desire to see his favorite works displayed prominently, the unexpected acquisition of paintings by gift or by their chance availability on the art market, and the mechanical need to fill empty wall spaces with pictures of matching proportions – could result in the introduction of one or more pictures into an ensemble even though their subjects did not fit the selective principle that con-

57 Titian, *Religion Aided by Spain* (Madrid, Museo del Prado, all rights reserved).

121

trolled the majority of paintings in the room. For that reason, an apparent inconsistency in an ensemble need not necessarily mean that the greater part of the ensemble was not informed by a program.[36]

It is possible to conceive of symbolic associations that would incorporate the *Shepherds* and the *Venus* into the 1636 program of the summer bedroom. The *Shepherds* could be explained as an allusion to the king's responsibility for his subjects, implying that he would tend to their well-being as a shepherd tends to his flock. Titian's painting of the goddess of love could be justified as a reference to the harmony that would result from benevolent Habsburg rule; it might also be taken as a comment on the marital love between the Habsburg rulers and their spouses who were depicted in some of the portraits elsewhere in the room. Nevertheless, such arguments are too forced to be persuasive, and the inclusion of those pictures can be accounted for on other grounds. Because Titian was one of Philip's favorite painters, the king may have had the *Venus* installed in the chamber simply for the aesthetic pleasure it gave him. If, as the inventory suggests, the goddess was shown at her morning toilette, then the painting illustrated an appropriate subject for a bedroom. The inventory also identifies the *Moses and Aaron* and the *Shepherds* as gifts for

58 Copy after Jusepe de Ribera, *Fable of Bacchus* (New York, private collection).

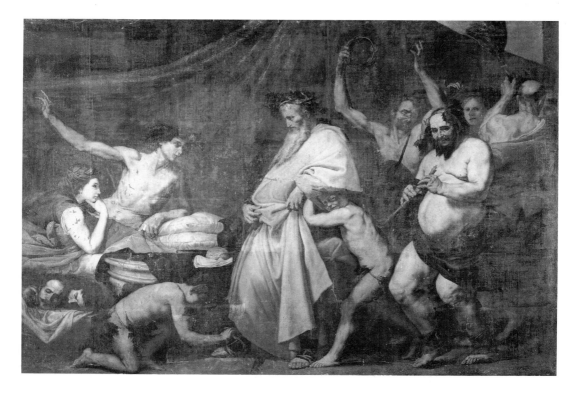

the decoration of the chamber from the duke of Medina de las Torres. Because they were gifts, the king may have been reluctant to separate them, even at the cost of introducing an irrelevant subject into the decorative program.

When the compilers of the 1636 inventory came upon Velázquez's painting, they listed it as a canvas "in which is Bacchus seated on a cask, crowning a drunkard. There are other figures who accompany him on their knees, another behind with a bowl in his hand, and another who is going to take off or put on his hat."[37] This description, which assigns no symbolic or narrative meaning to the picture, does not necessarily invalidate the hypothesis advanced in this chapter; rather, it underscores the recondite nature of Velázquez's invention. In the absence of any tradition of works depicting Bacchus's conquests in Iberia, the subject was not likely to be discerned by the men whose immediate concern was listing several hundred of the king's pictures. Their lack of comprehension raises the question of what impact, if any, the *Bacchus in Iberia* had beyond the immediate outcome of pleasing the king. Apparently, its influence was minimal.

One of the few other Spanish pictures from Philip's reign that may have alluded to Bacchus as ruler of Spain was the so-called *Fable of Bacchus* painted in Naples by Jusepe de Ribera.[38] It was

59 Anonymous, *Bacchus Visits the Poet Icarius* (Avery Architectural and Fine Arts Library, Columbia University in the City of New York).

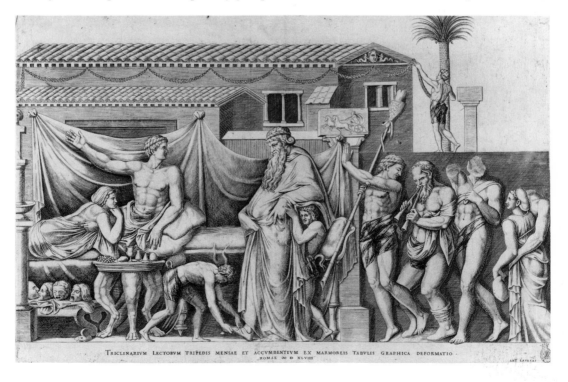

TRICLINARIVM LECTORVM TRIPEDIS MENSAE ET ACCVMBENTIVM EX MARMOREIS TABVLIS GRAPHICA DEFORMATIO · ROMAE ꝏ Ɔ XLVIII

badly damaged in the 1734 fire that destroyed the Alcázar of Madrid, and only three fragments of it are known; however, an anonymous copy records its overall appearance (fig. 58). Ribera's immediate source for his painting was an anonymous sixteenth-century engraving that was derived in turn from Hellenistic reliefs depicting Bacchus's visit to the dramatic poet Icarius of Athens (fig. 59).[39] It shows Icarius reclining on a triclinium, with a woman at his side and with theatrical masks lying on the ground below. The poet raises his right arm to welcome Bacchus, who is characterized as an elderly, bearded deity rather than as a clean-shaven youth. His retinue includes two small satyrs who attend upon him (one removes his sandals while the other supports him from behind) and three bigger satyrs who dance to music that Bacchus's best-known follower, Silenus, plays upon a flute. One of the latter satyrs holds a maenad who carries a bundle. Ribera reworked the engraving into a more compact design with more realistic and more animated figures. The three surviving fragments of his original depict Icarius's female companion (fig. 60), Bacchus (fig. 61), and Silenus (fig. 62).[40]

Ribera's painting was first documented in 1666, when it was listed in an inventory of the king's art collection in the Alcázar of Madrid as "a fable of Bacchus," with no further explanation of its subject.[41] The circumstances under which the picture traveled from Naples to Madrid are not recorded, but most likely its transfer was arranged by one of the viceroys whom Philip had sent to govern the kingdom of Naples in his place. The viceroys were Ribera's most important patrons, and it was through their agency that many of his works made their way to Spain.[42] Most likely one of them commissioned the *Fable of Bacchus* from Ribera and later gave it to the king. The implications of that are intriguing. Because there is no detailed record of what seventeenth-century viewers thought Ribera's subject represented, we cannot rule out the possibility that it was understood to depict Bacchus in Iberia, and that Icarius was taken to be Pan or Luso. If the picture was viewed in that light and it became a viceregal gift to Philip IV, it would have conveyed the message that just as Bacchus could rely upon Pan and Luso to govern his realms in his absence, so the king could rely upon his viceroy.[43]

The most likely candidate to have made such a gift was Fernando Enríquez Afán de Ribera, third duke of Alcalá, who became viceroy of Naples in 1629.[44] Previously he had represented the crown as viceroy of Catalonia (1618–22) and as an extraordinary ambassador to the Holy See (1625–26). The duke's Neapolitan appointment ended abruptly in 1631 when he was suspended from office and recalled to Madrid to answer charges

of misconduct that an enemy, the duke of Alba, had orchestrated against him. Alcalá defended his performance and eventually obtained a royal pardon. He was later named viceroy of Sicily (1632–35), and when he died in Villach in 1637, he was awaiting the start of the Council of Cologne, at which he was to represent the

60 Jusepe de Ribera, *A Woman* (Madrid, Museo del Prado, all rights reserved).

61 Jusepe de Ribera, *Bacchus* (Madrid, Museo del Prado, all rights reserved).

62 Jusepe de Ribera, *Silenus* (New York, private collection).

king once again. At some point in this career Alcalá may have given Ribera's *Fable* to the king as a reminder of his services.[45] Its composition (as recorded in the anonymous copy) and its surviving fragments are generally regarded as consistent with Ribera's style during the duke's residency in Naples.[46] Of course, Alcalá could also have commissioned the work from Ribera sometime thereafter.[47]

The case for assigning the *Fable of Bacchus* to Alcalá's patronage is not confined to his political activities. He also took part in Pacheco's academy in Seville, which put him in direct contact with a circle of artists and scholars who were familiar with the Bacchic conquest of Iberia.[48] An amateur painter and an enthusiastic art collector, it was he who commissioned Pacheco to create an ensemble of allegorical ceiling paintings for the study in the Casa de Pilatos (among which was fig. 39).[49] Most important, he was intimately familiar with the type of composition on which Ribera's *Fable* was based because he owned an Icarius relief.[50] When Velázquez visited Naples in 1631, he could have described his *Bacchus in Iberia* to the duke; if he did so, he might thereby have reminded the duke of the potential connection between the relief and the Bacchic conquest of Iberia.[51]

The next most likely candidate to have commissioned the *Fable* is Alcalá's successor as viceroy of Naples, Manuel de Acevedo y Zúñiga, sixth count of Monterrey, who held that office from 1631 to 1637 and who became Ribera's greatest patron.[52] As Olivares's brother-in-law, he had ties to the circle of courtiers most likely to have learned the meaning of Velázquez's *Bacchus in Iberia*. In fact, Velázquez himself could have told Monterrey about it in Rome in 1630, when the artist met with the count while the latter was Spanish ambassador to the Holy See.[53] All things considered, however, the evidence for Alcalá's having commissioned the *Fable* – in particular, his owning an Icarius relief – is more compelling than the evidence for Monterrey's having done so.[54]

The 1666 inventory of the Alcázar lists the *Fable of Bacchus* as the second of sixteen pictures hanging in the dining room of the king's summer apartments. (See Appendix C for the inventory text.) The first to be cited is another mythological subject of comparable size, Massimo Stanzione's *Sacrifice to Bacchus* (fig. 63), which the inventory identifies as a "Triumph of Bacchus." This may have been one of a group of Italian paintings illustrating ancient life that were commissioned for the Palace of the Buen Retiro in the 1630s and 1640s.[55] The fact that it was later placed in close proximity to Ribera's *Fable* raises the possibility that it was taken to illustrate the revelry of Bacchus's Iberian followers.[56]

If that were the case, however, the references to the Iberian Bacchus in the two pictures would have been obscured by the main theme governing the decoration of the dining room. The third and fourth pictures listed there by the 1666 inventory are equestrian portraits, Rubens's *Cardinal-Infante Ferdinand at the Battle of Nördlingen* and Sébastien Bourdon's *Queen Christina of Sweden*. Two others are mythologies, an anonymous *Orpheus* and a *Ceres and Pan* by Rubens and Frans Snyders. The remaining ten pictures are listed as Flemish hunting scenes, animal pieces, and still lifes, three of which the inventory assigns to Snyders and the rest of which it leaves unattributed; two of these last have been identified as works by Juan van der Hamen y León. The primary theme informing the ensemble seems to have been the bounty of the earth, over which deities like Bacchus, Ceres, and Pan exerted a nurturing influence. By this reading, the two equestrian portraits were exceptions to the scheme – another consequence of the improvisational manner in which decorative ensembles in the Alcázar were assembled. The inventory does not identify the precise subject of the *Orpheus*, but if it depicted him calming wild beasts with his music, the variety of animals customarily shown at that event would also have fit the theme of earthly abundance. In such a context, any sense that Ribera's *Fable* and Stanzione's *Sacrifice* referred to the Iberian Bacchus might soon have been forgotten.

63 Massimo Stanzione, *A Sacrifice to Bacchus* (Madrid, Museo del Prado, all rights reserved).

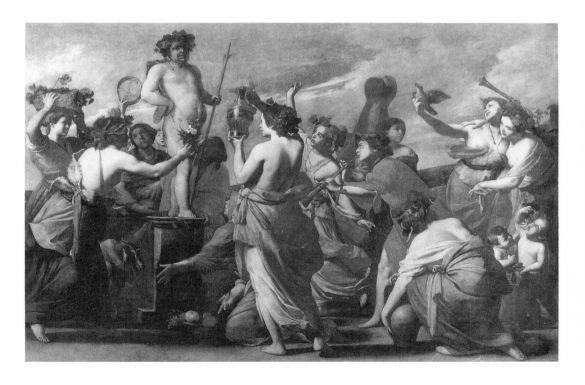

127

One other painting from this period may have alluded to the Bacchic conquest of Iberia. When Philip IV's second wife, Mariana of Austria, first entered Madrid in 1649, she proceeded along a parade route that had been adorned with elaborate temporary constructions, among which were four triumphal arches decorated according to a program that related them to the continents of Europe, Asia, Africa, and America.[57] One of the paintings adorning the arch dedicated to America represented *Columbus Before Ferdinand the Catholic;* it has not survived, but its appearance is known from a preparatory drawing by Francisco Rizi (fig. 64) and from a contemporary account of the queen's entry.[58] The picture showed Columbus kneeling before Ferdinand II of Aragon, who sat enthroned beneath a dossel. With one hand the explorer indicated globes, nautical instruments, and sea charts, signifying his discovery of the Indies; with the other he held keys and letters of credence, signifying that the newly discovered realms were now part of the king's dominions. Behind Columbus stood Hercules and Bacchus, "celebrated in Antiquity as *Conquerors* of New Lands and Provinces," looking on in admiration of an achievement that had surpassed their own deeds.[59] Opposite them a woman in Indian costume who personified Santa Fe (the capital of New Granada) offered emeralds to the king. Beyond these figures lay a vast ocean with islands and promontories.

It has been suggested that this pairing of Hercules and Bacchus referred to them both as former conquerors of Spain.[60] That is certainly possible — euhemerist historians held that a hero named Hercules, as well as one named Bacchus, had visited Iberia and had founded cities there[61] — but the matter is open to question. Because the arch was devoted to America, not Europe, the pair may have been meant to evoke other associations. To reach the New World, Columbus had to sail beyond the Pillars of Hercules (that is, beyond the Strait of Gibraltar), and his discovery of the West Indies (*las Indias Occidentales*) may have called to mind Bacchus's conquest of India, not Iberia.[62]

Thus, *Bacchus in Iberia* seems to have inspired little, if anything, in the way of a new iconographic convention that used Bacchus as a metaphor for the kingship of Spain. Ironically, by having Velázquez's painting hung in his summer bedroom, Philip may have ensured that its distinctive subject would be forgotten because the royal bedchamber would have been one of the least accessible rooms in the palace. As a result, it would have been difficult for other painters to acquire sufficient familiarity with the picture to inspire their own interpretations of the tradition that it depicted. In like fashion, the circle of connoisseurs who understood its meaning need not have become very large.

Furthermore, any effort to establish an iconography of Bacchus as a forerunner of the kings of Spain had to contend with the potent rivalry of Hercules, who, as just remarked, had also been identified as a former ruler in Iberia. Using Hercules as a metaphor for Habsburg virtue was an established practice at the Spanish court well before Velázquez undertook *Bacchus in Iberia,* and whatever the success that his painting enjoyed, it was not enough to supplant the earlier tradition.[63] It is telling that in 1634, when scenes depicting a mythological analogue of the Habsburgs were needed for the decoration of the Hall of Realms, the crown commissioned ten pictures of Hercules, not Bacchus (among them, see figs. 52 and 53).[64]

The preference for Hercules resulted from more than the inertia of tradition. Although Bacchus's gift of wine could signify his benevolence toward mankind, it also associated him with drunkenness and gross indulgence, which surely worked to his disadvantage. Hercules, who was widely regarded as the classical paragon of heroic virtue, was less encumbered by negative associations.[65] In addition, the myths of Hercules seem to have been more familiar to seventeenth-century audiences than those of Bacchus, which suggests that a wider public would have respon-

64 Francisco Rizi, *Columbus Before Ferdinand the Catholic* (Courtesy of the Biblioteca Nacional, Madrid).

ded to his use as a metaphor of Habsburg virtue.[66] (No ten Bacchic themes would have been as readily identifiable as the ten deeds of Hercules that were selected for the Hall of Realms.) Even when Hercules and Bacchus appeared side by side in the *Columbus Before Ferdinand the Catholic* at Mariana of Austria's entry into Madrid (fig. 64), Hercules enjoyed the more prominent place.

It may also have discouraged others from imitating *Bacchus in Iberia* that Velázquez painted it in a style he soon put behind him. Had he died shortly after completing it, the picture would be regarded as one of the boldest undertakings of an abbreviated career, but viewed in comparison to the paintings he went on to create, it is a flawed work, not a product of his artistic maturity. Its composition is cramped, its space is shallow, its coloring is limited, and its brushwork is labored. In the 1620s Velázquez's facility at rendering human anatomy was limited, and in *Bacchus in Iberia* he resorted to covering several of his characters with bulky garments and to concealing the lower half of the scantily clad figure behind Bacchus from view. It is a testimony to the power of his early realism that the exuberance of the peasants has nonetheless sufficed to make the picture one of his most beloved works.

At odds with Velázquez's attempt to bring this unusual theme to life was a reductive tendency in his art – that is, a predilection for expressing a subject with a suppression of movement and a minimum of embellishing details. To gauge this tendency, we can compare another of his early narrative pictures, the *Adoration of the Magi* of 1619 (see fig. 32 and plate 4), to Maino's version of that subject from 1613 (see fig. 35 and plate 5). Maino conceives of the Magi's arrival at the stable in Bethlehem as a spectacle of joyful celebration. The three kings wear elaborate, brilliantly colored outfits of sumptuous fabrics. As they crowd about the Christ Child, they present Him their gifts of gold, myrrh, and frankincense in precious containers – two elegant, golden urns and a gilded nautilus-shell cup. The kings are attended by two servants, one of whom points out what is happening to other, unseen figures located outside the picture space, implying that there is more to the Magi's retinue. The stable is a massive edifice whose stonework rises to an arch that spans the width of the picture. Through that arch shines a beam of light from the miraculous star that has guided the Magi to their destination.

Velázquez, on the other hand, presents the event as a quiet moment of solemn reverence. His more rigid Magi, on whom a single servant attends, do not crowd about the Child; instead, they pay Him reverence from a respectful distance. They are dressed

in simpler, more plainly colored costumes; even the golden vessels containing their gifts are more modest in design. The stable is reduced to a silhouette of masonry that is distinguished from the rear landscape with difficulty. No miraculous star shines overhead; rather, the ordinary first light of day breaks on the distant horizon. The only overt indication that an event of transcendental significance is taking place is the faint nimbus of light along the crown of the Child's head, a detail that is easily overlooked. Where Maino is ostentatious, Velázquez is subdued.[67]

Notwithstanding its reductive character, Velázquez's picture is easily identified as an *Adoration of the Magi* because it incorporates enough features that are customary in representations of the subject to facilitate its recognition. The overall division of the composition – with one side occupied by the newly arrived Magi dropping to their knees and the other side occupied by the Holy Family in an architectural setting – conforms to a well-established formula for depicting the theme. So, too, does the characterization of two kings as Caucasians and one as an African. Moreover, even though the Magi are dressed simply, they can be distinguished from their servant by the gifts they carry. Although no miraculous star is present, the fact that they have reached their destination at daybreak implies that they have traveled by night, when the star would have been visible. That the object of their veneration is a newborn child wrapped in swaddling clothes identifies Him as the Christ Child, as does the discreet nimbus of His divinity.

Although Velázquez strove for simplicity in the *Adoration of the Magi,* he remained faithful to essential conventions governing depictions of its subject. In the *Bacchus in Iberia,* however, he attempted to illustrate a subject for which there was no pictorial tradition. This required him to tell his story with particular clarity so that it might be understood in spite of its novelty. Instead, his reductive tendency worked to minimize the signs by which a viewer might identify his theme, and the story came out muddled. To begin with, there is no sense of place to the picture – that is, there is no indication where the landscape in which Bacchus's company has gathered is found. Had Velázquez incorporated a more specific reference to where the action was located (be it a symbolic device or a literal rendering of a familiar landmark), it would have signaled the Iberian significance of the subject more clearly. Similarly, the naturalism of the picture invites confusion over whether it is set in antiquity, as the presence of Bacchus suggests, or in the seventeenth century, as the appearance of the peasants suggests. In his desire to render a history painting in a markedly realistic idiom, Velázquez deprived his figures of the

classical form that in more conventional, idealized representations of mythology indicated that what was depicted took place in antiquity. This novel realism gave Bacchus's companions their distinctive, hearty character, but it eventually led Mengs and others to conclude that the central figure was a "feigned Bacchus," rather than the god himself. Finally, the interplay among the figures in the *Bacchus* does not coalesce into a dramatic unity that is easily grasped. The central motif of the composition is Bacchus crowning one of his companions, but by showing the god looking off to the side as he awards the prize, Velázquez diminishes the import of his action. The two men who grin broadly at the viewer (see fig. 4) are engaging presences, but their apparent lack of interest in the crowning likewise undermines the viewer's sense of its importance. The wildly diverse explanations that have been advanced to account for the action in the picture are the direct consequence of Velázquez's failure to fuse his characters into a cohesive ensemble.

It was to overcome his limitations as a painter that Velázquez made his first trip to Italy (1629–31), where he sought to improve his art through study and practice.[68] His success is apparent in his second mythological subject, the *Forge of Vulcan* (fig. 65, plate 8). Painted before he returned to Spain, it depicts the dramatic moment when Apollo visits Vulcan at his forge and informs him that his wife, Venus, has cuckolded him by engaging in an illicit affair with Mars. While Vulcan reacts angrily to the unwelcome news, the Cyclopes who assist him pause from their labors to follow the conversation. Like the *Bacchus in Iberia,* this painting is based upon an engraving, the *Forge of Vulcan* from Antonio Tempesta's series of prints illustrating Ovid's *Metamorphoses* (fig. 66).[69] This time, however, Velázquez remained more faithful to his visual source. Although he reversed the sequence of figures from left to right, Velázquez preserved the essential arrangement of Apollo at one side, a Cyclops at the other, and Vulcan in the middle. He also retained, and elaborated upon, the basic elements of the setting: the hearth with its glowing fire; the anvil, tools, and strip of metal with which Vulcan works; the mallet carried by the Cyclops closest to Vulcan; and the pieces of armor lying on the shop floor.

This close dependence on his model suggests that Velázquez undertook the picture primarily as an exercise in perfecting his skills. In that, he succeeded, for the *Forge of Vulcan* is executed far more proficiently than the *Bacchus in Iberia.* Its composition is more open, its illusion of depth is more convincing, its brushwork is thinner and freer, and the anatomical definition of its figures is more assured. As in the *Bacchus,* earth tones dominate the color

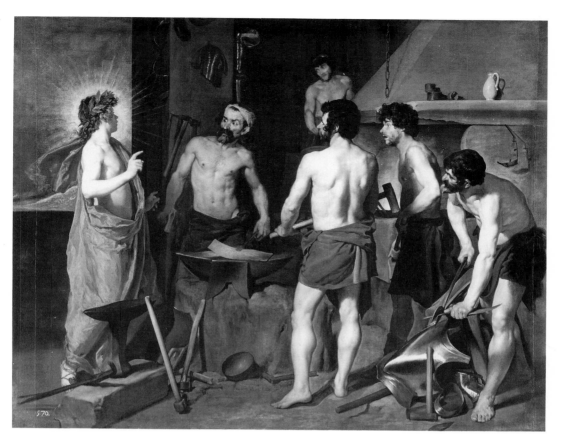

65 Diego de Velázquez, *The Forge of Vulcan* (Madrid, Museo del Prado, all rights reserved).

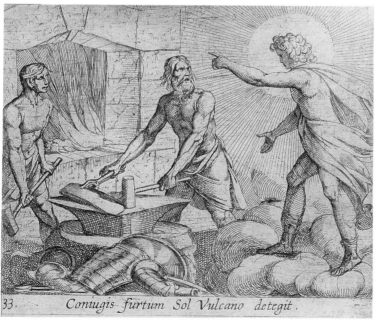

33. *Coniugis furtum Sol Vulcano detegit.*

66 Antonio Tempesta, *The Forge of Vulcan* (New York, The Metropolitan Museum of Art, Gift of S. P. Jones, 1935 [33.6 (leaf 33)]).

scheme, but Apollo's glistening orange robe and blue-green sandals show that Velázquez has expanded the range of his palette. Passages such as Apollo's solar nimbus, the reflection of a red-hot sheet of metal on the polished surface of an anvil, the glow of the flames in the forge, and the play of shadow over the Cyclops in the background reveal an increased capacity to render subtle effects of light.

Along with his new mastery of technique, Velázquez enhanced his prowess as a narrator. Compared to the *Bacchus in Iberia,* the *Forge of Vulcan* is a more eloquent piece of storytelling. The interplay of gesture, pose, and facial expression among its characters is so carefully articulated that even a viewer who was ignorant of Greco-Roman mythology would grasp the essential nature of the action: The young man at the left (Apollo) says something that enrages the man in the middle (Vulcan) while the others present (the Cyclopes) pause and listen attentively. This clarity of action is reinforced by a specificity of place, for Velázquez's figures are now gathered in what is indisputably a blacksmith's workshop.

Although his studies in Italy helped Velázquez develop his narrative technique, it did not deter him from rendering a mythological subject in a naturalistic idiom. Velázquez's Apollo has the god's conventional attributes of a solar nimbus and a laurel garland, but Velázquez has subtly altered Tempesta's conception of him. Tempesta perches Apollo miraculously on a cloud, but Velázquez plants him solidly on the ground. Moreover, whereas Tempesta's Apollo reveals Venus's betrayal of her husband with outflung arms, Velázquez mutes Apollo's gesture to a prim bit of finger-pointing – a change that heightens the contrast between Apollo's boyishness and Vulcan's grizzled maturity. Velázquez likewise alters Vulcan from his engraved prototype by giving him a leaner, less heroic physique, albeit one that retains the smith's muscularity. More important, Velázquez poses Vulcan more awkwardly by bending his torso so that his left shoulder drops. This is no accident, for technical examination of the canvas has revealed that Velázquez originally posed Vulcan in a more upright stance. His decision to alter the god's posture surely sprang from his awareness that according to ancient myth, Vulcan was lame.[70]

The distinctive realism found in the *Forge of Vulcan* is also brought out by comparing it to another work, a *Vulcan Forging Thunderbolts* that Rubens painted in the mid-1630s (fig. 67). Rubens, like Velázquez, characterizes the god as a rough, muscular blacksmith hard at work at his anvil. Unlike Velázquez, Rubens is fully committed to the classical tradition and its tendency to idealize the human form. As a consequence, Rubens gives Vulcan

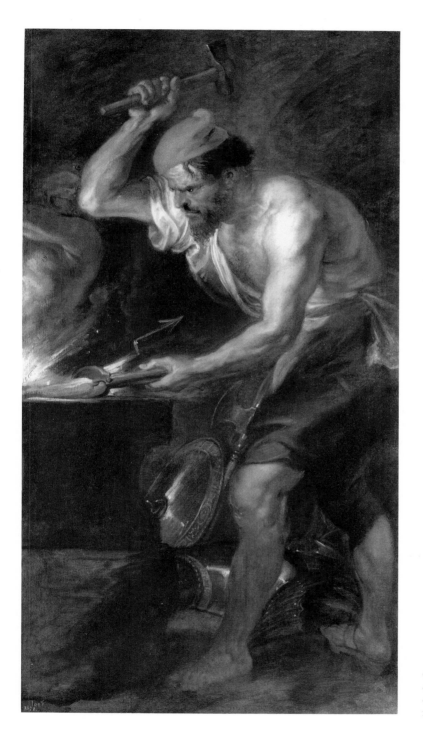

67 Peter Paul Rubens, *Vulcan Forging Thunderbolts* (Madrid, Museo del Prado, all rights reserved).

68 Diego de Velázquez,
Mars (Madrid, Museo del
Prado, all rights reserved).

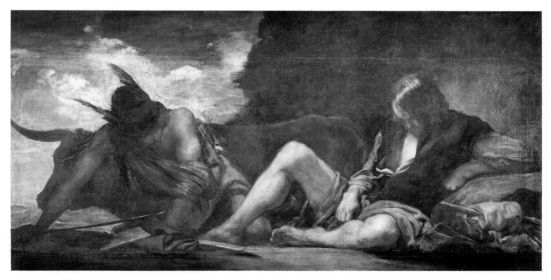

69 (*top*) Diego de Velázquez, *Venus and Cupid* (London, National Gallery).

70 (*bottom*) Diego de Velázquez, *Mercury and Argus* (Madrid, Museo del Prado, all rights reserved).

a more powerful frame and camouflages his deformity by permitting him to stand upright with the discreet aid of a corrective sandal that he wears on his right foot. Moreover, Rubens illustrates the miraculous quality of Vulcan's craftsmanship by showing him forging a thunderbolt, which is rendered symbolically as a glowing, zigzagging arrow. Velázquez, in contrast, follows Tempesta by showing Vulcan interrupted from hammering a glowing strip of ordinary metal, a choice that makes the object of the god's toil and sweat more mundane.

It is in the treatment of Vulcan's assistants that the difference in approach between the two artists is most evident. Rubens is more faithful to ancient mythology by showing Vulcan's lone assistant as a true Cyclops – that is, as a one-eyed creature. Although otherwise human in form, the Cyclops has a single eye in the center of his forehead; the sockets where eyes would appear are blank. Velázquez follows Tempesta's lead and gives Vulcan's assistants human likenesses; however, by showing the three most prominent of his four Cyclopes in profile, Velázquez preserves a sense of their monocular character.

With motifs like Vulcan's heroic build, the thunderbolt-in-the-making, and the one-eyed Cyclops, Rubens's glimpse into Vul-

71 Diego de Velázquez, *Fable of Arachne* (Madrid, Museo del Prado, all rights reserved).

can's workshop transports the viewer from mundane reality to the fantastic realm of the ancient gods. Such is the power of Rubens's art that he makes the fantastic credible. Velázquez, on the other hand, brings Vulcan and his assistants into the familiar world of the viewer by rendering them in a more naturalistic idiom. The crooked posture of Vulcan, the human aspect of the Cyclopes, and the still lifes of tools and armor that litter the shop floor – all these motifs anchor the god and his assistants in everyday reality. Only Apollo, the luminous figure who intrudes upon the scene, overtly introduces a sense of the divine. His solar nimbus, his garland, and his shimmering garment, which distinguish him from the scantily clad he-men who hang upon his words, are concessions to convention that characterize him unequivocably as god of the sun. These concessions are essential, for it is Apollo's recognizability that ensures that viewers will identify the subject of the picture without difficulty. Were Apollo to be trimmed from the canvas, the remaining fragment would pass for a genre painting.

That was the dilemma Velázquez faced whenever he turned to mythology: how to balance the demands of his reductive, realist impulse against the need to provide his viewers with appropriate

72 Detail of Figure 71.

means to identify a classical subject. The deftness he could bring to the task is evident in the next of his mythologies, *Mars* (fig. 68). In it, Velázquez returns to the tale of Venus's betrayal of Vulcan. After Vulcan learned of his wife's infidelity with Mars, he took his revenge by trapping the lovers *in flagrante delicto,* whereupon he exposed the mortified couple to the mockery of their fellow gods. Velázquez portrays Mars in the aftermath of his humiliation, sitting on the corner of an untidy bed, too stunned by what has happened to put his clothes back on and depart. The situation is comic, but Velázquez imparts a bittersweet edge to the story by giving Mars a melancholic expression that elicits sympathy. He has been brutally stripped of his dignity, and he has been denied the intimate companionship of the fairest of the goddesses. *Mars* is a devastating study of a male ego in collapse.

There was no pictorial precedent for illustrating the moment that Velázquez depicted in *Mars,* and as in the case of *Bacchus in Iberia,* later generations of viewers failed to recognize the precise subject of the painting. Indeed, the correct identification did not enter the literature on the artist until 1976.[71] Nevertheless, Velázquez cannot be faulted for the subtlety of his conception, for he provided adequate clues to his theme: The helmet Mars wears and the arms that litter the floor identify him as the god of war, his poignant expression conveys a sense of loss, and the rumpled bedclothes betray where that loss has occurred. The "fit" between Velázquez's image and the myth that it illustrates is much tighter for *Mars* than it is for *Bacchus in Iberia.* If later generations had difficulty recognizing what the *Mars* represented, the fault lay not in Velázquez's talent, but in the perspicacity of his audience.

Velázquez's other surviving mythologies show that he continued to seek an equilibrium between realism and narrative clarity in his later years.[72] The obvious relationship of his *Venus and Cupid* (fig. 69) to other renderings of "Venus Reclining" and "Venus at a Mirror" provides a basis for identifying his sensuous nude as the goddess of love and beauty; the wings he gives the child who supports the goddess's mirror characterize the tot as Cupid, Venus's son, which clinches the identification.[73] Similarly, the viewer who stands before *Mercury and Argus* (fig. 70) easily recognizes Mercury by his winged cap.[74] Mercury's sword and pipe, together with the presence of a cow in the background, suffice to identify the scene as the episode in which Mercury lulled the watchman Argus to sleep and beheaded him in order to rescue Io, who had been disguised as a heifer. Velázquez's reductive tendency is evident in his treatment of Argus, for whereas ancient myth held that the watchman possessed one hundred eyes, Velázquez gives him but two.

In what is by far the most complex of his mythological inventions, the *Fable of Arachne* (fig. 71), Velázquez returns to the unusual compositional format he employed years before in his *Christ in the House of Mary and Martha* (see fig. 37).[75] Once again the manifestation of a divinity among human beings (in this case, the goddess Minerva's tapestry-weaving contest with the mortal woman Arachne) is pushed into the background (fig. 72), while the foreground is dominated by ordinary persons (in this case, the women who spin and wind thread in Arachne's workshop). This was another of Velázquez's mythologies that later generations misunderstood. For many years it was known as *The Spinners* in the mistaken belief that it was a genre painting showing fashionable ladies visiting a tapestry works in order to view panels on display in the rear alcove. Yet, Velázquez has again provided the necessary clues to discerning the subject. Minerva, who gestures at the recoiling Arachne, can be identified by her armor, and the two competitors stand in front of a tapestry depicting the "Rape of Europa" (clearly copied from Titian's celebrated painting of the subject), which was one of the themes that Arachne wove during the contest.

Velázquez's six surviving mythologies are uniform neither in conception nor execution. His subjects range from the familiar to the innovative, and his compositions from the lucidly straightforward to the deceptively subtle. Velázquez explored the world of mythology sporadically, with the result that his pictures of such themes are highly individualized conceptions. *Bacchus in Iberia* was his first attempt at re-creating this world in the idiom of everyday reality. It revealed his potential as a narrator of myth, but it was the flawed work of a young artist whose ambition exceeded his proficiency. His subsequent studies in Italy enabled him to close that gap, with the happiest of results – the select group of later mythologies that number among the most sophisticated of his paintings.

EPILOGUE

ALTHOUGH VELÁZQUEZ had established himself as Philip IV's principal painter by the end of the 1620s, echoes of the artistic competitions in which he had been embroiled continued to be heard in the years that followed. In particular, the old rivalries manifested themselves in 1634 and 1635, when the Hall of Realms in the Palace of the Buen Retiro was decorated with an ensemble of paintings meant to celebrate the glory of Philip IV's regime and the success of the policies advocated by the count-duke of Olivares.[1] The hall took its name from a ceiling fresco that incorporated the coats of arms of the principal realms of the Spanish empire; more important, however, were three sets of canvases that adorned its walls. These comprised five equestrian portraits of Spanish Habsburgs by Velázquez and his assistants, ten paintings of deeds of Hercules (an analogue of the heroic virtue of the Habsburg kings) by Francisco de Zurbarán, and twelve pictures commissioned from eight artists that depicted military victories Philip's troops had won during the early years of his reign. Three men are likely to have overseen the conception and execution of the program: Olivares, who was the driving force behind the construction of the Buen Retiro; his librarian, Francisco de Rioja, who had the intellectual background necessary for the formulation of the program; and Velázquez, who provided the practical skill necessary for coordinating the work of the participating artists.

It was in the creation and installation of the battle paintings that artistic rivalries reasserted themselves. The commissions for the twelve pictures were divided among Eugenio Cajés, Vicente Carducho, Félix Castelo, Jusepe Leonardo, Juan Bautista Maino, Antonio de Pereda, Velázquez, and Zurbarán. These works lined the north and south walls of the hall at regular intervals, separated from each other by intervening windows. (Figure 73 indicates their subjects and positions relative to one another.) The organizing principle that determined the arrangement of

the battle scenes has long defied analysis. They were not positioned according to the chronological sequence of the events that they depicted; nor were they organized by geographic regions; nor were they placed so that the victorious commanders they depicted were related consistently to the equestrian portraits of the Habsburgs on the end walls of the room. When their placement is considered with regard to the identities of their makers, however, the basis of their arrangement becomes clear. The division of the paintings reflected the division of the court artists into opposing factions.

The six battle paintings on the south wall were the work of the conservative "old guard." Three were assigned to Carducho and two to Cajés – the two painters whose rivalry with Velázquez and whose decline in standing in the 1620s are described at length in Chapter 2. Cajés died before finishing his pictures, which were completed by his assistants Luis Fernández and Antonio Puga.[2] The sixth picture was Castelo's *Recapture of St. Christopher,* which is very much in the spirit of Carducho's and Cajés's works. Castelo's art, like that of Carducho and Cajés, was rooted in the early reform of mannerism that had been introduced into Spain by Italian painters who had worked at El Escorial for Philip II.[3] Moreover, Castelo was tied to Carducho professionally. A contemporary source, the painter Jusepe Martínez, characterizes Castelo as the oldest of Carducho's disciples and asserts that some

Franscisco de Zurbarán *Defense of Cádiz*	Eugenio Cajés and assistants *Capture of St. Martin*
Juan Bautista Maino *Recapture of Bahía*	Vicente Carducho *Battle of Fleurus*
Jusepe Leonardo *Surrender of Jülich*	Vicente Carducho *Relief of Constance*
Diego de Velázquez *Surrender of Breda*	Vicente Carducho *Siege of Rheinfelden*
Antonio de Pereda *Relief of Genoa*	Eugenio Cajés and assistants *Recapture of Puerto Rico*
Jusepe Leonardo *Relief of Breisach*	Félix Castelo *Recapture of St. Christopher*

73 The Arrangement of Battle Paintings in the Hall of Realms.

of his paintings were mistaken for Carducho's work.[4] As we have seen, when Carducho, Cajés, and Velázquez had to evaluate candidates for the position of painter to the king that had been left vacant by Bartolomé González's death in 1627, Carducho and Cajés ranked Castelo second, but Velázquez ranked him third.[5] Years later, when a price for Carducho's *Scipio Addressing the Romans* was finally determined in 1641, Carducho's heirs chose Castelo to represent them at the appraisal.[6]

The five painters whose works were displayed on the north wall constituted a "new guard" who, to varying degrees, were disposed toward a more vigorous naturalism than their counterparts across the room. They also benefited from well-placed connections at the court because four of the five were associated with Olivares and his circle. As we have seen, Velázquez had been a prime beneficiary of the "Sevillian connection" that the count-duke had used to bring men of talent to the court, and Maino had been one of the two judges who had named Velázquez the winner in the "Expulsion of the Moriscos" competition of 1627.[7] Antonio de Pereda was associated with this group through his patron, Giovanni Battista Crescenzi, marquis of la Torre, the other judge in the "Moriscos" competition and one of Olivares's creatures.[8] (It was to the count-duke, for example, that Crescenzi owed his appointment as architect of the Buen Retiro.) Pereda's battle scene, *The Relief of Genoa,* is especially striking for its rich coloring and its naturalistic observation of surface patterns and textures.

Another beneficiary of the "Sevillian connection" was Zurbarán, who had been summoned to Madrid to participate in the decoration of the hall. Olivares may have hoped that Zurbarán, the leading painter in Seville, would establish himself as a formidable new talent at the court, but if so, his paintings failed to meet such expectations. His *Defense of Cádiz* is static − it is the least accomplished of the battle paintings that hung on the north wall − and his Hercules series falls short of the standard set for mythological painting by Rubens, who by the mid-1630s had become one of the king's favorite painters. If Zurbarán's contributions to the ensemble were considered disappointing, that reaction would account for his prompt return to Seville.[9]

The fifth painter represented on the north wall, Jusepe Leonardo, occupies a middle ground between Velázquez and his conservative rivals. On the one hand, his style appears to be rooted in the examples of Carducho and Cajés, as is evident from the marked compositional similarities between his *Surrender of Jülich* and *Relief of Breisach,* and the battle pictures that hung on the south wall. On the other hand, his two pictures possess a vivacity of

coloring that has generally been taken to reflect the influence of Velázquez. It is tempting to speculate that Leonardo was moving from one artistic camp to another, but the paucity of securely dated, surviving works from his hand that postdate the *Jülich* and *Breisach* makes this difficult to prove. He is known to have received royal commissions after 1635, which indicates that he found at least some favor with the king and his ministers; on the other hand, when he asked to be made a painter to the king in 1638 (following the death of Carducho), his request was apparently rejected.[10]

As a consequence of the way in which the battle pictures were arranged, the six paintings by the "new guard" were shown to better advantage than those by the "old guard." Arrayed along the north side of the room, the favored canvases would have been illuminated brilliantly by the sunlight pouring through the windows in the south wall. In contrast, the paintings by the "old guard" would have been viewed against the glare of that light. If it was Velázquez who assigned those works to the south wall, then once again he put his rivals at a disadvantage.

It is also possible that echoes of the factionalism of the 1620s were heard in the 1640s in Velázquez's dealings with the architect Juan Gómez de Mora, master-in-chief of the royal works.[11] Like Carducho and Cajés, Gómez de Mora had come to prominence under Philip III, and like them, he had experienced setbacks to his career under Philip IV. In particular, he seems to have run afoul of Olivares, who saw to it that he was excluded from participation in the construction of the Buen Retiro. Gómez de Mora's career as a royal architect suffered from that and from other moves against him, and it was not until Olivares had fallen from power in 1643 that Gómez de Mora's standing was fully restored.[12] If Gómez de Mora regarded Olivares and his circle as enemies, that might account for evidence of hostility between him and Velázquez.

Following the deaths of Philip's first wife, Isabella of Bourbon, and his son, Prince Baltasar Carlos, respectively in 1644 and 1646, Gómez de Mora designed the temporary decorations that were erected in the church of San Jerónimo in Madrid for the royal exequies that were celebrated in memory of the deceased.[13] On each occasion, Gómez de Mora oversaw a team of artists and craftsmen who raced to complete the ensembles that were required for the rites as soon as possible. In neither case, however, did Velázquez participate in the effort; instead, lesser talents carried out the necessary painting.[14] Work of that sort was not necessarily beneath Velázquez's office, for in 1621, many of the paintings on view amid the decorations that Gó-

mez de Mora had designed for the royal exequies for Philip III had been carried out by two painters to the king, Carducho and Cajés.[15] Thus, it is possible that Gómez de Mora deliberately excluded Velázquez from his decorative teams in 1644 and 1646 out of personal hostility. Of course, the explanation could be more mundane – for example, Velázquez may have refrained from participating because the need to make decorations quickly was antithetical to his manner of painting. That would entail a marked change in an artist who had won his initial court appointment on the basis of a swiftly painted portrait, but there is evidence that by the 1640s Velázquez's technique had become slow and deliberate.[16]

In addition, Gómez de Mora and Velázquez are known to have quarreled over another royal project, the renovation of some rooms in the Alcázar of Madrid, in 1645.[17] When a problem developed on which the two could not agree, the superintendant of the palace works, the Marquis of Malpica, had to refer the matter to the king for resolution. (Philip responded by ordering the implementation of a solution that a third party had devised.) Here, too, it is possible that the tension between Velázquez and Gómez de Mora was rooted in previous infighting at the court, but as with the royal exequies, too little is known to admit a definite conclusion.

And what became of *Bacchus in Iberia?* When the royal art collection in the Alcázar of Madrid was inventoried in 1666, the picture was no longer on view in the king's summer bedroom. By then it had been transferred to the North Gallery on the main floor of the palace (see fig. 23, room 20). The shift was probably effected soon after 16 October 1652, when all the paintings in the gallery were removed, most likely as a prelude to redecorating the space.[18] In 1666 the *Bacchus* was one of fifty-eight paintings on view there. (See Appendix D for the inventory text.) Besides Velázquez, other masters represented on the walls included El Greco, Tintoretto, Mor, Rubens, Snyders, Jan Brueghel, Annibale Carracci, Guido Reni, and Viviano Codazzi.[19] Most of the fifty-eight subjects can be assigned to subsidiary groups – portraits and other single figures, landscapes, mythologies, scenes of Flemish life, and views of papal ceremonies, leaving only a few miscellaneous pieces. Within these groups, however, no consistency of size or hand is apparent.

The gallery also contained six porphyry tables with carved wooden legs, eight marble medallions on wooden bases, and five plaster statues. The statues were acquired for the king by Velázquez during his second trip to Italy (1649–51), and Palomino later

described one of them, a *Bacchus,* as "young, nude, leaning on a tree trunk, where he has his robe; he has his right arm raised and a cluster of grapes in his hand."[20] Its presence could have reinforced the god's role as wine-giver in the *Bacchus in Iberia,* but the inventory gives no indication whether the statue was placed near the painting.

As a group, the paintings and sculptures do not seem to have been chosen to fit any program, and the sequence in which the inventory lists them suggests no ordering principle that might have governed their arrangement. In other words, the ensemble provided no context to clarify the meaning of Velázquez's painting. That, too, would have contributed to its failure to inspire other treatments of its unusual subject.

The person who was most likely to have arranged for the picture to be brought to the North Gallery was none other than Velázquez himself. Beginning in the mid-1640s, he had become increasingly involved in administering the decoration of the Alcázar.[21] Acquiring sculptures for the palace on his second trip to Italy was one aspect of that activity. Another was his appointment on 8 March 1652 as *aposentador de palacio,* which placed him in charge of the *furriera,* the bureau that maintained the Alcázar's furnishings.[22] Around that time he also assumed responsibility for the display of the king's art collection.[23] Whatever necessitated removing the paintings from the North Gallery in October 1652, it would have been done at his order.[24]

By shifting *Bacchus in Iberia* from the king's summer bedroom to the North Gallery, Velázquez probably made the painting accessible to a larger audience, but in doing so, he deprived it of the surrounding cues to its meaning that were incorporated in the 1636 ensemble in the bedroom. Perhaps he had concluded that the Iberian Bacchus was not going to be adopted as a metaphor for the Habsburg regime. Even so, his picture still enjoyed a privileged place in the king's esteem because the apparent purpose of the North Gallery was the display of fine art, and many of its works were of superb quality. The other mythologies in the room constituted an imposing group: an *Atalanta and Hippomenes* by Reni, a *Venus and Adonis* by Annibale Carracci, a supposed *Abduction of Helen* by Tintoretto (now identified as a *Battle of Christians and Turks*), and two pictures by Rubens, a *Diana and Callisto* and a *Judgment of Paris.*[25]

That *Bacchus in Iberia* could find a place among such works, even though it did not reflect the full maturity of Velázquez's talents, gave renewed testimony to his artistic genius. When he had created the piece, his concern had been to surpass local rivals

like Carducho, Cajés, and Van der Hamen. Years later, by having the picture displayed in the North Gallery, he suggested more boldly that he was the peer of masters of international renown. In that sense, *Bacchus in Iberia* continued to serve as proof of the exceptional gifts that Velázquez brought to the demanding art of history painting.

ANTONIO DE NEBRIJA'S
DE PATRIAE ANTIQUITATE

The complete text of Nebrija's elegy *De Patriae Antiquitate* is transcribed below; a prose translation follows.[1]

ELEGIA DE PATRIAE ANTIQVITATE ET
PARENTIBVS AVCTORIS

Est locus Hesperiae qua Bethis arundine cinctus
 In laeuam campos influit atque tenet.
Dixerat hunc aestus fluuio stagnante uetustas
 At uero Albinam saecula nostra uocant.
Hic uarium genus et uolucrum maris atque paludis
 Exciuit[2] foetus incubat et refouet.
Haud procul hinc colitur muro Nebrissa uetusto
 Quam Bacchus posuit littus ad Oceani.
Namque ferunt Semele genitum Gangetide uicta
 Inuasisse feros Hesperiae populos.
Et socio amisso a quo Lusitania nomen
 Duxerat in Calpes littora uertit iter.
Dum uehitur curru per inhospita rura marismae
 Quae sequitur nebris deficit atque sitit,
Et curuus pando residens Silenus asello
 Et uariae linces Maenades et Satyri.
Ventum erat ad speculam quae Fontinalia dicunt
 Indigenae diuus nunc Benedictus habet.
Ad strepitum lymphae nebris prior arrigit aures
 Et cauda ludens praeuia monstrat iter.
In gelidos latices et amoenam frondibus umbram
 Et fontes sacros arida turba ruit.
Cumque refecta cohors undis salientibus esset
 Captus amore loci dicitur esse pater,
Concilioque habito Satyris dixisse uocatis
 Atque Mimalloneis, caetera turba silet:
Accipite o comites laetasque aduertite mentes
 Hic mihi collis erit relligione sacer.
Nec tam Nyssa mihi natusque ad sacra Cithaeron

Gratus erit quantum a nebride dictus ager.
Nec qui plus Baccho qui se plus iactet oliuo
 Et Cereris flauae messibus atque fauis
Quare agite o Satyri nocturna reposcite sacra
 Et uos Bassarides hunc celebrate locum.
Iam Tarthessiacas Titan descendit in undas
 Et fessos curuo littore soluit equos.
Inuadunt thyrsos resonant ululatibus agri
 Et te Bacche uocant et tua sacra canunt.
Insomnesque trahunt Bacchantes orgia donec
 Cedere Luciferum cogeret orta dies.
Est prope monticulus surgens clementer in austros
 Parte tamen reliqua praecipitante latus.
Hic promissa pater fundauit moenia Bacchus
 Nebrissamque uocat nebridis auspicio.
Quae cum polleret Roderico rege furores
 Diruerant libyci nunc[3] renouata uiget.
Hic domus haec patria est hic me genuere parentes
 Ingenui et media conditione pares.
Nam mihi Ioannes pater est Caterinaque mater.
 Debemus patriae plus tamen illa mihi.
Illa mihi dedit hunc uitae mortalis honorem
 Sed studiis nostris illa perennis erit.

ELEGY ON THE ANTIQUITY OF HIS NATIVE LAND AND ON
HIS PARENTS

There is a place in the western lands where the Baetis river, choked with
weeds, pours out of its left bank and holds the fields there flooded.
Antiquity had called it this for the stagnant river's flood, but our times
call it Albina. Here an assortment of birds of sea and swamp has brought
forth its brood, nurturing and nourishing it. Not far from here they dwell
in Nebrissa, inside the old wall, a town that Bacchus placed by the Ocean
shore. For they say that the son of Semele, after he conquered India,
attacked the fierce peoples of the western lands. When he lost the com-
rade from whom Lusitania took its name, he turned his course to the
shore of Calpe. While he was being driven in his chariot through the
barren marsh country, the fawn-skin following him grew faint and
thirsty, and Silenus as well, bent with age, sitting on a sway-backed ass,
and all the lynxes, Maenads, and Satyrs that were with him. When they
had come to the watchtower the natives call Fontinalia (now it belongs
to the Benedictines), the fawn-skin was first to raise her ears to the noise
of the water: frisking with her tail, she goes before and shows the way.
The whole thirsty crowd rushes to the cool waters and the leafy, pleasant
shade by the sacred springs. And when the whole band had been re-
freshed on the fresh spring water, father [Bacchus] fell in love with the
place. He held council with all the Satyrs and Mimallonei, and the rest
of the crowd kept silent.

[He speaks:] "Hear this with pleasure, comrades: This hill will be sacred to me. Neither Nyssa nor Cithaeron (though it is destined for sacred things) will be as pleasing to me as the place named for the fawn-skin. No place will boast more abundantly of its fruits, of Bacchus, of the olive, of the harvests of blond Ceres, of the honeycomb. So go forth, O Satyrs, start again your nocturnal rites, and you, Bassarides, make festival in this place."

Now Titan[4] settles into the Tarthessian waves[5] and turns his weary horses loose on the curving shore. They snatch up their thyrsi, the fields resound with their cries, and they call on you, Bacchus, and they intone your rites. The sleepless Bacchantes drag out their orgies until the break of day forces Lucifer[6] to yield his place.

There is nearby a little mountain rising gently on the south, but steeper on the other sides. Here father Bacchus founded the city he had promised and called it Nebrissa in honor of the fawn-skin. In the days when it flourished under King Roderic, Libyan madness destroyed the walls,[7] but now, renewed, it flourishes again.

This is my home, this my native land, here my parents begot me, free-born and equal, in a middle station. For my father is John and my mother is Catherine. We owe more to our native land than she owes to me: She gave to me the honor of a mortal life, but she will be undying as a result of our literary accomplishments.

THE 1636 INVENTORY OF THE KING'S BEDROOM IN THE SUMMER APARTMENTS OF THE ALCÁZAR OF MADRID

In 1636 twenty paintings were inventoried in the king's bedroom in the summer apartments of the Alcázar of Madrid. The inventory text is transcribed here; a translation follows.[1] Pictures that can be recognized from their inventory descriptions are identified in the notes to the translation.

PIEÇA EN QUE DUERME SU MAG.^d EN EL QUARTO VAJO DE BERANO

[1] Vn retrato al natural con moldura dorada y negra que es la Ynfante D.ª Ysabel Con saya entera de tela de oro y p.ᵗᵃ y gorra puesta la mano sobre madalena ruiz y vn retrato del Rey su p.ᵉ en vn Camafeo en la mano derecha.

[2] Otro retrato de medio Cuerpo arriba con moldura dorada y nega que es la Reyna Doña ysabel con saya negra puntas de oro y cintas coloradas y gorra adereçada y vna marta en las manos asida de vna Cadenilla de oro

[3] Otro retrato de medio cuerpo arriba sobre tabla de la Reyna Doña Maria de Yngalaterra bestida de negro saya y mangas blancas sentada en vna Silla Carmesi bordado el espaldar, en la mano derecha vna rossa y en la hizquierda vnos guantes y vna Joya al pecho pendiente vna Perla

[4] Otro retrato de las Rodillas arriba en tabla que es la Reyna Doña Catalina de Portugal con ropa negra bordada y en la mano hizquierda vn abanico de Plumas y en la derecha vn lençuelo y guantes y Sobre vn bufete Cubierto de Verde Vn Papel.

[5] Otro retrato entero al olio del Rey nῖo S.ʳ Ph.ᵉ terçero siendo prinçipe armado Con Calças y butas blancas con morrion puesto y manopla la mano hizquierda Puesta en la espada tiene tres figuras q̃ᵉ son la Justiçia tiempo y Cupido de Dos baras de alto y bara poco mas de ancho es de mano de Justo tiles.

[6] Otro retrato al olio del Rey Don Phelipe Segundo armado y con calças blancas bufete carmesi q.ᵉ atrabiesa todo el quadro y ençima del la çelada y manoplas y la mano derecha ençima de la çelada y la otra en la espada.

[7] Otro retrato al olio del Rey nr̃o S.ʳ Don Ph.ᵉ quarto siendo niño Cuerpo entero armado y con calças blancas y en lo alto dos angeles con vnos geroglificos y en lo vajo de vnas gradas vn Leon = tiene moldura dorada y negra.

[8] Otro retrato de medio Cuerpo arriua en lienço forrado en tabla al olio que tiene marco dorado y negro y es del Prinçipe Don Carlos bestido de morado con bordaduras de oro y Cuelleçillo a modo de estudiante tiene tres quartas de alto y de ancho media bara.

[9] Vna Pintura al olio de Vna benus los pechos desnudos con ropa de lebantar carmesi con vn braçalete de Perlas en la mano derecha y en el dedo pequeño de la hizquierda vn anillo y Cupido delante della desnudo con vn espejo en q.ᵉ ella se esta mirando, es de mano del tiçiano y tiene moldura dorada y negra.

[10] Otro retrato de m.º Cuerpo arriba de el S.ʳ Ph.ᵉ Segundo siendo niño bestido de colorado forrado en armiños con vn lienço en la mano derecha y en la otra vn Cascauelillo dorado moldura dorada y negra y quebrada de alto tres quartas y de ancho m.ᵃ bara.

[11] Otro lienço al olio de çinco pies de largo o poco mas, o, menos con la moldura que es dorada y negra en q.ᵉ estan de medio Cuerpo arriba los retratos del emperador Carlos V. [*Insert:* y su muger] bestidos de negro las manos sobre vn bufete Carmesi y las de ella Juntas con vn lienço y en medio vn relox son de mano del tiçiano que se truxo de la Casa R¹ del Pardo tiene n.º leeiij

[12–13] Dos lienços de dos baras y media de largo con molduras doradas y negras de mano del Basan que el vno es de Aron y Moysen caminando por el disierto y va vna muger a cauallo con vn muchacho a las ancas = el otro de vnos pastores en que ay vno durmiendo estos dos lienços son de los que dio el duque de medina de las torres a Su mag.ᵈ p.ᵃ esta pieça.

[14] Otro lienço de quatro baras y m.ᵃ de largo con moldura dorada y negra de mano de rubenes en q.ᵉ esta la ystoria de Vn prinçipe de la Casa de Austria que lleba de diestro su Cauallo y ençima del Vn saçerdote con sobrepelliz q.ᵉ lleua en la mano vna custodia con el Santisimo y detras vn Sacristan con Sobre Pelliz tambien y vna linterna con Luz en la mano y le lleba del diestro Vn Criado [*Another hand:* el Cauallo y] Junto a ellos dos Perros.

[15] Otro lienço pegado sobre tabla de bara y media de largo y moldura negra en que estan de medio Cuerpo arriba San Jorge y S.^ta Margarita y la S.^ta tiene con ambas manos la Cabeça del Dragon = esta Pintura Dio a su mag.^d vn frayle de San Lorenço el Real.

[16] Otro lienço de casi tres baras de largo con moldura dorada y negra en q^e esta Baco asentado sobre vna pipa coronando a vn borracho y ay otras figuras q^e le acompañan de rodillas y otra detras con vna taça en la mano y otra q^e se va a quitar o, poner el sombrero es de mano de Diego Belazquez.

[17] Otro lienço con moldura dorada y negra de tres baras de largo y dos terçias de alto en que esta pintado vn feston de diferentes flores y frutas y tres niños que los dos le tienen y el otro en medio que quiere Coxer vn Pajaro es de mano de Balderramen

[18] Otro lienço de dos terçias de ancho y mas de dos baras de alto con moldura dorada y negra en que esta vn feston o, subiente de frutas y flores con dos angelillos que le tienen vno en lo alto y otro en lo vajo las figuras de mano de Rubenes y las frutas de esneyre y es de los que se vaxaron de la torre de la Reyna nr̃a. S.^ra

[19] Otro retrato entero del Prinçipe Don fer.^do bestido con vn coleto de ambas acuchillaďo, calças y mangas amarillas en la mano derecha vna barilla blanca caida açia avajo y la otra en la espada cortina Carmesi y al otro lado vnas colunas moldura dorada y negra.

[20] Vn lienço de ocho pies de largo con moldura dorada y negra en que esta la fee amparandose de españa, esta la fee desnuda cubierta por medio del Cuerpo con vn paño morado arrimada a vn arbol y detras vn caliz y vna Cruz quebrada y españa en pie con vna lança con vna banderilla carmesi en la mano hizquierda y en la derecha vna tarxeta con las armas R^s es de mano del tiçiano y Se trujo del Pardo.

ROOM IN WHICH HIS MAJESTY SLEEPS IN THE SUMMER APARTMENTS

[1] A life-size portrait with a gilded and black frame, which is the Infanta Doña Isabella with a *saya entera* of gold and silver fabric and a bonnet, with her hand put on Magdalena Ruiz, and with a portrait of the King her father in a cameo in her right hand.[2]

[2] Another, half-length portrait with a gilded and black frame, which is the Queen Doña Isabella in a black *saya* with gold *puntas*

and red ribbons, and an embellished bonnet. In her hands is a marten attached to a small gold chain.[3]

[3] Another, half-length portrait on panel of the Queen Doña Mary of England dressed in a black *saya* and white sleeves, seated in a bright red chair with an embroidered back. In her right hand is a rose and in the left some gloves, and a pearl depends from a jewel at her breast.[4]

[4] Another, knee-length portrait on panel, which is the Queen Doña Catherine of Portugal with a black, embroidered *ropa*. In her left hand is a feather fan, and in her right are a handkerchief [*pañuelo*] and gloves. On a table covered in green is a paper.[5]

[5] Another, full-length portrait in oil of the King our Lord Philip III as a prince, in armor with white hose and boots, wearing a morion and gauntlet. His left hand rests on his sword. It has three figures, who are Justice, Time, and Cupid. It measures two *varas* in height and a little more than a *vara* in width. It is by the hand of Justus Tilens.[6]

[6] Another portrait in oil of the King Don Philip II in armor with white hose. There is a bright red table that runs across all the picture, and on it the helm and gauntlets. His right hand is on top of the helm, and the other is on his sword.[7]

[7] Another portrait in oil of the King our Lord Don Philip IV as a boy, full-length in armor and with white hose. Above there are two angels with hieroglyphs, and at the bottom of some steps is a lion. It has a gilded and black frame.

[8] Another, half-length portrait on canvas stretched on a panel, in oil, which has a gilded and black frame. It is the Prince Don Carlos dressed in purple, with gold embroideries and a little collar like a student's. It is three *quartas* in height and half a *vara* in width.

[9] A painting in oil of a Venus with bared breasts, in bright red morning clothes, with a bracelet of pearls on her right hand and a ring on the little finger of her left. Cupid is in front of her nude with a mirror in which she is looking at herself. It is by the hand of Titian and has a gilded and black frame.[8]

[10] Another, half-length portrait of the Lord Philip II as a boy, dressed in red lined with ermine, with a canvas in his right hand and a gilded little bell in the other. It has a gilded, black, and broken frame, and measures three *quartas* in height and half a *vara* in width.

[11] Another canvas in oil measuring five *pies* in length, more or less, with a gilded and black frame, in which are in half-length

the portraits of the Emperor Charles V [*Insert:* and his wife] dressed in black. Their hands are on a bright red table, and hers are together with a linen. In the middle is a clock. They are by the hand of Titian. It was brought from the Royal House of the Pardo and has the number 73.[9]

[12–13] Two canvases measuring two and one-half *varas* in length with gilded and black frames by the hand of Bassano. The one is of Aaron and Moses walking through the desert, and there is a woman on horseback with a little boy on its croup. The other is of some shepherds, in which there is one sleeping. These two canvases are from those that the duke of Medina de las Torres gave His Majesty for this room.

[14] Another canvas measuring four and one-half *varas* in length with a gilded and black frame, by the hand of Rubens, in which is the story of a prince of the House of Austria who leads his horse by the bridle. On it is a priest in a surplice who holds a mons-trance with the Most Holy Sacrament. Behind is a sacristan also in a surplice with a lighted lantern in his hand, and a servant leads [*Another hand:* his horse] by the bridle. Near them are two dogs.[10]

[15] Another canvas fastened to a panel measuring one and one-half *varas* in length, with a black frame, in which Saint George and Saint Margaret are in half-length. The female saint holds the head of the dragon with both hands. A friar of San Lorenzo el Real gave this painting to His Majesty.

[16] Another canvas measuring almost three *varas* in length, with a gilded and black frame, in which is Bacchus seated on a cask, crowning a drunkard. There are other figures who accompany him on their knees, another behind with a bowl in his hand, and another who is going to take off or put on his hat. It is by the hand of Diego Velázquez.[11]

[17] Another canvas with a gilded and black frame measuring three *varas* in length and two *tercias* in height, in which is painted a festoon of different flowers and fruits. There are three children, two of whom are holding it [the festoon], and the other, who wants to catch a bird, is in the middle. It is by the hand of Van der Hamen.

[18] Another canvas measuring two *tercias* in width and more than two *varas* in height, with a gilded and black frame, in which is a festoon or *subiente* of fruits and flowers, with two little angels who hold it, one above and one below. The figures are by the hand of Rubens, and the fruits are by Snyders. It is from those that were brought down from the tower of the Queen our Lady.[12]

[19] Another, full-length portrait of the Prince Don Ferdinand dressed with a slashed *coleto de ambas*,[13] and yellow hose and sleeves. In his right hand is a small white rod lowered toward the ground, and his other is on his sword. There is a bright red curtain, and on the other side are some columns. It has a gilded and black frame.[14]

[20] A canvas measuring eight *pies* in length with a gilded and black frame, in which is Faith seeking protection from Spain. Faith is nude, covered across the middle of her body with a purple cloth, leaning against a tree. Behind her are a chalice and a broken Cross. Spain is standing with a lance with a bright red little banner in her left hand, and in her right a shield with the royal arms. It is by the hand of Titian, and it was brought from the Pardo.[15]

THE 1666 INVENTORY OF THE KING'S DINING ROOM IN THE SUMMER APARTMENTS OF THE ALCÁZAR OF MADRID

In 1666 sixteen paintings and three pieces of furniture were inventoried in the king's dining room in the summer apartments of the Alcázar of Madrid. The inventory text is transcribed here; a translation follows.[1] Pictures that can be recognized from their inventory descriptions are identified in the notes to the translation.

PIEZE Q LLAMAN DONDE SU MAG.d CENAUA

[1] Un quadro de quatro baras de largo Y dos y media de ancho Con marco negro Vn triunfo a baco de mano del cauallero massimo tasado en quinientos dos de plata

[2] Otro quadro del mismo tamano Con marco negro Vna fabula de baco de mano de Jusepe de Riuera tasado en quinientos dos de plata

[3] Otra pintura del s Infante Don fernando A cauallo de quatro baras de alto y dos Y ma de ancho de mano de Rubenis Con marco negro en trezientos dos de Plata

[4] Otro Retrato de la Reyna de Suezia a Cauallo de quatro baras de alto y tres y media de ancho Con su marco Negro en ciento Zinqta dos de plata

[5] Otra pintura de Vn orfeo de dos baras y ma de alto Con moldura negra tasada En ciento y cinqta dos

[6] Un frutero de dos Varas y media de alto y dos de ancho con marco negro de mano de Vn flamenco tasado En ciento dos de plata

[7] Otro quadro de Vna mujer con un satiro Con frutas en las manos de mano de rubenis de tres baras de largo y dos y ma de ancho con su marco negro tasado En dozientos Y cinquenta dos

[8] Un quadro de quatro baras de Largo Y dos y ma de alto de una caza de Mano de esneile Con marco negro en dozientos Zinqta dos

[9] Otro quadro de dos baras Y media de alto y bara [*Canceled:* y media] de ancho [*Written over:* alto] de Vna caza de zorras de mano de esneile tasado en cien dos de pta

[10] Otro quadro de dos baras Y media de alto Y de ancho dos y media qe es Vn bodegon de pescados flamenco tasado en cient dos de pta

[11] Otra pintura de tres baras de largo Y dos y media de ancho de frutas y aues de Vn flamenco tasado en docientos Zinqta dos pta

[12] Otra de dos baras Y media de alto y dos de ancho otro bodegon de Jabalies flamenco Con su marco tasado En ciento y cinqta dos de plata

[13] Otra pintura de dos baras Y media de alto [*Written over:* ancho] Y [*Canceled:* dos de alto] vna de ancho de Vnas flores un perro flamenco tasado En trezientos Y treynta Rs

[14] Otro del mesmo ttamaño qe tiene Vn gato tasado En treynta dos

[15] Otra pintura de dos baras Y media de alto y dos de ancho de Vn garabato Con diferentes abes flamenco tasado en mill y cient Rs de plata

[16] Otra pintura de media bara de alto y dos y media de [*Canceled:* alto] largo Vn feston con frutas Y flores flamenco tassado en cient Rs de plata

[17–19] Dos bufetes de marmol de san pablo con los pies dorados, Y una manpara guarnezida de damasco

ROOM THAT THEY CALL [THE ONE] WHERE HIS MAJESTY DINES

[1] A picture measuring four *varas* in length and two and one-half in height, with a black frame, a triumph of Bacchus by the hand of the Cavaliere Massimo, appraised at five hundred silver ducats.[2]

[2] Another picture of the same size with a black frame, a fable of Bacchus by the hand of Jusepe de Ribera, appraised at five hundred silver ducats.[3]

[3] Another painting of the lord Infante Don Ferdinand on horseback, measuring four *varas* in height and two and one-half in width, by the hand of Rubens, with a black frame, [appraised] at three hundred silver ducats.[4]

[4] Another portrait of the Queen of Sweden on horseback, measuring four *varas* in height and three and one-half in width, with its black frame, [appraised] at one hundred fifty silver ducats.[5]

[5] Another painting of an Orpheus, measuring two and one-half *varas* in height, with a black frame, appraised at one hundred fifty ducats.

[6] A fruiterer, measuring two and one-half *varas* in height and two in width, with a black frame, by the hand of a Fleming, appraised at one hundred silver ducats.[6]

[7] Another picture of a woman with a satyr, with fruits in their hands, by the hand of Rubens, measuring three *varas* in length and two and one-half in height, with its black frame, appraised at two hundred fifty ducats.[7]

[8] A picture measuring four *varas* in length and two and one-half in height, of a hunt, by the hand of Snyders, with a black frame, [appraised] at two hundred fifty ducats.

[9] Another picture measuring two and one-half *varas* in height and one [*Canceled:* and one-half] *vara* in width [*Written over:* height], of a fox hunt, by the hand of Snyders, appraised at one hundred silver ducats.

[10] Another picture measuring two and one-half *varas* in height and two and one-half in width, which is a still life of fish, Flemish, appraised at one hundred silver ducats.

[11] Another painting measuring three *varas* in length and two and one-half in height, of fruits and birds by a Fleming, appraised at two hundred fifty silver ducats.

[12] Another measuring two and one-half *varas* in height and two in width, another still life of wild boars, Flemish, with its frame, appraised at one hundred fifty silver ducats.

[13] Another painting measuring two and one-half *varas* in height [*Written over:* width] and [*Canceled:* two in height] one in width, of some flowers [and] a dog, Flemish, appraised at three hundred and thirty *reales.*[8]

[14] Another of the same size that has a cat, appraised at thirty ducats.[9]

[15] Another painting measuring two and one-half *varas* in height and two in width, of a market stall with different birds, Flemish, appraised at one thousand one hundred silver *reales.*

[16] Another painting measuring one-half *vara* in height and two and one-half in [*Canceled:* height] length, a festoon with fruits and flowers, Flemish, appraised at one hundred silver *reales*.

[17–19] Two tables made of San Pablo marble with gilded legs, and a screen adorned with damask.

THE 1666 INVENTORY OF THE NORTH GALLERY IN THE ALCÁZAR OF MADRID

In 1666 fifty-eight paintings and nineteen pieces of sculpture and furniture were inventoried in the North Gallery of the Alcázar of Madrid. The inventory text is transcribed here; a translation follows.[1] Pictures that can be recognized from their inventory descriptions are identified in the notes to the translation.

EN LA GALERIA DEL CIERZO

[1] Una pintura de tres baras de largo Y dos de alto de mano del bolones de la fabula de atalante Con marco [*Canceled:* dorado] negro en dozientos Zinqta dos de plata

[2–3] Dos cauezas del Griego con marcos negros a treynta dos cada una de plata

[4] Otra pintura de dos baras y media de largo Y de alto bara y ma Con su moldura negra Vna istoria de baco coronando a sus cofrades de mano de Diego belazquez en trezientos dos de plata

[5] Un pais en tabla de bara de largo Y tres qtas de ancho Con marco negro flamenco en cinqta dos plata

[6] Otra en tabla con unos soldadillos y muchas armas flamenco de Dauid teniers en cient dos pta

[7] Otra de bara Y quarta de largo y bara de alto el Juicio de paris con marco negro en ciento y cinqta dos de plata de Rubenes

[8] Otra de bara Y quarta de alto y bara de largo de Vn medico de mano del griego en cient dos de plata

[9] Otra de Cuatro baras de largo y tres de alto de la istoria de pitagoras y sus dizipulos Con muchas frutas en quatrocientos dos de plata de mano de rubenes

[10] Otra pintura de bara y quarta en quadro de la Reyna Dona margarita [*Canceled:* de rubenes] en cinqta dos de plata

[11] Otra de bara y media de largo y bara de alto de Vnas Jaulas y libres de rubenes en cient dos de pta

[12] Otra de tres baras de alto y dos y media de largo la capilla del Pontifize diziendo misa de mano de leonfranco en trezientos dos de plata

[13] Otra de bara y quarta de alto y bara de ancho del Rey de Ingalaterra degollado de mano de bandic en ciento y cinquenta dos pta

[14–17] quatro pinturas de bara y media de alto y de largo bara y media de fiestas de billanos de flandes con marcos dorados tallados a dozientos dos de plata cada una

[18] Otra de quatro baras de largo y mas de tres de alto la entrada del s Don Juan de austria a bruselas en seiscientos ducados de plata

[19] Otra de bara Y ma de alto del Retrato de la Reyna madre de francia de la reyna dona ana en cinquenta dos de plata

[20] Otra de quatro baras de largo y dos y media de alto la fabula de Calisto de mano de Pedro pablo de rubenes en quatrocientos dos de plata

[21] Una caueza de Vn pie de alto casi en quadro de mano de leonardo abinci en quarenta dos pta

[22] Otra de quatro baras de largo y tres y media de alto la entrada del s.r D. Jun de austria en bruselas de dabid teniers en seiscientos dos de plata

[23] Otra de bara Y media de alto Y bara Y quarta de largo del Rey de Ingalaterra siendo nino de mano de bandic en ciet Ds de pta

[24] Otra de tres baras de alto y dos de ancho el Relicario donde estan las cauezas de San Pedro y san Pablo en roma Docientos dos de plata

[25] Otra de bara y media de alto Y bara y quarta de largo de Vna senora de la casa de austria de mano de tintoreto en cient dos de plata

[26] Otra de bara Y ma de largo y bara Y quarta de largo de Vnas bodas de billanos en flandes en ciento Zinqta dos de plata

[27] Otra de quatro baras de largo y dos y media de ancho de mano de tintoreto El Robo de elena en seiscientos dos

[28] Otra de Vn pais de tres quartas de largo y media de ancho de Vna marina en treynta ducados pta

[29] Otra de bara y media de alto y bara y quarto de largo Vn Retrato de Vna mujer de mano de antonio moro con Vn perillo En la mano En ciento Zinqta dos plata

163

[30] Otra de bara Y quarta de largo y bara de alto de Vnas gallinas de mano de esneile en zinqta do.s

[31] Otra de dos baras y quarta de largo del porquechin de Sanson quando le sacaron los ojos en dozientos Zinqta dos plata

[32–33] Otros dos paisitos flamencos en tabla a treynta dos cada una

[34] Otra de tres [*Written over:* dos] baras de largo Y dos Y quarta de ancho de adonis y benus de anibal caracho en mill dos de plata

[35] Otra de bara y quarta de alto y tres quartas de ancho Vn Retrato de una muchacha de mano de pablo barones en zinqta dos pta

[36–39] Quatro Retratos hechos de barias baratijas en quarenta dos plata todos

[40] Otra de [*Canceled:* bara Y] siete quartas de alto y tres de ancho [*Canceled:* me] una diana con una flecha en la mano en Veinte y cinco dos pta

[41] Otra de bara y media de alto Y bara de ancho Vn Retrato de ombre En tabla con Vna ropa de martas en cient dos

[42] Otra de bara y quarta de largo y tres de ancho Vna yierba en Veinte dos pta

[43] Otra de tres baras de alto y dos y media de ancho quando El pontifize abre la puerta santa en docientos Zinquenta dos de plata

[44–49] Seis paises de bara de largo casi en quadro a doze dos cada uno de plata

[50] Otra pintura de tres baras de alto y dos y media de ancho quando coronan al pontifize en docientos dos plata

[51] Otra del mismo tamano quando laba los pies El pontifice a los pobres en dos mill y duzientos Rs

[52] Otra del mesmo tamano quando entran los enbajadores a la audienzia en duzientos dos pta

[53] Otra del mismo tamano de Vn conzilio en qe se alla El pontifize en duzientos dos de plata

[54] Otra del mismo tamano quando da la acanea al pontifize el embaxador de espana en quatrocientos dos de plata de Pedro de Cortona

[55] Otra de tres baras de largo y dos y media de largo la prezesion del corpus en roma en trezientos dos pta

[56] Otra del Juebes Santo quando descomulga los erijes El Pontifiçe en trezientos dos pta

[57] Un Retrato de anto moro de Vna ynfanta de portugal Con su marco negro En quarenta do.s plata

[58] Otro del mismo tamaño de Vn hombre con una serpiente En la m° en q^ta do^s p^ta

[59–64] Seis bufetes de Porfido los tres ochabados y los otros tres largos con sus pies de madera de Reliebes tasados por el dho Don Sebastian de herrera en diez mill [*Canceled:* tre] quinientos Zinq^ta Reales de Vellen todos tres Y lo miss° los otros tres

[65–72] Ocho medallas de marmol con sus pies de madera tasados por el dho Don sebastian de herrera en Veinte mill duzientos y quarenta R^s todos

[73] Vna estatua de benus de yeso tasada por el dho Don sebastian de herrera en quarenta do^s de plata

[74] Otra de cleopatria Moribunda hechada de yeso en ciento y cinquenta ducados de plata p El dho Don sebastian de herrera

[75] Otra de baco Con un razimo de vbas en la mano de yesso tasada p^r el dho D. Sebastian de herrera En quarenta do^s de plata

[76] dos figuras luchando de yeso en sesenta ducados de plata tasadas p El dho D Sebastian de herrera

[77] Vna figura de Vn glaudiator de yeso moribundo tasada por El dho Don Sebastian de Herrera En ochenta ducados de p^ta

IN THE NORTH GALLERY

[1] A painting measuring three *varas* in length and two in height, by the hand of the Bolognese, of the fable of Atalanta, with a [*Canceled:* gilded] black frame, [appraised] at two hundred fifty silver ducats.[2]

[2–3] Two heads by El Greco, with black frames, [appraised] at thirty silver ducats each.

[4] Another painting measuring two and one-half *varas* in length and one and one-half in height, with its black frame, a history painting of Bacchus crowning his *cofrades*, by the hand of Diego Velázquez, [appraised] at three hundred silver ducats.[3]

[5] A landscape on panel, measuring one *varas* in length and three *quartas* in height, with a black flame, Flemish, [appraised] at fifty silver ducats.

[6] Another on panel, with some little soldiers and many arms, Flemish, by David Teniers, [appraised] at one hundred silver ducats.[4]

[7] Another one and one-quarter *varas* in length and one *vara* in height, the Judgment of Paris, with a black frame, [appraised] at one hundred fifty silver ducats, by Rubens.[5]

[8] Another measuring one and one-quarter *varas* in height and one *vara* in length, of a doctor, by the hand of El Greco, [appraised] at one hundred silver ducats.[6]

[9] Another measuring four *varas* in length and three in height, of the story of Pythagoras and his disciples with many fruits, [appraised] at four hundred silver ducats, by the hand of Rubens.

[10] Another painting measuring one and one-quarter *varas* square, of the Queen Doña Margarita [*Canceled:* by Rubens], [appraised] at fifty silver ducats.

[11] Another measuring one and one-half *varas* in length and one *vara* in height, of some cages[7] and hares, by Rubens, [appraised] at one hundred silver ducats.

[12] Another measuring three *varas* in height and two and one-half in length, the chapel of the pope [in which he is] saying Mass, by the hand of Lanfranco, [appraised] at three hundred silver ducats.

[13] Another measuring one and one-quarter *varas* in height and one *vara* in width, of the beheaded King of England, by the hand of Van Dyck, [appraised] at one hundred fifty silver ducats.[8]

[14–17] Four paintings measuring one and one-half *varas* in height and one and one-half *varas* in length, of festivals of Flemish peasants, with gilded [and] carved frames, [appraised] at two hundred silver ducats each.

[18] Another measuring four *varas* in length and more than three in height, the entry of the lord Don Juan de Austria into Brussels, [appraised] at six hundred silver ducats.

[19] Another measuring one and one-half *varas* in height, of the portrait of the queen mother of France, of the Queen Doña Ana, [appraised] at fifty silver ducats.[9]

[20] Another measuring four *varas* in length and two and one-half in height, the fable of Callisto, by the hand of Peter Paul Rubens, [appraised] at four hundred silver ducats.[10]

[21] A head measuring one *pie* in height, almost square, by the hand of Leonardo da Vinci, [appraised] at forty silver ducats.

[22] Another measuring four *varas* in length and three and one-half in height, the entry of the lord Don Juan de Austria into Brussels, by David Teniers, [appraised] at six hundred silver ducats.

[23] Another measuring one and one-half *varas* in height and one and one-quarter *varas* in length, of the King of England as a child, by the hand of Van Dyck, [appraised] at one hundred silver ducats.[11]

[24] Another measuring three *varas* in height and two in width,

the reliquary in which are found the heads of Saint Peter and Saint Paul in Rome, [appraised at] two hundred silver ducats.

[25] Another measuring one and one-half *varas* in height and one and one-quarter *varas* in length, of a lady of the House of Austria, by the hand of Tintoretto, [appraised] at one hundred silver ducats.

[26] Another measuring one and one-half *varas* in length and one and one-quarter *varas* in height, of some peasant weddings in Flanders, [appraised] at one hundred fifty silver ducats.[12]

[27] Another measuring four *varas* in length and two and one-half in height, by the hand of Tintoretto, the Rape of Helen, [appraised] at six hundred ducats.[13]

[28] Another of a landscape, three *quartas* in length and one *media* in height, of a sea coast, [appraised] at thirty silver ducats.

[29] Another measuring one and one-half *varas* in height and one and one-quarter *varas* in length, a portrait of a woman with a little dog in her hand, by the hand of Anthonis Mor, [appraised] at one hundred fifty silver ducats.[14]

[30] Another measuring one and one-quarter *varas* in length and one *vara* in height, of some hens, by the hand of Snyders, [appraised] at fifty ducats.

[31] Another measuring two and one-quarter *varas* in length, by Procaccini, of Samson when they put out his eyes, [appraised] at two hundred fifty silver ducats.

[32–33] Another two little Flemish landscapes on panel, [appraised] at thirty ducats each.

[34] Another measuring three [*Written over:* two] *varas* in length and two and one-quarter in height, of Adonis and Venus, by Annibale Carracci, [appraised] at one thousand silver ducats.[15]

[35] Another measuring one and one-quarter *varas* in height and three *quartas* in width, a portrait of a young woman, by the hand of Paolo Veronese, [appraised] at fifty silver ducats.

[36–39] Four portraits made from various trinkets, [appraised] at forty silver ducats altogether.[16]

[40] Another measuring [*Canceled:* a *vara* and] seven *quartas* in height and three [*quartas*] in width [*Canceled: me*], a Diana with an arrow in her hand, [appraised] at twenty-five silver ducats.

[41] Another measuring one and one-half *varas* in height and one *vara* in width, a portrait of a man with a marten-fur garment, on panel, [appraised] at one hundred ducats.

[42] Another measuring one and one-quarter *varas* in height and

three [*varas? quartas?*] in width, a pasture, [appraised] at twenty silver ducats.

[43] Another measuring three *varas* in height and two and one-half in width, [depicting] when the pope opens the Holy Door, [appraised] at two hundred fifty silver ducats.

[44–49] Six landscapes measuring one *vara* in length, almost square, [appraised] at twelve silver ducats each.

[50] Another painting measuring three *varas* in height and two and one-half in width, [depicting] when they crown the pope, [appraised] at two hundred silver ducats.

[51] Another of the same size, [depicting] when the pope washes the feet of the poor, [appraised] at two thousand two hundred *reales*.

[52] Another of the same size, [depicting] when the ambassadors enter at an audience, [appraised] at two hundred silver ducats.

[53] Another of the same size of a council at which the pope is found [an electoral conclave?], [appraised] at two hundred silver ducats.

[54] Another of the same size, [depicting] when the Spanish ambassador gives the small horse to the pope, [appraised] at four hundred silver ducats, by Pietro da Cortona.[17]

[55] Another measuring three *varas* in length and two and one-half in height, the Corpus Christi procession in Rome, [appraised] at three hundred silver ducats.[18]

[56] Another of Maundy Thursday when the pope excommunicates the heretics, [appraised] at three hundred silver ducats.

[57] A portrait by Anthonis Mor of an infanta of Portugal, with its black frame, [appraised] at forty silver ducats.

[58] Another of the same size of a man with a serpent in his hand, [appraised] at forty silver ducats.

[59–64] Six porphyry tables, three octagonal and the other three long, with their wooden legs [carved] in relief, appraised by the said Don Sebastián de Herrera,[19] three altogether at ten thousand [*Canceled:* three] five hundred fifty *reales de vellón,* and the same [for] the other three.

[65–72] Eight marble medallions with their wooden supports, appraised by the said Don Sebastián de Herrera at twenty thousand two hundred and forty *reales* altogether.

[73] A plaster statue of Venus, appraised by the said Don Sebastián de Herrera at forty silver ducats.

[74] Another of Cleopatra dying, made of plaster, [appraised] at one hundred fifty silver ducats by the said Don Sebastián de Herrera.

[75] Another of Bacchus with a bunch of grapes in his hand, in plaster, appraised by the said Don Sebastián de Herrera at forty silver ducats.

[76] Two wrestling figures, in plaster, appraised by the said Don Sebastián de Herrera at sixty silver ducats.

[77] A figure of a dying gladiator, in plaster, appraised by the said Don Sebastián de Herrera at eighty silver ducats.

NOTES

INTRODUCTION

1 As a result of that fire, the overall picture darkened unevenly (López-Rey, 1979, 281). For a recent technical examination of the picture, see Garrido Pérez, 1992, 167–79; for the Alcázar fire, see Bottineau, 1960, 476–96.

2 According to López-Rey, 1979, 280, the painting was probably cut around the edges to remove it from its frame when it was rescued from the 1734 fire.

3 "Documentos," 1960, 231, no. 42.

4 Ibid., 229, no. 36.

5 Ibid., nos. 37–38.

6 Ibid., no. 37. As Azcárate, 1960, 362–63, has shown, Velázquez began to have difficulty collecting his regular salary in 1627, when a year's wages went unpaid, and he did not receive his salary for the first half of 1628 until 24 October 1628. (The arrears in his salary were not paid in full until 20 June 1629, shortly before he departed Madrid for Italy.) It seems likely that the daily ration was granted to relieve the financial strain that such delays would have caused him.

7 "Documentos," 1960, 230, no. 39.

8 This is the reasoning of Justi, 1888, 1:255–56.

9 López-Rey, 1963, 141, and 1979, 280, takes the order to mean that the king acquired *Los Borrachos* after 9 February 1629.

10 See Appendix B, no. 16.

11 See Appendix D, no. 4.

12 Covarrubias Orozco, 1977, 332–33, as *cofadre:* "comúnmente se entiende de los que tienen hermandad en alguna obra pía y religiosa."

13 For 1686, see APM, SA, Bellas Artes, leg. 38, inventory of 1686, fol. 20 (transcribed in Bottineau, 1956–58, 60:173, no. 372). For 1700 and 1702, see APM, reg. 240, fol. 45, no. 178, and reg. 242, fol. 574, respectively (transcribed in Fernández Bayton, 1975–85, 1:35, no. 178, and 3:443, no. 282, respectively).

14 APM, SA, Inventarios, leg. 768, 1735, fol. 10bisv, no. 197.

15 APM, SA, Inventarios, leg. 768, Pinturas Que se le entregaron â D.n Bar.me Rusca para componer el Quarto del sor Infante D.n Phelipe, fol. 6bis, no. 197.

16 For 1772, see APM, SA, Bellas Artes, leg. 38, inventory of 1772, fol. 14, no. 197. For 1789, see APM, reg. 260, Testamentaría del Rey Carlos III, fol. 5, no. 197 (transcribed in Fernández-Miranda y Lozana, 1988, 1:16,

no. 38). For 1814, see APM, SA, Bellas Artes, leg. 38, inventory of 1814, fol. 2ᵛ, no. 197.

17 López-Rey, 1979, 280–81.

18 Pacheco, 1956, 1:154–66.

19 Palomino de Castro y Velasco, 1947, 891–936.

1. THE WEB OF RESPONSES

1 A detailed history of critical reactions to Velázquez's works has yet to be written. For some preliminary remarks on the subject with references to further literature, see Brown, 1986, 266–69; for Velázquez's mythologies, see also Angulo Iñiguez, 1961, 49–55. The survey of responses to *Los Borrachos* that follows is by no means exhaustive; rather, I have chosen examples to illustrate the principal arguments that have been advanced to explain the picture's meaning. The original dates of the opinions I cite are given in the text to enable the reader to follow chronological developments more easily and to avoid the confusion that might otherwise result from my occasionally having to footnote later editions of some of the works in question.

2 Ponz, 1988, 2:240.

3 Ibid., 2:326.

4 Ibid., 4:700.

5 Sayre, 1974, 22 and 42–45.

6 Harris, 1982, 74 and 227, suggests it may have been Goya's etching that prompted Ponz to shift his reading of the picture from one of figures playing in a "kind of Bacchanal" to one of a triumph "in burlesque."

7 Sayre, 1974, 42 and 45.

8 Ceán Bermúdez, 1800, 5:178.

9 Beruete, 1898, 44; I quote the English edition, 1906, 28.

10 Riggs, 1947, 102–03.

11 Lafuente Ferrari, 1960, 48 and 50.

12 Pantorba [*pseud.*], 1955, 95.

13 Castro, 1857, xxxi–xxxiii. Castro does not provide the date of the tourney, but it must have preceded the archduke's death on 15 July 1621.

14 Picón, 1899, 53–54.

15 Riggs, 1947, 100.

16 Trapier, 1948, 140.

17 Soria, 1953, 281–82; and Sánchez Cantón, 1961, 14–15.

18 López-Rey, 1963, 43; he reiterated that view in 1968, 51–52, and in 1979, 42–43.

19 Stirling[-Maxwell], 1848, 2:596.

20 Ibid., 2:597.

21 Camón Aznar, 1964, 1:318.

22 Haraszti-Takács, 1983, 225.

23 For portrayals of entertainers at the Spanish court, see Museo del Prado, 1986; for those painted by Velázquez, see also Brown, 1986, 97–104, 148–54, 174, 270–71, and 274–77.

24 López-Rey, 1963, 44; he repeated this argument in 1968, 52–53, and in 1979, 43.

25 For an overview of the literature on this painting, see Wethey, 1969–75,

3:37–41 and 151–53; see also Cavalli-Björkman, 1987, passim; and Museo del Prado, 1987, 14–19, 27–36, and 40–41.

26 Although it is difficult to read in photographs of the painting, there is an indication of reddish-purple fabric drawn across the latter figure's waist. The motif is indicated clearly in Salvador Carmona's print (fig. 9).

27 Wethey, 1969–75, 3:151.

28 On the ideal of the learned painter, see Blunt, 1973, 10, 34, and 49–51.

29 For introductions to Rembrandt's and Rubens's relationships to the classical tradition, see Clark, 1966, and Stechow, 1968.

30 Justi, 1888, 1:257–59; I quote the revised English edition, 1889, 140–42.

31 Ortega y Gasset, 1972, 19–20.

32 Ibid., 101–02 (by permission of W. W. Norton & Co., Inc.). It is now widely accepted that *The Spinners* depicts the myth of Minerva and Arachne.

33 Trapier, 1948, 140.

34 Soria, 1953, 278–81. It is from a set of three prints depicting mortals beseeching the favors of gods; the others are an *Homage to Ceres* and an *Homage to Venus* (Bartsch 70–72, Hollstein 69–71).

35 As translated in Brown, 1986, 66.

36 However, Camón Aznar, 1964, 1:322, rejected it as a source owing to the mannerist style in which Saenredam rendered Bacchus and the satyr, and to differences between the two compositions.

37 Tolnay, 1961, 32; and Kahr, 1976, 60–61.

38 Angulo Iñiguez, 1947, 97–98; and Trapier, 1948, 139.

39 Curtis, 1883, 18; and Kahr, 1976, 60 n. 44.

40 Colombier, 1939, 37–38, first noted the link between the two works; many Velázquez specialists have since endorsed that view. However, a few have related the painting to other sources, notably a marble relief of *Vulcan and the Cyclopes Forging the Shield of Achilles* (Rome, Palazzo dei Conservatori). For a review of proposed sources, see Sebastián [López], 1983, 24–26. Kitaura, 1989, has recently revived the suggestion by Angulo Iñiguez, 1947, 75–78, that the *Forge* is derived from compositions by El Greco, but I remain unconvinced.

41 Soria, 1948, 252–53; and Angulo Iñiguez, 1946, 21–24. Various prints have been proposed over the years as possible sources for Velázquez's *Coronation of the Virgin* (Madrid, Museo del Prado), but the compositional type is so common that identifying a specific model may not be possible.

42 See Brown, 1986, 16–21 and 252–53, with references to further literature. In addition, the background passage in the *Fable of Arachne* was inspired by a painting designed by Rubens; see Angulo Iñiguez, 1948, 8–9 and 18. Moffitt, 1990, reads such compositions differently and perceives an alternative source for Velázquez in Hieronymus Wierix's illustrations for Jerome Nadal's *Evangelicae historiae imagines;* I find this unpersuasive.

43 In Chapter 4 I propose another visual source that may have been of secondary importance to Velázquez.

44 Tolnay, 1961, 32.

45 Ibid., 32–33.

46 Angulo Iñiguez, 1963, 37–38 (by permission of Princeton University Press). See also his remarks on *Los Borrachos* in two earlier studies, 1960, 106–08, and 1961, 56–58.

47 The case for Caravaggio's having inspired Spanish seventeenth-century naturalism is argued by Ainaud [de Lasarte], 1947, 364–410; for his presumed

influence on Velázquez, see also Harris, 1982, 53–54, and Haraszti-Takács, 1983, 53–78 passim. Nevertheless, the case against Caravaggio's influence is more persuasive: See Brown, 1986, 12–15, and 1991, 100–04, 109–10, and 310–11; Pérez Sánchez, 1973, introduction, unnumbered pages; Spear, 1975, 19–20; and Wind, 1987, 47–53. One red herring we must dispense with is Caravaggio's *Bacchus* (Florence, Uffizi), which Velázquez could not have known; see Hibbard, 1983, 39.

48 For example, it informs the characterization of *Los Borrachos* in López Torrijos, 1985, 343–45, as a painting of Bacchus as the god who was "closest to mankind."

49 Kahr, 1976, 61. Kahr cites unillustrated paintings by David Teniers the Younger, Christiaen van Couwenberch, and Louis de Caullery; however, she does not mention Saenredam's engraving. I have been unable to check all the paintings she cites, but no Netherlandish "Homage to Bacchus" with which I am familiar impresses me as a more likely source for *Los Borrachos* than Saenredam's print.

50 Ibid.

51 Moffitt, 1985a.

52 Sánchez Cantón, 1925, 396, no. 61.

53 Pérez de Moya, 1928, 1:257–69.

54 See Diodorus of Sicily, *The Library of History* 3.63–64.

55 Pérez de Moya, 1928, 1:266.

56 Ibid., 1:268–69; the reference to Seneca is *De Tranquillitate Animi* 17.8–9.

57 Sebastián [López], 1985a, and 1985b, 54–59. Velázquez could have known the first edition of López's commentary (Nájera, 1615), from which figs. 15–17 are taken.

58 Moffitt, 1989, 158; fig. 18 is also taken from the 1615 edition of López's commentary.

59 Moffitt, 1989, 158–59.

60 Ibid., 157.

61 For the text of the sonnet and a detailed commentary, see Arguijo, 1985, 117–22.

62 Sebastián and Moffitt present such moralizing as a standard practice. Sebastián [López], 1985b, 59, remarks, "The mythological scenes seen by the authors of treatises on the subject in the sixteenth and seventeenth centuries bore a moralizing message, and the popular canvas *Los Borrachos* did not escape *this norm*" [my emphasis]. Moffitt, 1989, 162, regards Pérez de Moya as "an absolutely essential source for the correct art-historical reading of Velázquez's hitherto puzzling mythological anomalies." For his views on Velázquez's relationship to the *Filosofía secreta,* see Moffitt, 1983, 323–26; 1985a, 27–28; 1985b, 82–83; and 1989, 161–73.

63 Welles, 1986, 137–39; see also Sánchez Cantón, 1925, 405–06, no. 150, and 1960, 642 n. 9.

64 [Bustamante,] 1551, 53–53ᵛ.

65 Welles, 1986, 139.

66 Ibid., 140.

67 Ibid., 135.

68 Brown, 1986, 66.

69 Sotomayor Román, 1990, 66–68. This suggestion was part of a larger argument in which Sotomayor Román proposed Velázquez's *Fable of Arachne* might be a kind of belated pendant to *Los Borrachos*. To this end Sotomayor Román related *Los Borrachos* to Ovid's account of how the daughters of

Minyas resisted joining the other citizens of Thebes in celebrating Bacchus's rites when he visited their city, for which impiety he transformed them into bats (*Metamorphoses* 4.1–415). For reasons lying beyond our present concern, Sotomayor Román further argued that the women in the foreground of the *Fable* were the daughters of Minyas; it then followed that if the *Fable* were paired with *Los Borrachos,* Bacchus's looking to one side would illustrate his annoyance with Minyas's daughters, who stayed home from the rites in which the other Thebans (the peasants in *Los Borrachos*) participated.

Because nothing in *Los Borrachos* specifically identifies where the god and his companions have gathered, the suggestion that it might illustrate Bacchus's rites at Thebes can be neither confirmed nor disproved; however, it should be noted that the company assembled in the painting matches neither the description of Bacchus's retinue given by Ovid nor the description provided by Pedro Sánchez de Viana, whose sixteenth-century translation of Ovid into Spanish was cited by Sotomayor Román as the text that Velázquez was likely to have consulted.

Insofar as the *Fable* is concerned, Sotomayor Román's proposal that it was conceived as a companion to *Los Borrachos* is unlikely, not least because the two pictures were made for different patrons, which would have worked against their being seen together. For a more persuasive approach to the *Fable,* see Brown, 1986, 252–53.

70 A more detailed consideration of Rubens's second visit to Madrid is found in Chapter 2.

71 Among those dating the start of the painting prior to Rubens's arrival in Madrid are Mayer, 1936, 13; Trapier, 1948, 143; Soria, 1953, 278; Gerstenberg, 1957, 52; Tolnay, 1961, 32; Camón Aznar, 1964, 1:312–13; and Haraszti-Takács, 1983, 225.

72 Beruete, 1898, 42; I quote the English edition, 1906, 27.

73 Riggs, 1947, 99.

74 Gállego, 1983, 71.

75 Picón, 1899, 54.

76 Kahr, 1976, 62.

77 Welles, 1986, 136–40.

78 Kahr, 1976, 59.

79 Harris, 1982, 70 and 73.

80 Wethey, 1969–75, 3:145, 147–48, and 150. The *Andrians* was not shipped to Spain until 1637. There were other mythologies with nude figures by Titian in the royal collection – notably the *poesie* for Philip II – but they did not depict bacchanals.

2. THE RISING STAR

1 Pacheco, 1956, 1:156.

2 For the academy, see Brown, 1978, 21–43.

3 Ibid., 42 and 61 n. 52; Barrera y Leirado, 1867, 292–319; and López Navío, 1961.

4 For the duties of the *sumiller de cortina,* see Rodríguez Villa, 1913, 49 (as *sumiller de oratorio*).

5 "Documentos," 1960, 221–22, nos. 20–21.

6 López-Rey, 1968–69, 3.

7 Pacheco, 1956, 1:156–57.

8 Brown, 1986, 45–47. Although Palomino de Castro y Velasco, 1947, 896–97, follows much of Pacheco's account, he identifies Velázquez's picture as a life-size equestrian portrait of the king in armor. In fact, that seems more likely to have been a painting that has been documented to 1625, to be considered later in this chapter.

9 See Azcárate, 1960, 357–59; and "Documentos," 1960, 222–23, nos. 22–24, for the following remarks.

10 The documents do not identify the painters named in the two other *cédulas* the Royal Works examined. I agree with Harris, 1981, 95 n. 4, that they were probably Vicente Carducho and Eugenio Cajés, whose terms of employment differed from González's, as is shown later in this chapter.

11 For the early reign of Philip IV, see Elliott, 1986, 1–202, with extensive bibliography; and Stradling, 1988, 3–64.

12 For the following remarks, see Brown, 1986, 44; Brown and Elliott, 1980, 23–24 and 42–44; and Elliott, 1986, 20–22.

13 Because Velázquez began his apprenticeship with Pacheco late in 1610 and did not take his licensing exam to become an independent master until 1617 ("Documentos," 215–17, nos. 8 and 10), it is possible that he first met Olivares while training with Pacheco; however, no record of such a meeting is known.

14 Ibid., 225, no. 29; for Morán's career, see Angulo Iñiguez and Pérez Sánchez, 1969, 68–73, and 1977, 53.

15 For Carducho's and Cajés's careers, see Angulo Iñiguez and Pérez Sánchez, 1969, 86–189 and 212–59, and 1977, 13–48; and Volk, 1977. There is no adequate study of González's career.

16 For López's career, see Angulo Iñiguez and Pérez Sánchez, 1969, 47–56.

17 Ibid., 47; and Kubler, 1965, 440 n. 5.

18 Angulo Iñiguez and Pérez Sánchez, 1969, 24, 105, and 223.

19 For the plan and its key, see Museo Municipal, 1986, 172–73 and 381–83.

20 Orso, 1986, 48. Because Velázquez was still using that studio on 3 December 1632 (ibid., 18), it was probably there that he painted *Los Borrachos* sometime in the intervening years.

21 Pacheco, 1956, 1:161; the "gallery" to which he referred was surely the adjacent North Gallery (room 20).

22 Gerard, 1978; and Museo Municipal, 1986, 40–49.

23 Orso, 1986, 32–117, recounts the history of its decoration.

24 The following discussion of events pertaining to the New Room draws upon ibid., 43–55, which should be consulted for more detailed documentation.

25 The *Philip II* and the *Religion Aided by Spain* were two of three pictures that Carducho was engaged to enlarge and retouch before they were hung in the New Room. Payment for his efforts was not authorized until 24 December 1625, but that does not mean it took him that long to complete the work because delays in payments to artists were common at the Spanish court. In fact, he was not paid in 1625; the authorization had to be reissued on 16 April 1626. See ibid., 45–46.

26 One of the documents cited in ibid., 47, suggests that González agreed to make the painting on 25 October 1620; however, Saltillo, 1953, 167, cites a document authorizing partial payment to González for what seems to be the same picture (a portrait of Philip III "dressed as he entered the Cortes of Lisbon, life-size, with his showy costume"), and that document would move the inception of the picture back to 31 December 1619.

27 Pozzo, BAV, Ms. Barb. lat. 5,689, unnumbered folios; as transcribed in Harris, 1970, 372.

28 Valdivieso and Serrera, 1985, 42.

29 Pacheco, 1956, 1:157.

30 For the nuncio's letter, see Camón Aznar, 1964, 1:330; and Harris, 1981, 95–96. Palomino de Castro y Velasco, 1947, 898, reiterates Pacheco's account of the equestrian portrait, but elsewhere (908) he describes how Velázquez painted an equestrian portrait of Philip IV when the king was twenty years old (that is, between 8 April 1625 and 8 April 1626), invited public opinion of it, and effaced much of his work when it was "vituperated." The horse, in particular, was attacked as "contrary to the rules of art." It is possible that both passages refer to the same portrait. Harris, 1970, 368–71, reviews the sources on early equestrian portraits by Velázquez.

31 APM, SA, Inventarios, leg. 768, 1636, fol. 14bis.

32 This more cautious position supersedes my earlier, unquestioning identification of Carducho's protagonist as Scipio the Elder (Orso, 1986, 93 and 108). I still lean toward that identification, but the evidence is not conclusive. See, in this regard, n. 87 in this section.

33 APM, SA, Inventarios, leg. 768, 1636, fol. 14bisv.

34 For Nardi's career, see Angulo Iñiguez and Pérez Sánchez, 1969, 271–98, and 1977, 54.

35 Philip IV may even have picked the theme he chose out of a desire to replace González's *Portrait of Philip III* with a better likeness of his father; see Orso, 1986, 54–55.

36 Martín González, 1958a, 59.

37 Brown and Elliott, 1980, 44–45.

38 Museo del Prado, Madrid, inv. no. F.A. 716.

39 APM, SA, Inventarios, leg. 768, 1636, fol. 14bisv.

40 Palomino de Castro y Velasco, 1947, 898–99, as translated in 1987, 146–47 and 180 nn. 41–42, with minor revisions.

41 Pacheco, 1956, 1:158; and "Documentos," 1960, 226, no. 30.

42 Other sources do not link the appointment directly to the competition. The painter Jusepe Martínez (1950, 194), who knew Velázquez, says Velázquez was named usher for painting portraits and by virtue of his superiority to other artists; this precedes Martínez's account of the events leading to the "Moriscos" competition. Palomino de Castro y Velasco, 1947, 899, reports Velázquez's appointment immediately after recounting the competition, but he does not explicitly connect the two events as cause and effect. I lean toward Pacheco's account because as Velázquez's father-in-law, he was in the best position to know the circumstances of the appointment.

43 "Documentos," 1960, 229, no. 36.

44 Carducho, 1979; the introductory study and extensive notes by Francisco Calvo Serraller in this edition of the treatise have proved invaluable for preparing the remarks that follow.

45 Ibid., 3.

46 Because the present study considers the *Diálogos* from a narrow perspective, it should be acknowledged that Carducho's primary aims in writing the treatise were to foster good painting and to win recognition of painting as a liberal art. See also Wázbiński, 1990.

47 Carducho, 1979, 326.

48 Gerard, 1978, 246.

49 See Orso, 1986, 144–53, for the decoration of the South Gallery.

50 Ibid., 126–27.

51 The best description of the royal exequies for Philip III is Gómez de Mora, Ms. 1,973. For Carducho and Cajés's contributions to that event, see Azcárate, 1962, 291; Martín González, 1958b, 133; and Orso, 1989, 39 and 71 n. 3.

52 It will be recalled as well from the Introduction that on 18 September 1628 the king settled all his outstanding accounts for pictures that Velázquez had made in his service until then. No artist at the seventeenth-century Spanish court was immune to delays in collecting payments due him, including Velázquez (see Azcárate, 1960, 362–66 and 374–78), but during the 1620s he seems to have fared better at having his accounts settled than did his colleagues.

53 Orso, 1986, 50.

54 Ibid. As was customary, Carducho's heirs and the king each named one of the two appraisers who were to determine the price; in an ironic twist, the king's representative was Veláquez. The outcome of the appraisal and date when the picture was finally paid for are unknown.

55 APM, SA, leg. 5,264, Contabilidad, Cuentas particulares, P-4, Pintores y doradores, 1621. See also Sánchez Cantón, 1916, 74; and Moreno Villa and Sánchez Cantón, 1937.

56 Carducho, 1979, 326–30 (quoted later in this chapter).

57 Ibid., 330–33. Some of the work Carducho describes was actually carried out under Philip II. For the decoration of the Pardo under both kings, see Calandre, 1953, 35–87; and Marías, 1989.

58 There is no little irony to Carducho's using this argument because when the work at the Pardo was completed, the crown's agents resisted paying the Pardo artists the fee they thought they deserved, offering only half that sum. Carducho was one of the appraisers who represented the artists in the negotiations to set the price. A lawsuit over the matter dragged on for more than three years before the artists admitted defeat. See Martín González, 1958b, 133–39.

59 Carducho, 1979, 435.

60 For the painters who decorated the Escorial and their influence, see Brown, 1991, 58–65 and 89–97; Pérez Sánchez, 1963; and Zarco Cuevas, 1931 and 1932.

61 The evidence for assessing the relationship of Nardi to the other artists is considered later in this chapter.

62 Of the other artists listed by Carducho who worked at the Pardo, all are known to have been dead by 1633, with the exception of Jerónimo de Mora, whose date of death is unknown.

63 For Velázquez's early works, see Brown, 1986, 7–35.

64 See Brown, 1991, 97–113 and 124–31.

65 For Maino's career, see Angulo Iñiguez and Pérez Sánchez, 1969, 299–325; Hospital de Tavera and Iglesia de San Pedro Mártir, Toledo, 1982, 172–77; and Junquera, 1977.

66 Carducho, 1979, 270–72; as translated in Enggass and Brown, 1970, 173–74.

67 However, it is unlikely that Caravaggio's example inspired Velázquez's early style – see Chapter 1, n. 47.

68 Carducho, 1979, lxxxviii–xcv and 177–213.

69 Ibid., 271–72 n. 701, following Angulo Iñiguez and Pérez Sánchez, 1969, 96.

70 Carducho, 1979, 275.

71 Ibid., 275 n. 708.

72 Ibid., 236–49.

73 For Carducho's drawings, see Angulo Iñiguez and Pérez Sánchez, 1977, 27–48.

74 For Velázquez's working methods, see Garrido Pérez, 1992; McKim-Smith, 1979 and 1980; and McKim-Smith, Andersen-Bergdoll, and Newman, 1988.

75 Carducho, 1979, 350–51.

76 Velázquez also painted an early *Supper at Emmaus* (Dublin, National Gallery of Ireland) with a similar compositional inversion; Brown, 1986, 16–21, discusses both pictures.

77 See ibid., 43–56; and Cherry, 1991.

78 After Fonseca died on 15 January 1627, the *Waterseller* remained within the sphere of the court. It was acquired from Fonseca's estate by Gaspar de Bracamonte, a chamberlain (*camerero*) to one of the king's brothers, the Cardinal-Infante Ferdinand. See López Navío, 1961, 54 and 64.

79 A *Supper at Emmaus* (New York, Metropolitan Museum of Art) by Velázquez has been assigned dates ranging from 1619 to 1628–29. His *Christ after the Flagellation Contemplated by the Christian Soul* (London, National Gallery) and *Temptation of Saint Thomas Aquinas* (Orihuela, Museo Diocesano) have each been assigned dates before and after his first trip to Italy (1629–31) by different scholars.

80 Carducho, 1979, 137–38.

81 He also remarks on the efficacy of religious painting in ibid., 354–58.

82 Alternatively, "pleasure to the senses" (*que dé gusto al sentido*).

83 Ibid., 326–30.

84 Ibid., 330–33.

85 For this project, see also Angulo Iñiguez and Pérez Sánchez, 1969, 185–86, nos. 495–508, and 1977, 31, no. 134; and Marías, 1989, 143.

86 The Pardo Palace has yet to be studied with the thoroughness it merits, but Calandre, 1953, provides a useful introduction; see also Marías, 1989.

87 In Orso, 1986, 108 and 110, I incorporated such moralizing readings of these two pictures into an overall interpretation (87–117) of the New Room decoration as a declaration of the virtues and mission of the Spanish Habsburg regime. Notwithstanding my revised, more cautious stance regarding the subject of Carducho's painting (see n. 32 in this section), I continue to believe the picture would have conformed to the programmatic aims that governed the New Room ensemble, whichever Scipio it depicted.

 Regarding the problem of identifying Carducho's subject, it is suggestive that the Master's prescription for decorating royal galleries includes "Scipio against Hannibal" as a suitable topic. If Hannibal's opponent, Scipio the Elder, was the hero of Carducho's New Room painting, then it is possible that by listing "Scipio against Hannibal" in the Seventh Dialogue, Carducho was slipping another reminder of his past services to the crown into the *Diálogos*. Scipio the Elder would be especially relevant at the Spanish court because he won battles against the Carthaginians in Spain. On the other hand, Scipio the Younger served briefly in Spain, and as the destroyer of Carthage he could be regarded as a model for Christian Spain's traditional opposition to the Muslim forces of northern Africa.

 Another consideration in favor of identifying Carducho's protagonist as Scipio the Elder is that the episode from his life that was most often de-

picted in Baroque art, the "Continence of Scipio," demonstrated a moral restraint and generosity of spirit that were the antithesis of Agamemnon's behavior toward Chryses and Chryseis. (For Renaissance and Baroque renderings of the theme, see Pigler, 1974, 2:424–29.) It is conceivable that Carducho and Cajés might have coordinated their choices of subjects to make a moral contrast between the two. Against this reasoning, it must be conceded that the 1636 inventory entry on the *Scipio* quoted earlier in this chapter seems to describe something other than his continence – an *adlocutio* before battle, perhaps, or Scipio rewarding his troops following a victory.

88 Of course, Carducho expected such painters to demonstrate command of drawing and the theoretical bases of art. Following Vasari, his ideal masters were Michelangelo and Raphael; he regarded Titian as a colorist who was deficient in drawing. See, for example, Carducho, 1979, 200–01 and 270.

89 Ibid., 190.

90 Ibid., 334–36.

91 Ibid., 336–38.

92 Ibid., 338–39.

93 Ibid., 340.

94 Martínez, 1950, 194–95.

95 Palomino de Castro y Velasco, 1947, 930. The anecdote appears amid Palomino's account of Velázquez's career in the 1650s; however, because Palomino uses it to illustrate the artist's wit and lack of envy, it is uncertain when Palomino thought this exchange had occurred. Palomino also says that following his death, Velázquez was again the object of envious accusations, but these do not seem to have been attacks on his artistic ability (935). See also n. 30 in this section.

96 In particular, see Pacheco, 1956, 1:212–36; Brown, 1978, 54–59; and the editor's notes to Pacheco, 1990, 248–65.

97 Brown, 1986, 16–29, with references to further literature.

98 Brown, 1978, 73–77. See also Lleó Cañal, 1979, 52–55; and López Torrijos, 1985, 100–11.

99 Brown, 1978, 77–80. See also Lleó Cañal, 1979, 45–49; and López Torrijos, 1985, 129–37. For two other ceilings with mythological subjects in the Casa de Pilatos (a *Prometheus* by Pacheco and an ensemble by an anonymous hand centered on a *Banquet of the Gods*), see Lleó Cañal, 1979, 49–52; and López Torrijos, 1985, 111–13 and 245–48.

100 "Documentos," 1960, 215–16, no. 8.

101 See the cautionary remarks on this point by Francisco Calvo Serraller in Carducho, 1979, xvi–xvii; I perceive a bit more antagonism between the two artists than he does. For a markedly different interpretation of the situation that sees Carducho and Velázquez as allies, with Velázquez understood to be the Disciple and Carducho the Master in the *Diálogos,* see Volk, 1977, 108–12.

102 "Documentos," 1960, 228–29, no. 35; and Martín González, 1958a, 59–62. The other candidates were Juan de la Corte, Francisco de las Cuevas, Felipe Diriksen, Francisco Gómez, Antonio de Monreal, Antonio de Salazar, Giulio Cesare Semini, and Juan van der Hamen y León. Carducho, 1979, 447, refers to the concern that the king showed by ordering this review as evidence for the nobility of painting.

103 Lanchares, who died in 1630, seems not to have figured otherwise in the maneuvering among the king's painters; for his career, see Angulo Iñiguez and Pérez Sánchez, 1969, 260–65. On 25 January 1631 the crown settled

a debt of 670,202 *maravedís* that it owed Nardi by granting him the annual salary of 72,000 *maravedís* that González had received as a *pintor del rey* – see Martín González, 1958a, 62–63; and Pérez de Guzmán y Gallo, 1914–15, 57 n. 1. For evidence that Velázquez and Nardi were friends by the mid-1630s, see a document of 18 May 1633 in which Velázquez empowers Nardi to collect on Velázquez's behalf certain moneys that were due him – "Documentos," 1960, 234, no. 49. For more on Castelo's ties to Carducho, see the Epilogue to this volume.

104 "Documentos," 1960, 236–37, no. 53.

105 For Van der Hamen's life and art, see Jordan, 1967, and 1985, 18–19 and 103–46; and Museo del Prado, 1986, 26–51.

106 One foray into genre painting is also known – see Jordan, 1985, 115–16.

107 For these pictures, see Jordan, 1967, 1:122–42 and 2:339–40, and 1985, 114–15; and Ruiz Alcón, 1977.

108 For these pictures, see Jordan, 1985, 144–46.

109 For this portrait, see ibid., 120–21; and Museo del Prado, 1986, 28–29.

110 See Harris, 1970, 364–68 and 371–72; and Jordan, 1985, 117–18, for the following account.

111 As given in Jordan, 1985, 117; the journal is preserved in a copy in BAV, Ms. Barb. lat. 5,689, folios unnumbered.

112 Jordan, 1985, 119.

113 See n. 102 of this section.

114 Pacheco, 1956, 2:126–27, as translated in Enggass and Brown, 1970, 216.

115 For the following remarks, see Orso, 1986, 55–56 and 58–59, which builds upon Gerard, 1982.

116 For this picture, see *Correspondance,* 1887–1909, 2:137; Díaz Padrón, 1975, 1:317–20; Orso, 1986, 46–47; and Rubens, 1955, 61.

117 Balis, 1986, 180. Balis's documentation supersedes the claim by Pacheco, 1956, 1:153, which I previously followed (Orso, 1986, 56), that the paintings were Rubens's gift to Philip IV. In fact, the king ordered and paid for them.

118 On the identification of these works, see Orso, 1986, 56–57 (following Harris, 1970, 372 n. 37). For the hunts and the Old Testament subjects, see also Balis, 1986, 180–91, nos. 12–13; and D'Hulst and Vandenven, 1989, 67–69, no. 16, 96–99, no. 26, and 121–22, no. 35.

119 For Rubens's 1628–30 visits to Madrid and London, see Brown, 1978, 105–06; *Correspondance,* 1887–1909, 5:1–290 passim; Cruzada Villaamil, 1874, 94–274; Rubens, 1955, 283–354; Le Flem, 1990, 178–90; and Wedgwood, 1975, 7–10 and 42–52.

120 Pacheco, 1956, 1:153–54. The *Saint John* is lost; see Vlieghe, 1973, 102, no. 123. The other two pictures are in Madrid, Museo del Prado, cats. 1,627 and 1,638; see Díaz Padrón, 1975, 1:224–29.

121 Huemer, 1977, 72–78 and 150–54, no. 30; and Orso, 1986, 58.

122 Pacheco, 1956, 1:154. The correspondence to which he refers probably concerned a likeness of Olivares that Velázquez had provided as a model for a portrait engraving that the count-duke had commissioned Rubens to design. Olivares acknowledged receipt of the finished print on 8 August 1626. See Harris, 1970, 367; Brown, 1976; and Held, 1980, 1:398–99, no. 295. The suggestion by Balis, 1986, 180, that the correspondence dealt with Rubens's eight paintings for the New Room is less likely because Velázquez is not known to have overseen the decoration of the Alcázar that early in his career.

123 *Correspondance,* 1887–1909, 5:10 and 148; and Rubens, 1955, 291–93 and 321.

124 Pacheco, 1956, 1:153.

125 See Held, 1982, 302–34; and Museo del Prado, 1987, 37–62.

126 Brown, 1986, 65–66.

127 "Documentos," 1960, 230–31, no. 41; and Pacheco, 1956, 1:158.

3. BACCHUS AND THE HISTORIANS

1 For an introduction to the efforts of Spanish historians to evaluate the evidence of classical myths, see Tate, 1954.

2 As translated in Pliny the Elder, 1938–63, 2:9 and 11.

3 As translated in Silius Italicus, 1934, 1:121.

4 Translation adapted from ibid., 1:143; in particular, *Oceano* is here given literally as "ocean" rather than metaphorically as "commerce."

5 See, for example, Caro, 1634, 70v and 110v–11.

6 Campbell, 1936; and Vessey, 1984.

7 Plutarch [*spurious*], 1618, 54–55; the translation is by James J. O'Donnell.

8 For Margarit's life, see Tate, 1955; and Lawrance, 1990, 230–31. For the *Paralipomenon,* see Tate, 1951–52.

9 [Margarit i Pau,] 1545, 10v; the translation is by James J. O'Donnell. Margarit also makes briefer references to Pliny's remarks on 4 and 20.

10 For Nebrija's biography, see Lawrance, 1990, 240–46; Lemus y Rubio, 1910–13, 22:459–508; and the introductory studies in Nebrija, 1926, xviii–xl, and 1980, 9–18. For his activity as a historian, see also Sánchez Alonso, 1945; and Tate, 1957.

11 Nebrija took Aelius from inscriptions to anonymous Aelii and Aeliani found near Lebrija; by adopting it, he sought to associate himself with the Roman emperors Aelius Hadrian and Aelius Trajan, who had been born in Iberia (Lawrance, 1990, 241).

12 For this work, see Nebrija, 1980, 19–88.

13 Ibid., 108–09. Pliny cites Bocchus in *Natural History* 16.79.216.

14 For the *Muestra,* see Tate, 1957, 127–31.

15 Nebrija, 1926, 222–23, commentary on line 20.

16 For the *Decades,* see Sánchez Alonso, 1945, 129–49; and Tate, 1957, 131–40.

17 It was also Sancho who published Margarit's *Paralipomenon Hispaniae* in 1545 (Tate, 1951–52, 143). Tate, 1957, 128, leaves open whether Antonio was familiar with the work; Lawrance, 1990, 241, presumes Sancho based the publication upon a copy of the *Paralipomenon* that he had found among Antonio's papers.

18 Nebrija, 1545, unpaged; the translation is by James J. O'Donnell.

19 For Marineus, see Lynn, 1937; and Sánchez Alonso, 1941–44; 1:375–77. The first four books of *De rebus Hispaniae memorabilibus,* which treat the early history of Spain, incorporate material that Marineus published earlier in his *De Hispaniae laudibus* (Burgos, ca. 1497). I have not been able to consult the latter to determine whether it, too, refers to Bacchus in Iberia.

20 Marineus Siculus, 1539, IX.

21 Ibid., IXv.

22 Ibid., XLV.

23 Tate, 1954, 11–17.

24 Faria e Sousa, 1628, 23–24, propounded an ingenious solution to the prob-

lem. He held that after the death of Luso, whom he identified as a Portuguese king much beloved by his subjects, Bacchus persuaded the Portuguese to accept Bacchus's son Lisias as their ruler by telling them that Luso's soul had been transferred into Lisias's body.

25 For Ocampo, see Sánchez Alonso, 1941–50, 2:13–18, 70, and 90; and Tate, 1954, 15–16.

26 Ocampo, 1791, 1:156–59.

27 The correct citation is the eleventh chapter of Book One (ibid., 1:85–90).

28 In this complicated passage, Ocampo refers to an Egyptian captain, Osiris Dionysus, who journeyed to Iberia and conquered there (ibid.), as did his son Oron Libio, also known as the Egyptian Hercules (ibid., 1:92–104 and 114–18). On the several traditions of different men named Hercules who visited Spain, see also Tate, 1951–52, 159–60, and 1954, 3–18.

29 For his remarks on Deucalion and Pyrrha, see Ocampo, 1791, 1:135.

30 Ibid., 1:78–79; see also 1:403–04 and 2:2. Ocampo's remarks on the geography of Lebrija follow a passage in Nebrija's *Muestra* – compare Nebrija, 1926, 221–22.

31 The apparent reference is to the *Primera crónica general de España,* a history of Spain compiled at the order of Alfonso X, which attributes the founding of Lisbon (*Lixbona*) to a grandson of Ulysses; see *Primera crónica,* 1955, 1: 9.

32 See Pliny the Elder, *Natural History* 3.3.22; and Strabo, *Geography* 3.4.10. Livy, *From the Founding of the City,* gives the location of the town at 21.23.2 and recounts actions of its inhabitants at 21.61.8, 28.24.4, 28.26.7, 28.27.5, 28.34.4, and 34.20.2–9.

33 Ocampo, 1791, 1:7.

34 Ibid., 1:89.

35 Ibid., 1:361–62.

36 Ibid., 1:138–39.

37 The reference here is to Hispan, a mythic king of Spain said by some to have inspired the Latin name for Spain, *Hispania,* and to have founded Seville, called *Hispalis* in Latin. For Ocampo's account of Hispan's reign, see ibid., 1:108–14; see also Tate, 1954, 5–17.

38 Ocampo, 1791, 1:159–65; for his life of Palatuo, see 1:165–68.

39 Indeed, this distinction led the one previous scholar who considered Ocampo's text as a possible source for works like *Los Borrachos* to reject it; see López Torrijos, 1985, 338–39 and 342.

40 Ocampo, 1791, 1:92–94, 158, 193–94, 249, 274, and 316; see also n. 28 in this section.

41 For Spanish images of Hercules, see López Torrijos, 1985, 115–85.

42 For this series, see Brown and Elliott, 1980, 156–61; and Museo del Prado, 1988, 227–30 and 234–45.

43 Ocampo, 1791, 1:95–97; although Ocampo does not specify the mountains by name, this is clearly the feat to which he refers.

44 Epigrams 48–49, as translated in Ausonius, 1919, 2:187; the "sons of Ogyges" were the Thebans, and "Lucaniacus" was Ausonius's estate.

45 In order of appearance: Beuter, 1982, 116 (first published in Valencia, 1538); Medina, 1944, 16, 80, and 218 (first published in Seville, 1548); Tarafa, 1553, 29–30, and 1562–63, 20–20ᵛ; Garibay y Zamalloa, 1571, 1: 110 and 112; Mariana, 1864–72, 1:10 and 14 (first published in Latin in Toledo, 1592, and in Castilian in Toledo, 1601); Nonnius, 1603, 380, 396–97, and 409; and Carrillo, 1622, 15.

46 In order of appearance: Arraiz, 1604, 108 and 112ᵛ–13 (first published in

Coimbra, 1589); Brito, 1973, 50v–52v (first published in Alcobaça, 1597); Nunes do Leão, 1610, 11v–12 and 156–56v; and Faria e Sousa, 1628, 23–24.

47 Respectively, Suarez de Salazar, 1610, 281–84; Arellano, 1628, 48v–49v; and Escolano, 1972, 1:42–44 (first published in Valencia, 1610). Suarez de Salazar, 282, notes that according to the Orphic *Argonautica*, Cádiz was consecrated to Bacchus; for that, see *Les Argonautiques*, 1987, 164, lines 1,243–44.

48 Respectively, Poza, 1959, part 2, 19v and 25–25v (first published in Bilbao, 1587); Aldrete, 1606, 263 (misnumbered '267'), 274–75, and 297–98; Ortelius, 1968, 16 and X (first published in Latin in Antwerp, 1570, and in Castilian in Antwerp, 1588); Marieta, 1596, 26 and 29v; and Hurtado de Mendoza, 1948, 89 and 182–84 (first published in Lisbon, 1627). Hurtado de Mendoza suggested that Seville was founded by followers of Bacchus, but that was a minority view. For a useful compilation of different traditions of the founding of Seville, see Caro, 1634, 3–6v.

49 Covarrubias Orozco, 1977, 765 (first published in Madrid, 1611).

50 For Pineda and the academy, see Brown, 1978, 41.

51 Pineda, 1609, 193; the translation is by James J. O'Donnell.

52 For Caro, see Brown, 1978, 35–37, 39, and 82–83; Santiago Montoto's introduction to Caro, 1915, i–lxxix; Gómez Canseco, 1986; and Morales, 1947.

53 Caro, 1634, unpaged prologue ("Silva a Sevilla"), 2v, 5, 8–8v, 118v, and 138v.

54 Sánchez Cantón, 1925, 396, no. 65. The library also contained Latin and Italian editions of Pliny's *Natural History* and a Spanish edition of Ortelius (see n. 48 in this section), but there is no way to determine whether Velázquez acquired them before he painted *Los Borrachos* (Sánchez Cantón, 1925, 401, no. 109, 402, no. 122, and 404, no. 139).

55 Brown, 1978, 81–82, speculates that Velázquez's experience in Pacheco's academy was crucial in shaping Velázquez's distinctive approach to mythological subjects. Insofar as *Los Borrachos* is concerned, I believe his position is borne out by the likelihood that it was in Pacheco's circle that Velázquez learned the myth of Bacchus in Iberia. As I argue in Chapter 4, that tradition is essential to understanding the painting.

4. BACCHUS IN IBERIA

1 For these prints, see Lightbown, 1986, 239–40 and 490, cats. 208–09. Because *Los Borrachos* has apparently been cut around its edges (see Introduction, n. 2), its original height-to-width ratio may have differed slightly from the present one, but it would still have been close to the ratio for Mantegna's prints.

2 Valdivieso and Serrera, 1985, 42.

3 Pacheco, 1956, 1:157–58.

4 Maravall, 1944, 322–23.

5 Elliott and Peña, 1978–80, 1:238 (as translated in Stradling, 1988, 189).

6 Garrido Pérez, 1992, 171–73, concludes from a detailed technical study of the canvas that Velázquez could have introduced the standing figure asking for a drink and the seated figure at the lower left late in the development of the composition in order to give it "a diagonal movement from left to

right." It is also possible that Velázquez added the standing figure in order to reinforce the idea that the god offered his followers desirable benefits. (It was probably the introduction of the standing figure that prompted Velázquez to change what was originally a frontal view of the bagpiper's head to the left profile view, looking up toward the newcomer, that we see today – ibid., 173.) For the seated figure at the lower left, see also n. 17 in this section.

7 Borelius, 1960, 246; and Gállego, 1983, 71, note the division of the composition into halves. They perceive the figures in those halves to be painted in different styles: markedly realistic peasants to the right, and a more idealized god and his companion to the left.

8 See *Coronacion,* 1619, unpaged.

9 For this trip, see Elliott, 1986, 152–54, 158, and 165; Mercado Egea, 1980; and Stradling, 1988, 54–55. The king's itinerary included Seville and Cádiz, but he did not visit Lebrija.

10 For this trip, see Elliott, 1963, 214–47, and 1986, 255–66; and Novoa, 1876–86, 1:14–51 passim.

11 As translated in Diodorus of Sicily, 1933–67, 2:93.

12 As translated in Silius Italicus, 1934, 2:331 and 487.

13 Núñez de Castro, 1658, 24ᵛ; however, in a revised, second edition published a few years after Philip IV's death in 1665, Núñez de Castro lists the same nine viceregencies but only ten governorships (1669, 159).

14 As translated in Pliny the Elder, 1938–62, 4:393.

15 See Chapter 1.

16 Carducho, 1979, 328.

17 As remarked in n. 6 in this section, Garrido Pérez, 1992, 171–73, concludes that Velázquez could have introduced the seated, garlanded figure at the lower left corner (along with the standing figure at the upper right) late in the development of the composition in order to give it a diagonal movement. It is also possible that Velázquez added the seated figure to amplify the suggestion that Bacchus rewarded his Iberian followers for the victories they had won for him.

18 For the *annus mirabilis,* see Elliott, 1986, 226–43.

19 Ibid., 256–58.

20 Ibid., 299–304 and 355–57.

21 Ibid., 362–65 and 387–88.

22 Ibid., 337–46, 366–67, 387, 398–99, and 400–02; Elliott, 1984, 95–112; and Stradling, 1988, 72–75.

23 The possibility that the tree is supporting grapevines, like the fruit tree in Mantegna's *Bacchanal with a Wine Vat* (fig. 55), can be dismissed because no grapes are visible amid the foliage.

24 See the Introduction and Appendix D, no. 4.

25 As translated in Pliny the Elder, 1938–62, 9:277 and 279. The victory in question was Mummius's defeat of the Greeks in 146 B.C., when Corinth was destroyed; however, for other sources that contradict Pliny's account, see 9:278 n. a.

26 Ibid., 9:335.

27 Pacheco, 1956, 1:102.

28 Brown and Elliott, 1980, 40–42; and Stradling, 1988, 310–11. In an autobiographical essay written in 1633, the king explicitly acknowledged the vital role that studying history had played in preparing him to govern; see Philip IV of Spain, 1958.

29 In 1701 an inventory was taken of the library in the Alcázar of Madrid for the massive *testamentaría* of the king's possessions that was compiled following the death of Charles II in 1700 – see Fernández Bayton, 1975–85, 3:287–410. An anonymous modern hand has noted on the original of the library inventory that its first 1,985 entries correspond to an earlier accounting of Philip IV's library, based upon a comparison to a manuscript in the Biblioteca Nacional, Madrid that I have not been able to consult (ibid., 3:380). Thus, the identifications from Philip's library that follow use the entry numbers given in the modern edition of the Charles II *testamentaría*.

 For Nebrija's *Decades,* Marineus's *Cosas memorables,* and Ocampo's *Crónica general,* see numbers 38, 52, and 53. For fifteen of the nineteen books cited in Chapter 3, nn. 45–49, compare numbers 25, 36, 37, 63, 69, 78, 114, 124, 156, 184, 191 and 242 (two copies of one work), 223, 795, 1,353, and 1,758. In addition, numbers 62 and 1,538 may correspond to two other titles cited in Chapter 3, n. 48.

 The inventory also lists other works that bear upon this study: Alciati's *Emblems* (1,757), two copies of Diodorus of Sicily (1,057 and 1,086), two copies of Livy (1,096 and 1,098), five copies of Ovid's *Metamorphoses* (1,130–33 and 1,152), Pérez de Moya's *Filosofía secreta* (884), Pliny the Elder's *Natural History* (1,128), and Strabo's *Geography* (805). If an "*Obras de Pultarrcho*" (1,069) was a collection of Plutarch's works, perhaps it included the pseudo-Plutarchian *De fluviorum et montium nominibus.*

30 Mariana, 1864–72, 1:10 and 14.

31 Elliott, 1986, 175; and Stradling, 1988, 63.

32 Brown, 1978, 35, 36, 40, 59–61, 70, and 82; Brown and Elliott, 1980, 23–24 and 42; and Elliott, 1986, 22, 25, and 141.

33 The apartments were located on two of the lower floors on the north side of the Alcázar, where they were shielded from direct exposure to the sun. See Orso, 1986, 23; and Volk, 1981.

34 Like so many other Habsburgs, Philip IV was especially devoted to the Eucharist – see Stradling, 1988, 343; and Orso, 1989, 3, 4, 76, 88, and 98–99.

35 Wethey, 1969–75, 1:124.

36 This view of palace decoration under Philip IV informs the analysis of the Alcázar of Madrid – in particular, of its Hall of Mirrors – that I advanced in Orso, 1986. Reaction to my arguments has varied. Brown, 1986, adopts many of my conclusions, but for a dissenting view, see Lleó Cañal, 1987.

37 See Appendix B, no. 16.

38 For this painting, see Kimbell Art Museum, 1982, 122–27; and López Torrijos, 1985, 345–48.

39 Mayer, 1927, first associated Ribera's painting with Icarius reliefs. For examples of such reliefs known in Ribera's time, see Bober and Rubinstein, 1986, 122–24. It was Darby, 1943, 142, who related Ribera's painting to the engraving, which is usually said to be an illustration to Antonio Lafreri's *Speculum Romanae Magnificentiae,* a book that never existed. What Lafreri, who was a publisher, actually issued was a title page to be used for collections of prints illustrating the antiquities of Rome; see Lowry, 1952, 46–47.

40 A fourth fragment showing *Three Heads on a Table* (the theatrical masks beneath the triclinium) was recorded in the Buen Retiro in 1772, but its present whereabouts are unknown (Darby, 1943, 140–41 n. 4; and López Torrijos, 1985, 346).

41 See Appendix C, no. 2.

42 For Ribera's viceregal patronage, see Brown, 1984.

43 In this vein, Kimbell Art Museum, 1982, 122–23, argues that the figure traditionally identified in the reliefs as Silenus was meant to be identified in Ribera's painting as Pan (fig. 62). I think it unlikely that it was to a viceroy's advantage to identify himself with so coarse a fellow, especially when the figure based upon Icarius would have provided a more attractive counterpart.

44 For the duke's biography, see Brown and Kagan, 1987, 231–36; and González Moreno, 1969.

45 Although the painting was not listed in the 1636 inventory of the king's collection in the Alcázar, it is not necessarily the case that the *Fable* came into Philip's possession sometime thereafter. It could have hung for a time in another of the king's residences.

46 However, Spinosa, 1979, 106, no. 90, dates it to 1634–35.

47 For example, when he lived in Palermo as viceroy of Sicily, he used an agent in Naples to order a print and a painting of the Virgin from the artist – see Brown and Kagan, 1987, 245; and Saltillo, 1941.

48 Brown, 1978, 38–39, 60–61, 71, 73, and 77–80.

49 For the duke's art collecting, see Brown and Kagan, 1987, 236–55; Burke, 1984, 1:50–56 and 2:9–13; and López Torrijos, 1985, 76–78. For the ceiling paintings, see this volume, Chapter 2, n. 99.

50 Darby, 1943, 146–47, noted that the duke owned an Icarius relief and suggested that his understanding of it was informed by the tradition of Bacchus in Iberia, which, she argued, he could have known from Rodrigo Caro's *Antigüedades de Sevilla*. However, she thought that Ribera intended his painting to be a satire on the corruption of the court and the king's reliance upon his favorite, the count-duke of Olivares (147–48). It is improbable that a painter or a viceroy would have insulted the king by making him such a gift. Darby did not relate Velázquez's painting of Bacchus to the myth, declaring instead that, "As the lord of the vineyard . . . [Dionysus] may also vouchsafe to churls a mocking delusion of equality with the gods; so he does in Velasquez's *Borrachos* but not in the ancient reliefs which now concern us" (145).

51 Velázquez returned to Madrid from Naples early in 1631 (Pacheco, 1956, 1:161); Alcalá did not depart from Naples until 13 May 1631 (Brown and Kagan, 1987, 235).

52 Brown, 1984, 144–45; for the count's art collecting, see also Burke, 1984, 1:57–72 and 2:15–18.

53 Pacheco, 1956, 1:160.

54 Antonio Alvarez de Toledo, fifth duke of Alba, who preceded Alcalá as viceroy from 1622 to 1629, is unlikely to have commissioned the *Fable* because he preferred Belisario Corenzio's work to Ribera's; see Brown, 1984, 142.

55 Brown and Elliott, 1980, 123–25; and Museo del Prado, 1985, 304.

56 Kimbell Art Museum, 1982, 122–23.

57 The most detailed description of the entry is *Noticia,* 1650. See also Sáenz de Miera Santos, 1986; Varey and Salazar, 1966; and Villaverde Prado y Salazar, n.d.

58 For this drawing, see Pérez Sánchez, 1980, 104, no. 231; and Sáenz de Miera Santos, 1986, 172. The contemporary account is *Noticia,* 1650, 85–86.

59 *Noticia,* 1650, 85 (emphasis in the original).

60 López Torrijos, 1985, 155–56, 338–39, and 342.

61 For Hercules as a conqueror of Spain, see Chapter 3, n. 28.

62 Bacchus also appeared along the queen's parade route in the Calle de los Boteros as a statue in a fountain that flowed with wine (*Noticia*, 1650, 72; and Villaverde Prado y Salazar, n.d., unpaged). This showed him in his role as wine-giver rather than as a ruler of Spain.

63 For Hercules imagery in Spain, see López Torrijos, 1985, 115–85.

64 Brown and Elliott, 1980, 156–61; and Museo del Prado, 1988, 227–30 and 234–45.

65 For example, in his influential handbook on symbolism, Cesare Ripa cites four different images of Hercules as personifications of heroic virtue (Ripa, 1976, 537–38).

66 Compare the greater number of images of Hercules, as opposed to those of Bacchus, cited in two surveys: Pigler, 1974, 2:43–53, 107–33, 179–80, 182, and 225; and López Torrijos, 1985, 115–85 and 337–49.

67 A similar phenomenon has been observed in Velázquez's portraits of Philip IV, which eschew bombast in favor of sober understatement; see Brown, 1988.

68 See Brown, 1986, 69–81, for an overview of the trip.

69 See Chapter 1, n. 40. Velázquez's other known history painting from his first Italian trip, the *Bloody Coat of Joseph,* likewise seems to have been a straightforward exercise in the techniques that he was trying to master. It, too, adapts a print – a woodcut by Bernard Salomon (Soria, 1948, 252–53).

70 McKim-Smith, Andersen-Bergdoll, and Newman, 1988, 75–76.

71 Kahr, 1976, 92, made the identification; see also the pertinent remarks in Brown, 1986, 168.

72 Brief mention might also be made of Velázquez's other surviving ventures into the world of antiquity – two paintings of sibyls and three paintings of ancient philosophers. Each sibyl, like the mythologies, can be understood simply as a classical subject rendered in a realist style. Brown, 1986, 178 and 181, has questioned the identification of one *Sibyl* (Dallas, Meadows Museum), which he prefers to describe as a "Female Figure"; however, unpublished research by Marcus B. Burke has since established grounds for retaining its designation as a *Sibyl.* (I am grateful to Dr. Burke for sharing his findings with me.) For the other *Sibyl* (Madrid, Museo del Prado), see Brown, 1986, 161–62.

The philosophers have more complicated origins that have yet to be fully explained. The *Democritus* (Rouen, Musée des Beaux-Arts) is a re-painting of what was originally a "Sense of Taste." To understand the *Aesop* and *Menippus* (both Madrid, Museo del Prado), it will first be necessary to explain the origins of the "beggar-philosopher" as a subject in the art of Jusepe de Ribera, whose example apparently inspired Velázquez's treatments of the theme. For these three pictures, see Brown, 1986, 57 and 162–68.

73 For the genesis of this picture, see Brown, 1986, 181–83; and Bull and Harris, 1986.

74 For this picture, see Brown, 1986, 246–48.

75 For an overview of the challenges to our understanding posed by the *Arachne,* see ibid., 252–53 and 302–03 nn. 32–42; and Burke, 1981.

1 The essential account of the Hall of Realms is Brown and Elliott, 1980, 141–92, which illustrates all the pictures for the hall that survive.

2 Angulo Iñiguez and Pérez Sánchez, 1969, 219 and 253–55. Only one of the pictures, the *Recapture of Puerto Rico,* has survived; the other, the *Capture of St. Martin,* is lost.

3 Ibid., 190–202, for Castelo's career.

4 Martínez, 1950, 189.

5 "Documentos," 1960, 228–29, no. 35.

6 Ibid., 250–51, no. 80; and see this volume, Chapter 2, n. 54.

7 For more on Maino's ties to the Olivares circle as a factor in his receiving a commission for a battle picture, see Orso, 1991.

8 For Pereda's career, see Angulo Iñiguez and Pérez Sánchez, 1983, 138–239; and Pérez Sánchez, 1978, unnumbered pages.

9 Brown and Elliott, 1980, 138.

10 For Leonardo's career, see Angulo Iñiguez and Pérez Sánchez, 1983, 78–103; and Mazón de la Torre, 1977.

11 For Gómez de Mora's career, see Museo Municipal, 1986.

12 For the tangled evidence on these matters, see ibid., 31–33; Brown and Elliott, 1980, 57; and Orso, 1986, 25 n. 40.

13 For the decoration of royal exequies, see Orso, 1989, 13–49.

14 For the artists who worked on Isabella's exequies, see Orso, 1990, 54–55 and 57–58. The preparations for Baltasar Carlos's exequies are documented in APM, SH, Honras fúnebres, caja 76, Baltasar Carlos (1646); and in the Archivo General de Simancas, Contaduría Mayor, 3ª época, leg. 756, Pagador Francisco de Villanueva, 1645–48, Destajos, nos. 1–29, 37–38, 81, 101, 104, 125, 152–54, 156–57, and 187, and Extraordinario, nos. 97–98, 103–08, 224, 247, 303, 305, 314, and 325.

15 Martín González, 1958b, 133; and Orso, 1989, 39 and 71 n. 3.

16 Brown, 1986, 183.

17 For the following remarks, see ibid., 192–93; and "Documentos," 1960, 257, no. 95.

18 Harris, 1960, 128; see also Brown, 1986, 242–44.

19 Other works listed in the 1666 inventory are assigned to Leonardo da Vinci, Giovanni Lanfranco, one of the Procaccini, Anthony Van Dyck, and Paolo Veronese, but these attributions cannot be confirmed. A picture attributed to Pietro da Cortona has been identified as a work by Viviano Codazzi; four other paintings may have been by Giuseppe Arcimboldo.

20 Bottineau, 1956–58, 60:179; and Palomino de Castro y Velasco, 1947, 916.

21 For Velázquez's career as a court decorator, see Brown, 1986, 191–97, 208–09, 213–17, and 232–51.

22 "Documentos," 1960, 280, no. 145.

23 Harris, 1960, 127; and Orso, 1986, 65.

24 Harris, 1960, 128.

25 The inventory also lists an unattributed *Diana with an Arrow* and two other history paintings with antique subjects, a *Pythagoras and His Disciples* by Rubens and a *Blinding of Samson* by one of the Procaccini.

APPENDIX A

1 The Latin text is taken from Calderón y Tejero, 1945, 12–13; the translation is by James J. O'Donnell.

2 Ibid., 12, gives *Excluit,* but *Exciuit* is probably intended.

3 Ibid., 13, gives *nunca,* but *nunc* is surely intended.

4 The sun.

5 The Atlantic.

6 The morning star.

7 The reference is to the Islamic invasion of Spain in 711 during the reign of the Visigothic king Roderic.

APPENDIX B

1 APM, SA, Inventarios, leg. 768, 1636, fols. 35bis–37v; the numbering is my own. The transcription omits marginal notations that reiterate the identifications of the subjects given in the entries and other notations by a later hand that are irrelevant to this study. Most of the identifications of works in the notes that follow were made in Volk, 1981, 520. I have left untranslated some of the specialized vocabulary for sixteenth-century Spanish costume, for which see Bernis, 1990.

2 Alonso Sánchez Coello, *Infanta Isabella Clara Eugenia and Magdalena Ruiz* (Madrid, Museo del Prado, cat. 861).

3 Juan Pantoja de la Cruz after Sophonisba Anguissola, *Isabella of Valois* (Madrid, Museo del Prado, cat. 1,030).

4 Anthonis Mor, *Mary, Queen of England* (Madrid, Museo del Prado, cat. 2,108).

5 Anthonis Mor, *Catherine of Austria, Queen of Portugal* (Madrid, Museo del Prado, cat. 2,109).

6 Justus Tilens (Tiel), *Allegory of the Education of Philip III* (Madrid, Museo del Prado, cat. 1,846).

7 Titian, *Philip II in Armor* (Madrid, Museo del Prado, cat. 411).

8 Titian, *Venus Looking at a Mirror Held by Cupid,* a lost work known from a copy by Peter Paul Rubens (Castaguola, Thyssen-Bornemisza Foundation).

9 Titian, *Charles V and Isabella of Portugal,* a lost work known from a copy by Peter Paul Rubens (Madrid, collection of the Duchess of Alba).

10 Peter Paul Rubens and Jan Wildens, *The Act of Devotion of Rudolf I* (Madrid, Museo del Prado, cat. 1,645).

11 Diego de Velázquez, *Los Borrachos,* here identified as *Bacchus in Iberia* (Madrid, Museo del Prado, cat. 1,170).

12 Peter Paul Rubens and Frans Snyders, *Festoon of Fruits and Flowers* (Madrid, Museo del Prado, cat. 1,420).

13 Perhaps a corruption of *coleto de ámbar,* referring to the perfuming of a *coleto* with amber (for which practice, see Bernis, 1990, 74).

14 Apparently a variant of Alonso Sánchez Coello, *Prince Ferdinand* (Madrid, Monasterio de las Descalzas Reales), in which the *coleto* is not slashed.

15 Titian, *Religion Aided by Spain* (Madrid, Museo del Prado, cat. 430).

1 APM, SA, Bellas Artes, leg. 38, inventory of 1666, fols. 7–9; the numbering is my own. This transcription omits marginal notations that restate the appraised values of the works in *reales*. Most of the identifications of works in the notes that follow are taken from Bottineau, 1956–58, 60:292–93; see also Orihuela Maeso, 1982.

2 Massimo Stanzione, *A Sacrifice to Bacchus* (Madrid, Museo del Prado, cat. 259).

3 Jusepe de Ribera, *Fable of Bacchus,* three fragments of which are known (two in Madrid, Museo del Prado, cats. 1,122 and 1,123; and one in New York, private collection).

4 Peter Paul Rubens, *Cardinal-Infante Ferdinand at the Battle of Nördlingen* (Madrid, Museo del Prado, cat. 1,687).

5 Sébastien Bourdon, *Queen Christina of Sweden on Horseback* (Madrid, Museo del Prado, cat. 1,503).

6 I am skeptical of the speculation in Bottineau, 1956–58, 60:292, that this might be Frans Snyders's *Fruiteress* (Madrid, Museo del Prado, cat. 1,757).

7 Peter Paul Rubens and Frans Snyders, *Ceres and Pan* (Madrid, Museo del Prado, cat. 1,672).

8 Juan van der Hamen y León, *Still Life with a Vase of Flowers and a Dog* (Madrid, Museo del Prado, cat. 4,158)

9 Juan van der Hamen y León, *Still Life with a Vase of Flowers and a Puppy* (Madrid, Museo del Prado, cat. 6,413).

APPENDIX D

1 APM, SA, Bellas Artes, leg. 38, inventory of 1666, fols. 33–38; the numbering is my own. This transcription omits marginal notations that restate the appraised values of the works in *reales* and other notations by a later hand that are irrelevant to this study. Most of the identifications of individual works in the notes that follow are taken from Bottineau, 1956–58, 60:172–77.

2 Guido Reni, *Atalanta and Hippomenes* (Madrid, Museo del Prado, cat. 3,090).

3 Diego de Velázquez, *Los Borrachos,* here identified as *Bacchus in Iberia* (Madrid, Museo del Prado, cat. 1,170).

4 David Teniers the Younger, *The Bivouac* (Madrid, Museo del Prado, cat. 1,811).

5 Peter Paul Rubens, *The Judgment of Paris* (Madrid, Museo del Prado, cat. 1,731).

6 El Greco, *The Doctor* (Madrid, Museo del Prado, cat. 807).

7 Alternatively, "some hunting hounds" if *Vnas jaulas* is a corruption of *una jauría.*

8 Possibly studio of Van Dyck, *Charles I of England on Horseback* (Madrid, Museo del Prado, cat. 1,484).

9 Peter Paul Rubens, *Anne of Austria* (Madrid, Museo del Prado, cat. 1,689).

10 Peter Paul Rubens, *Diana and Callisto* (Madrid, Museo del Prado, cat. 1,671).

11 Copy after Van Dyck, *Charles II as Prince of Wales* (Madrid, Museo del Prado, cat. 1,499).

12 Jan Brueghel the Elder, *Country Wedding* (Madrid, Museo del Prado, cat. 1,441).

13 Tintoretto, *Battle of Christians and Turks* (Madrid, Museo del Prado, cat. 399); see Orso, 1986, 72.

14 Anthonis Mor, *The Artist's Wife Metgen* (Madrid, Museo del Prado, cat. 2,114).

15 Annibale Carracci, *Venus, Adonis, and Cupid* (Madrid, Museo del Prado, cat. 2,631).

16 Possibly a set of *Seasons* or *Elements* by Giuseppe Arcimboldo; see Orso, 1986, 163 n. 64.

17 Viviano Codazzi, *Exterior View of St. Peter's in Rome* (Madrid, Museo del Prado, cat. 510).

18 Destroyed in 1915; see Museo del Prado, 1990, 707, no. 2,705.

19 Sebastián de Herrera Barnuevo, the master-in-chief of the royal works and an assistant in the *furriera* (the office in charge of the palace furnishings), appraised the sculptures and furnishings cited in this inventory. The paintings were appraised by the *pintor de cámara* Juan Bautista Martínez del Mazo, who was Velázquez's son-in-law.

BIBLIOGRAPHY

Ainaud [de Lasarte], Juan. "Ribalta y Caravaggio." *Anales y Boletín de los Museos de Arte de Barcelona* 5 (1947): 345–413.

Aldrete, Bernardo [J. de]. *Del origen, y principio de la lengva castellana ò romāce que oi se usa en España.* Rome, 1606.

Angulo Iñiguez, Diego. "El 'San Antonio Abad y San Pablo Ermitaño,' de Velázquez: Algunas consideraciones sobre su arte de componer." *Archivo Español de Arte* 19 (1946): 18–34.

Velázquez: Cómo compuso sus principales cuadros. Seville, 1947.

"Las Hilanderas." *Archivo Español de Arte* 21 (1948): 1–19.

"Fábulas mitológicas de Velázquez." *Goya,* nos. 37–38 (July–Oct. 1960): 104–19.

"Velázquez y la mitología." In *III Centenario de la muerte de Velázquez,* 47–62. Madrid, 1961.

"Mythology and Seventeenth-Century Spanish Painters." In *Acts of the Twentieth International Congress of the History of Art,* 3:36–40. Princeton, N.J., 1963.

Angulo Iñiguez, Diego, and Alfonso E. Pérez Sánchez. *Escuela madrileña del primer tercio del siglo XVII.* Historia de la Pintura Española. Madrid, 1969.

A Corpus of Spanish Drawings. Volume Two: Madrid, 1600–1650. London, 1977.

Escuela madrileña del segundo tercio del siglo XVII. Historia de la Pintura Española. Madrid, 1983.

Arellano, Juan S. B. *Antigvedades, y excelencias de la villa de Carmona. Y compendio de historias.* Seville, 1628.

Arguijo, Juan de. *Obra completa de Don Juan de Arguijo (1567–1622).* Edited by Stanko B. Vranich. Valencia, 1985.

Arraiz, Amador. *Dialogos.* 2d ed. Coimbra, 1604.

Ausonius. *Ausonius.* Translated and edited by Hugh G. White. 2 vols. Loeb Classical Library. London, 1919.

Azcárate, José M. de. "Noticias sobre Velázquez en la corte." *Archivo Español de Arte* 33 (1960): 357–85.

"Datos sobre túmulos de la época de Felipe IV." *Boletín del Seminario de Estudios de Arte y Arqueología* 28 (1962): 289–96.

Balis, Arnout. *Landscapes and Hunting Scenes, II.* Translated by P. S. Falla. Corpus Rubenianum Ludwig Burchard, pt. 18, vol. 2. London, 1986.

Barrera y Leirado, Cayetano A. de la, ed. *Poesías de Francisco de Rioja.* Madrid, 1867.

Bernis, Carmen. "La moda en la España de Felipe II a través del retrato de corte." In Museo del Prado, Madrid, *Alonso Sánchez Coello y el retrato en la corte de Felipe II,* 66–111. Madrid, 1990.

Beruete, Aureliano de. *Velazquez*. Paris, 1898. English edition translated by Hugh E. Poynter. London, 1906.

Beuter, Antoni. *Crònica*. Edited by Enric Iborra. Valencia, 1982.

Blunt, Anthony. *Artistic Theory in Italy, 1450–1600*. 1940. Reprint. Oxford, 1973.

Bober, Phyllis P., and Ruth Rubinstein. *Renaissance Artists & Antique Sculpture: A Handbook of Sources*. London, 1986.

Borelius, Aron. "En torno a 'Los Borrachos.' " In *Varia velazqueña: Homenaje a Velázquez en el III centenario de su muerte, 1660–1960*, 1:245–49. Madrid, 1960.

Bottineau, Yves. "L'Alcázar de Madrid et l'inventaire de 1686: Aspects de la cour d'Espagne au XVII⁰ siècle." *Bulletin Hispanique* 58 (1956): 421–52, and 60 (1958): 30–61, 145–79, 289–326, and 450–83.

L'Art de cour dans l'Espagne de Philippe V, 1700–1746. Bordeaux, 1960.

Brito, Bernardo de. *Monarchia Lusytana. Parte Primera*. 1632. Reprint. Lisbon, 1973.

Brown, Jonathan. "A Portrait Drawing by Velázquez." *Master Drawings* 14 (1976): 46–51.

Images and Ideas in Seventeenth-Century Spanish Painting. Princeton Essays on the Arts, no. 6. Princeton, N.J., 1978.

"Mecenas y coleccionistas españoles de Jusepe de Ribera." *Goya*, no. 183 (Nov.–Dec. 1984): 140–50.

Velázquez: Painter and Courtier. New Haven, Conn., 1986.

"Enemies of Flattery: Velázquez' Portraits of Philip IV." In *Art and History: Images and Their Meanings*, 137–54. Edited by Robert I. Rotberg and Theodore K. Rabb. Cambridge, 1988.

The Golden Age of Painting in Spain. New Haven, Conn., 1991.

Brown, Jonathan, and J. H. Elliott. *A Palace for a King: The Buen Retiro and the Court of Philip IV*. New Haven, Conn., 1980.

Brown, Jonathan, and Richard L. Kagan. "The Duke of Alcalá: His Collection and Its Evolution." *Art Bulletin* 69 (1987): 231–55.

Bull, Duncan, and Enriqueta Harris. "The Companion of Velázquez's *Rokeby Venus* and a Source for Goya's *Naked Maja*." *Burlington Magazine* 128 (1986): 643–54.

Burke, Marcus B. "Velázquez's *Las Hilanderas*." *Art Bulletin* 63 (1981): 500–01.

"Private Collections of Italian Art in Seventeenth-Century Spain." 3 vols. Ph.D. dissertation, New York University, 1984.

[Bustamante, Jorge de.] *Las Metamorphoses, o Transformaciones del muy excelente poeta Ouidio, repartidas en quinze libros y traduzidas en Castellano*. Antwerp, 1551.

Calandre, Luis. *El Palacio del Pardo (Enrique III–Carlos III): Estudio preliminar*. Madrid, 1953.

Calderón y Tejero, Antonio. "La casa natal de Antonio de Nebrija." *Revista de Filología Española* 29 (1945): 1–16.

Camón Aznar, José. *Velázquez*. 2 vols. Madrid, 1964.

Campbell, Donald J. "The Birthplace of Silius Italicus." *Classical Review* 50 (1936): 56–58.

Carducho, Vicente. *Diálogos de la pintura: Su defensa, origen, esencia, definición, modos y diferencias*. Edited by Francisco Calvo Serraller. Madrid, 1979.

Caro, Rodrigo. *Antigvedades, y principado de la ilvstrissima civdad de Sevilla. Y chorographia de sv convento ivridico, o antigva chancilleria*. Seville, 1634.

Varones insignes en letras naturales de la ilustrísima ciudad de Sevilla. Epistolario. Edited by Santiago Montoto. Seville, 1915.

Carrillo, Martín. *Annales y memorias cronologicas. Contienen las cossas mas notables*

assi Ecclesiasticas como Seculares succedidas en el Mūdo señaladamente en España desde su principio y poblacion hasta el Año M.DC.XX. Huesca, 1622.

Castro, Adolfo de. "Varias observaciones sobre algunas particularidades de la poesía española." In *Poetas líricos de los siglos XVI y XVII,* 2:v–xli. Biblioteca de Autores Españoles, vol. 42. Madrid, 1857.

Cavalli-Björkman, Görel, ed. *Bacchanals by Titian and Rubens: Papers Given at a Symposium in Nationalmuseum, Stockholm, March 18–19, 1987.* Nationalmusei Skriftserie, n.s., 10. Stockholm, 1987.

Ceán Bermúdez, Juan A. *Diccionario histórico de los más ilustres profesores de las bellas artes en España.* 6 vols. 1800. Reprint. Madrid, 1965.

Cherry, Peter. "New Documents for Velázquez in the 1620s." *Burlington Magazine* 133 (1991): 108–15.

Clark, Kenneth. *Rembrandt and the Italian Renaissance.* New York, 1966.

Colombier, Pierre du. "La Forge de Vulcain au château d'Effiat." *Gazette des Beaux-Arts,* 6th ser., 21 (1939): 30–38.

Coronacion de la Magestad del Rey don Felipe Tercero nuestro Señor; Ivramento del serenissimo Principe de España su hijo; Celebrado todo en el Real Salon del Palacio, en la ciudad de Lisboa, Domingo catorce de Iulio. Seville, 1619.

Correspondance de Rubens et documents épistolaires. Translated and edited by Max Rooses and Charles Reulens. 6 vols. Antwerp, 1887–1909.

Covarrubias Orozco, Sebastián de. *Tesoro de la lengua castellana o española.* Madrid, 1977.

Cruzada Villaamil, Gregorio. *Rubens diplomático español.* Madrid, 1874.

Curtis, Charles B. *Velazquez and Murillo: A Descriptive and Historical Catalogue.* London, 1883.

Darby, Delphine F. "In the Train of a Vagrant Silenus." *Art in America* 31 (1943): 140–49.

D'Hulst, R.-A., and M. Vandenven. *The Old Testament.* Translated by P. S. Falla. Corpus Rubenianum Ludwig Burchard, pt. 3. London, 1989.

Díaz Padrón, Matías. *Museo del Prado, catálogo de pinturas. I. Escuela flamenca, siglo XVII.* 2 vols. Madrid, 1975.

Diodorus of Sicily. *Diodorus of Sicily.* Translated and edited by C. H. Oldfather, Charles L. Sherman, C. Bradford Welles, Russell M. Geer, and Francis R. Watson. 12 vols. Loeb Classical Library. London, 1933–67.

"Documentos relativos a Velázquez." In *Varia velazqueña: Homenaje a Velázquez en el III centenario de su muerte, 1660–1960,* 2:209–413. Madrid, 1960.

Elliott, J. H. *The Revolt of the Catalans: A Study in the Decline of Spain, 1598–1640.* Cambridge, 1963.

——— . *Richelieu and Olivares.* Cambridge, 1984.

——— . *The Count-Duke of Olivares: The Statesman in an Age of Decline.* New Haven, Conn., 1986.

Elliott, J. H., and José F. de la Peña. *Memoriales y cartas del Conde Duque de Olivares.* 2 vols. Madrid, 1978–80.

Enggass, Robert, and Jonathan Brown. *Italy and Spain, 1600–1750: Sources and Documents.* Englewood Cliffs, N.J., 1970.

Escolano, Gaspar. *Decada primera de la Historia de la Insigne y Coronada Ciudad y Reyno de Valencia.* 3 vols. 1610. Reprint. Valencia, 1972.

Faria e Sousa, Manuel de. *Epitome de las historias portvgvesas.* Madrid, 1628.

Fernández Bayton, Gloria, ed. *Inventarios Reales: Testamentaría del Rey Carlos II, 1701–1703.* Vols. 1–3. Madrid, 1975–85.

Fernández-Miranda y Lozana, Fernando, ed. *Inventarios Reales: Carlos III, 1789–1790.* Vol. 1. Madrid, 1988.

Gállego, Julián. *Diego Velázquez*. Palabra Plástica, no. 2. Madrid, 1983.

Garibay y Zamalloa, Esteban. *Compendio historial de las chronicas y vniversal historia de todos los reynos d'España, donde se escriven las vidas de los Reyes de Castilla, y Leon*. 4 vols. Antwerp, 1571.

Garrido Pérez, Carmen. *Velázquez: Técnica y evolución*. Madrid, 1992.

Gerard, Véronique. "La fachada del Alcázar de Madrid (1608–1630)." *Cuadernos de Investigación Histórica* 2 (1978): 237–57.

"Philip IV's Early Italian Commissions." *Oxford Art Journal* 5:1 (1982): 9–14.

Gerstenberg, Kurt. *Diego Velazquez*. Munich, 1957.

Gómez Canseco, Luis M. *Rodrigo Caro: Un humanista en la Sevilla del seiscientos*. Seville, 1986.

Gómez de Mora, Juan. "Aparato del tvmulo real que se edifico en el Conuēto de S. Geronimo De la villa de Madrid para celebrar las honras Del Inclito y esclarecido Rey Don Filipe. III." Salamanca, Biblioteca Universitaria, Ms. 1,973.

González Moreno, Joaquín. *Don Fernando Enríquez de Ribera, tercer duque de Alcalá de los Gazules (1583–1637): Estudio biográfico*. Seville, 1969.

Haraszti-Takács, Marianna. *Spanish Genre Painting in the Seventeenth Century*. Translated by Alfréd Falvay. Budapest, 1983.

Harris, Enriqueta. "La misión de Velázquez en Italia." *Archivo Español de Arte* 33 (1960): 109–36.

"Cassiano dal Pozzo on Diego Velázquez." *Burlington Magazine* 112 (1970): 364–73.

"Velázquez and His Ecclesiastical Benefice." *Burlington Magazine* 123 (1981): 95–96.

Velázquez. Ithaca, N.Y., 1982.

Held, Julius S. *The Oil Sketches of Peter Paul Rubens: A Critical Catalogue*. 2 vols. Princeton, N.J., 1980.

"Rubens and Titian." In *Titian: His World and His Legacy*, 283–339. Edited by David Rosand. New York, 1982.

Hibbard, Howard. *Caravaggio*. New York, 1983.

Hospital de Tavera and Iglesia de San Pedro Mártir, Toledo. *El Toledo de El Greco*. Toledo, 1982.

Huemer, Frances. *Portraits, I*. Corpus Rubenianum Ludwig Burchard, pt. 19, vol. 1. London, 1977.

Hurtado de Mendoza, Diego. *De la guerra de Granada*. Edited by Manuel Gómez-Moreno. Memorial Histórico Español, vol. 49. Madrid, 1948.

Jordan, William B. "Juan van der Hamen y León." 2 vols. Ph.D. dissertation, New York University, 1967.

Spanish Still Life in the Golden Age, 1600–1650. With an essay by Sarah Schroth. Fort Worth, Texas, 1985.

Junquera, Juan J. "Un retablo de Maino en Pastrana." *Archivo Español de Arte* 50 (1977): 129–40.

Justi, Carl. *Diego Velazquez und sein Jahrhundert*. 2 vols. Bonn, 1888.

Diego Velazquez and His Times. Rev. ed. Translated by A. H. Keane. London, 1889.

Kahr, Madlyn M. *Velázquez: The Art of Painting*. New York, 1976.

Kimbell Art Museum. *Jusepe de Ribera lo Spagnoletto, 1591–1652*. Edited by Craig Felton and William B. Jordan. Fort Worth, Texas, 1982.

Kitaura, Yasunari. "¿Que aprendió Velázquez en su primer viaje por Italia?" *Archivo Español de Arte* 62 (1989): 435–54.

Kubler, George. "Vicente Carducho's Allegories of Painting." *Art Bulletin* 47 (1965): 439–45.

Lafuente Ferrari, Enrique. *Velazquez*. Translated by James Emmons. Cleveland, Ohio, 1960.

Lawrance, Jeremy N. H. "Humanism in the Iberian Peninsula." In *The Impact of Humanism on Western Europe*, 220–58. Edited by Anthony Goodman and Angus MacKay. London, 1990.

Le Flem, Jean P. "Un artista-diplomático en el tiempo de Olivares: Pierre-Paul Rubens." In *La España del Conde Duque de Olivares*, 161–92. Edited by John H. Elliott and Angel García Sanz. Valladolid, 1990.

Lemus y Rubio, Pedro. "El Maestro Elio Antonio de Lebrixa 1441?–1522." *Revue Hispanique* 22 (1910): 459–508, and 29 (1913): 13–120.

Les Argonautiques orphiques. Edited and translated by Francis Vian. Paris, 1987.

Lightbown, Ronald W. *Mantegna: With a Complete Catalogue of the Paintings, Drawings and Prints*. Oxford, 1986.

Lleó Cañal, Vicente. *Nueva Roma: Mitología y humanismo en el renacimiento sevillano*. Seville, 1979.

Review of *Philip IV and the Decoration of the Alcázar of Madrid* by Steven N. Orso. *Burlington Magazine* 129 (1987): 119–20.

López, Diego. *Declaracion magistral sobre las emblemas de Andres Alciato con todas las Historias, Antiguedades, Moralidad, y Doctrina tocante a las buenas costumbres*. Nájera, 1615.

López Navío, José. "Velázquez tasa los cuadros de su protector, D. Juan de Fonseca." *Archivo Español de Arte* 34 (1961): 53–84.

López Torrijos, Rosa. *La mitología en la pintura española del Siglo de Oro*. Madrid, 1985.

López-Rey, José. *Velázquez: A Catalogue Raisonné of His Oeuvre, with an Introductory Study*. London, 1963.

Velázquez' Work and World. Greenwich, Conn., 1968.

"Muerte de Villandrando y fortuna de Velázquez." *Arte Español* 26 (1968–69): 1–4.

Velázquez: The Artist as a Maker, with a Catalogue Raisonné of His Extant Works. Paris, 1979.

Lowry, Bates. "Notes on the *Speculum Romanae Magnificentiae* and Related Publications." *Art Bulletin* 34 (1952): 46–50.

Lynn, Caro. *A College Professor of the Renaissance: Lucio Marineo Sículo Among the Spanish Humanists*. Chicago, 1937.

Maravall, José Antonio. *La teoría española del estado en el siglo XVII*. Madrid, 1944.

[Margarit i Pau, Joan.] *Episcopi Gervndensis Paralipomenon Hispaniae libri decem antehac non excvssi*. Granada, 1545.

Mariana, Juan de. *Historia General de España*. In Juan de Mariana, *Obras*, 1:1–2: 411. Biblioteca de Autores Españoles, vols. 30–31. Madrid, 1864–72.

Marías, Fernando. "El Palacio Real de El Pardo: De Carlos V a Felipe III." *Reales Sitios: XXV Aniversario*, special number (1989): 137–46.

Marieta, Juan de. *Historia eclesiastica de todos los santos, de España. Primera, Segvnda, Tercera Y Quarta parte: donde se cuentá muy particularmente, todas las vidas, martyrios y milagros, de los Santos y Santas propios que en esta nuestra España ha auido, assi de Martires, Pontifices Confessores como no Pontifices, y Religiosos de todas Ordenes: y los Concilios que ha auido desde el tiempo de los Apostoles hasta agora (con otras cosas muy curiosas de todas las Ciudades de España que nunca han sido impressas) Con dos tablas muy copiosas la vna de capitulos, y la otra de sentencias*. Cuenca, 1596.

Marineus Siculus, Lucius [Luca di Marinis]. *Obra Compuesta por Lucio Marineo Siculo Coronista de sus Magestades de las cosas memorables de España*. Alcalá de Henares, 1539.

Martín González, Juan J. "Sobre las relaciones entre Nardi, Carducho y Veláz-
quez." *Archivo Español de Arte* 31 (1958a): 59–66.

"Arte y artistas del siglo XVII en la corte." *Archivo Español de Arte* 31 (1958b):
125–42.

Martínez, Jusepe. *Discursos practicables del nobilísimo arte de la pintura.* Edited by
Julián Gállego. Selecciones Bibliófilas, vol. 8. Madrid, 1950.

Mayer, August L. "El 'Bacchanal' de Ribera y su origen." *Boletín de la Sociedad
Española de Excursiones* 25 (1927): 159–60.

Velazquez: A Catalogue Raisonné of the Pictures and Drawings. London, 1936.

Mazón de la Torre, María A. *Jusepe Leonardo y su tiempo.* Zaragoza, 1977.

McKim-Smith, Gridley. "On Velázquez's Working Method." *Art Bulletin* 61
(1979): 589–603.

"The Problem of Velázquez's Drawings." *Master Drawings* 18 (1980): 3–24.

McKim-Smith, Gridley, Greta Andersen-Bergdoll, and Richard Newman. *Ex-
amining Velázquez.* New Haven, Conn., 1988.

Medina, Pedro de. *Libro de las grandezas y cosas memorables de España.* In *Obras de
Pedro Medina,* 1–258. Edited by Angel González Palencia. Clásicos Espa-
ñoles, vol. 1. Madrid, 1944.

Mercado Egea, Joaquín. *Felipe IV en las Andalucías.* Jaén, 1980.

Moffitt, John F. "Velázquez's 'Forge of Vulcan': The Cuckold, the Poets, and
the Painter." *Pantheon* 41 (1983): 322–26.

"*In vino veritas:* Velázquez, Baco y Pérez de Moya." Translated by Consuelo
Luca de Tena. *Boletín del Museo del Prado* 6 (1985a): 24–29.

"Painting, Music and Poetry in Velázquez's *Las Hilanderas.*" *Konsthistorisk Tids-
krift* 54 (1985b): 77–90.

"The 'Euhemeristic' Mythologies of Velázquez." *Artibus et Historiae* 10:19
(1989): 157–75.

"Francisco Pacheco and Jerome Nadal: New Light on the Flemish Sources of
the Spanish 'Picture-within-the-Picture.' " *Art Bulletin* 72 (1990): 631–38.

Morales, M. *Rodrigo Caro: Bosquejo de una biografía íntima.* Seville, 1947.

Moreno Villa, José, and Francisco J. Sánchez Cantón. "Noventa y siete retratos
de la familia de Felipe III por Bartolomé González." *Archivo Español de Arte*
13 (1937): 127–63.

Museo del Prado, Madrid. *Pintura napolitana de Caravaggio a Giordano.* Madrid,
1985.

*Monstruos, enanos y bufones en la Corte de los Austrias (A propósito del "Retrato de
enano" de Juan Van der Hamen).* Madrid, 1986.

Rubens, copista de Tiziano. Madrid, 1987.

Zurbarán. Madrid, 1988.

Museo del Prado. Inventario general de pinturas. I: La colección real. Madrid, 1990.

Museo Municipal, Madrid. *Juan Gómez de Mora (1586–1648): Arquitecto y trazador
del rey y maestro mayor de obras de la villa de Madrid.* Madrid, 1986.

Nebrija, Antonio de. *Rervm a Fernando & Elisabe Hispaniarũ fœlicissimis Regibus
gestarum Decades duas.* Granada, 1545.

*Nebrija. Gramatica de la lengua Castellana (Salamanca, 1492). Muestra de la istoria
de las antiguedades de España. Reglas de orthographia en la lengua castellana.*
Edited by I. González-Llubera. Oxford, 1926.

Gramática de la lengua castellana. Edited by Antonio Quilis. Madrid, 1980.

Nonnius, Ludovicus [Luis Núñez]. *Hispania, sive popvlorvm, vrbivm, insvlarvm, ac
flvminvm in ea accvratior descriptio.* Antwerp, 1603.

*Noticia del recibimiento i entrada de la Reyna nuestra Señora Doña Maria-Ana de Austria
en la mvy noble i leal Villa de Madrid.* N.p., 1650.

Novoa, Matías de. *Historia de Felipe IV, Rey de España.* 4 vols. Colección de Documentos Inéditos para la Historia de España, vols. 69, 77, 80, and 86. Madrid, 1876–86.

Nunes do Leão, Duarte. *Descripçao do Reino de Portugal.* Lisbon, 1610.

Núñez de Castro, Alonso. *Libro historico politico. Solo Madrid es corte, y el cortesano en Madrid.* Madrid, 1658. Rev. ed., Madrid, 1669.

Ocampo, Florián de. *Corónica general de España,* vols. 1 and 2. Madrid, 1791.

Orihuela Maeso, Mercedes. "Dos obras inéditas de Van der Hamen depositadas en la Embajada de Buenos Aires." *Boletín del Museo del Prado* 3 (1982): 11–14.

Orso, Steven N. *Philip IV and the Decoration of the Alcázar of Madrid.* Princeton, N.J., 1986.

Art and Death at the Spanish Habsburg Court: The Royal Exequies for Philip IV. Columbia, Mo., 1989.

"Praising the Queen: The Decorations at the Royal Exequies for Isabella of Bourbon." *Art Bulletin* 72 (1990): 51–73.

"Why Maino?: A Note on the *Recovery of Bahía.*" *Source: Notes in the History of Art* 10:2 (Winter 1991): 26–31.

Ortega y Gasset, José. *Velázquez, Goya and The Dehumanization of Art.* Translated by Alexis Brown. Introduction by Philip Troutman. New York, 1972.

Ortelius, Abraham. *The Theatre of the Whole World.* 1606. Reprint, with an introduction by R. A. Skelton. Amsterdam, 1968.

Pacheco, Francisco. *Arte de la pintura.* Edited by Francisco J. Sánchez Cantón. 2 vols. Madrid, 1956.

El arte de la pintura. Edited by Bonaventura Bassegoda i Hugas. Madrid, 1990.

Palomino de Castro y Velasco, Antonio. *El museo pictórico y escala óptica.* 1715–24. Reprint. Madrid, 1947.

Lives of the Eminent Spanish Painters and Sculptors. Translated by Nina A. Mallory. Cambridge, 1987.

Pantorba, Bernardino de [*pseud.*]. *La vida y la obra de Velázquez: Estudio biográfico y crítico.* Madrid, 1955.

Pérez de Guzmán y Gallo, Juan. "Fray Juan Bautista Mayno en un proceso de la Inquisición de Toledo." *Arte Español* 2 (1914–15): 55–72.

Pérez de Moya, Juan. *Philosophia secreta.* Edited by Eduardo Gómez de Baquero. 2 vols. Los Clásicos Olvidados, vols. 6 and 7. Madrid, 1928.

Pérez Sánchez, Alfonso E. "Sobre los pintores de El Escorial." *Goya,* nos. 56–57 (Sept.–Dec. 1963): 148–53.

Caravaggio y el naturalismo español. Seville, 1973.

D. Antonio de Pereda (1611–1678) y la pintura madrileña de su tiempo. Madrid, 1978.

El dibujo español de los siglos de oro. Madrid, 1980.

Philip IV of Spain. "Autosemblanza de Felipe IV." In *Cartas de Sor María de Agreda y de Felipe IV,* 2:231–36. Edited by Carlos Seco Serrano. Biblioteca de Autores Españoles, vol. 109. Madrid, 1958.

Picón, Jacinto O. *Vida y obras de Don Diego Velázquez.* Madrid, 1899.

Pigler, Andor. *Barockthemen: Eine Auswahl von Verzeichnissen zur Ikonographie des 17. und 18. Jahrhunderts.* Rev. ed. 3 vols. Budapest, 1974.

Pineda, Juan de. *Ad suos in Salomonem commentarios Salomon praevivs, id est, de rebvs salomonis regis libri octo.* Lyons, 1609.

Pliny the Elder. *Natural History.* Translated and edited by H. Rackham, W. H. S. Jones, and D. E. Eichholz. 10 vols. Loeb Classical Library. London, 1938–63.

Plutarch [*spurious*]. *De flvviorvm et montivm nominibvs, et de his qvæ in illis reperiuntur. Item. Psellvs de lapidvm virtvtibvs. Omnia nunc primum ex Manuscripto Græcè & Latinè cum Castigationibus & notis.* Edited by Phillipe J. de Maussac. Toulouse, 1618.

Ponz, Antonio. *Viaje de España.* Edited by Casto M. del Rivero. 4 vols. Madrid, 1988.

Poza, Andrés de. *Antigua lengua de las Españas.* Edited by Angel Rodríguez Herrero. Biblioteca Vasca, vol. 4. Madrid, 1959.

Pozzo, Cassiano dal. Untitled journal of Cardinal Francesco Barberini's legation to Spain in 1626. Biblioteca Apostolica Vaticana, Ms. Barb. lat. 5,689.

Primera crónica general de España que mandó componer Alfonso el Sabio y se continuaba bajo Sancho IV en 1289. Edited by Ramón Menéndez Pidal et al. 2 vols. Madrid, 1955.

Riggs, Arthur S. *Velázquez: Painter of Truth and Prisoner of the King.* New York, 1947.

Ripa, Cesare. *Iconologia, o vero descrittione d'imagini delle Virtv', Vitij, Affetti, Passioni humane, Corpi celesti, Mondo e sue parti.* 1611. Reprint. New York, 1976.

Rodríguez Villa, Antonio. *Etiquetas de la casa de Austria.* Madrid, 1913.

Rubens, Peter Paul. *The Letters of Peter Paul Rubens.* Translated and edited by Ruth S. Magurn. Cambridge, Mass., 1955.

Ruiz Alcón, María T. "Colecciones del Patrimonio Nacional. Pintura XXVII. J. van der Hamen." *Reales Sitios,* no. 52 (1977): 29–36.

Sáenz de Miera Santos, Carmen. "Entrada triunfal de la Reina Mariana de Austria en Madrid el día 15 de noviembre de 1649." *Anales del Instituto de Estudios Madrileños* 23 (1986): 167–74.

Saltillo, Marqués del. "Pinturas de Ribera." *Archivo Español de Arte* 14 (1941): 246–47.

———. "Artistas madrileñas (1592–1850)." *Boletín de la Sociedad Española de Excursiones* 57 (1953): 137–243.

Sánchez Alonso, Benito. *Historia de la historiografía española: Ensayo de un examen de conjunto.* 3 vols. Madrid, 1941–50.

———. "Nebrija, historiador." *Revista de Filología Española* 29 (1945): 129–52.

Sánchez Cantón, Francisco J. *Los pintores de cámara de los Reyes de España.* Madrid, 1916.

———. "La librería de Velázquez." In *Homenaje ofrecido a Menéndez Pidal: Miscelánea de estudios lingüísticos, literarios e históricos,* 3: 379–406. Madrid, 1925.

———. "Los libros españoles que poseyó Velázquez." In *Varia velazqueña: Homenaje a Velázquez en el III centenario de su muerte, 1660–1960.* 1:640–48. Madrid, 1960.

———. *Velázquez y "lo clásico".* Cuadernos de la Fundación Pastor, no. 5. Madrid, 1961.

Sayre, Eleanor. *The Changing Image: Prints by Francisco Goya.* Boston, 1974.

Sebastián [López], Santiago. "Lectura iconográfico-iconológica de 'La Fragua de Vulcano,'" *Traza y Baza* 8 (1983): 20–27.

———. "Lectura iconográfico-iconológica del *Rito de Baco* (Los Borrachos) de Velázquez." In *Homenaje a José Antonio Maravall,* 3:359–67. Madrid, 1985a.

———, ed. *Emblemas,* by Andrea Alciati. Arte y Estética, no. 2. Madrid [1985b].

Silius Italicus. *Punica.* Translated and edited by J. D. Duff. 2 vols. Loeb Classical Library. London, 1934.

Soria, Martin S. "Some Flemish Sources of Baroque Painting in Spain," *Art Bulletin* 30 (1948): 249–59.

———. "La Venus, Los Borrachos, y La Coronación, de Velázquez." *Archivo Español de Arte* 36 (1953): 269–84.

Sotomayor Román, Francisco. "Materiales para una iconografía de 'Las Hilanderas' y 'Los Borrachos' de Velázquez." *Cuadernos de Arte e Iconografía* 3:5 (1990): 55–69.

Spear, Richard E. *Caravaggio and His Followers*. Rev. ed. New York, 1975.

Spinosa, Nicola. *La obra pictórica completa de Ribera*. Translated by Jorge Binaghi. Madrid, 1979.

Stechow, Wolfgang. *Rubens and the Classical Tradition*. Cambridge, Mass., 1968.

Stirling[-Maxwell], William. *Annals of the Artists of Spain*. 3 vols. London, 1848.

Stradling, R. A. *Philip IV and the Government of Spain, 1621–1665*. Cambridge, 1988.

Suarez de Salazar, Juan Baptista. *Grandezas, y antigvedades de la isla y civdad de Cadiz. En qve se escriven muchas ceremonias que vsaua la Gentilidad, Varias costumbres antiguas, Ritos funerales con monedas, estatuas, piedras, y sepulcros antiguos: ilustrado de varia erudicion, y todas buenas letras*. Cádiz, 1610.

Tarafa, Francisco. *De origine, ac rebus gestis Regum Hispaniae liber, multarum rerum cognitioe refertus*. Antwerp, 1553.

 Chronica de España. Barcelona, 1562–63.

Tate, Robert B. "Italian Humanism and Spanish Historiography of the Fifteenth Century: A Study of the *Paralipomenon Hispaniae* of Joan Margarit, Cardinal Bishop of Gerona." *Bulletin of the John Rylands Library, Manchester* 34 (1951–52): 137–65.

 "Mythology in Spanish Historiography of the Middle Ages and the Renaissance." *Hispanic Review* 22 (1954): 1–18.

 Joan Margarit i Pau, Cardinal-Bishop of Gerona: A Biographical Study. Publications of the Faculty of Arts of the University of Manchester, no. 6. Manchester, 1955.

 "Nebrija the Historian." *Bulletin of Hispanic Studies* 34 (1957): 125–46.

Tolnay, Charles de. "Las pinturas mitológicas de Velázquez." *Archivo Español de Arte* 34 (1961): 31–45.

Trapier, Elizabeth D. G. *Velázquez*. New York, 1948.

Valdivieso, Enrique, and Juan M. Serrera. *Escuela sevillana del primer tercio del siglo XVII*. Historia de la Pintura Española. Madrid, 1985.

Varey, J. E., and A. M. Salazar. "Calderón and the Royal Entry of 1649." *Hispanic Review* 34 (1966): 1–26.

Vessey, D. W. T. "The Origin of Ti. Catius Asconius Silius Italicus." *Classical Bulletin* 60 (1984): 9–10.

Villaverde Prado y Salazar, Manuel de. *Relacion escrita a vn amigo avsente desta Corte, de la entrada que hizo la Reyna N. S. D. Mariana de Austria, Lunes 15. de Nouiembre de 1649. años, desde el Retiro a su Real Palacio de Madrid*. Madrid, n.d.

Vlieghe, Hans. *Saints, II*. Translated by P. S. Falla. Corpus Rubenianum Ludwig Burchard, pt. 8, vol. 2. London, 1973.

Volk, Mary C. *Vicencio Carducho and Seventeenth Century Castilian Painting*. New York, 1977.

 "Rubens in Madrid and the Decoration of the King's Summer Apartments." *Burlington Magazine* 123 (1981): 513–29.

Wázbiński, Zygmunt. "Los *Diálogos de la pintura* de Vicente Carducho: El manifiesto del academicismo español y su origen." *Archivo Español de Arte* 63 (1990): 435–47.

Wedgwood, C. V. *The Political Career of Peter Paul Rubens*. London, 1975.

Welles, Marcia L. *Arachne's Tapestry: The Transformation of Myth in Seventeenth-Century Spain*. San Antonio, Texas, 1986.

Wethey, Harold E. *The Paintings of Titian: Complete Edition.* 3 vols. London, 1969–75.

Wind, Barry. *Velázquez's Bodegones: A Study in Seventeenth-Century Spanish Genre Painting.* Fairfax, Va., 1987.

Zarco Cuevas, Julián. *Pintores españoles en San Lorenzo el Real de El Escorial (1566–1613).* Madrid, 1931.

Pintores italianos en San Lorenzo el Real de El Escorial (1575–1613). Madrid, 1932.

INDEX